In Memory of

Raymond & Alice Winther

DISCARDED

THE MAGIC OF MONET'S GARDEN

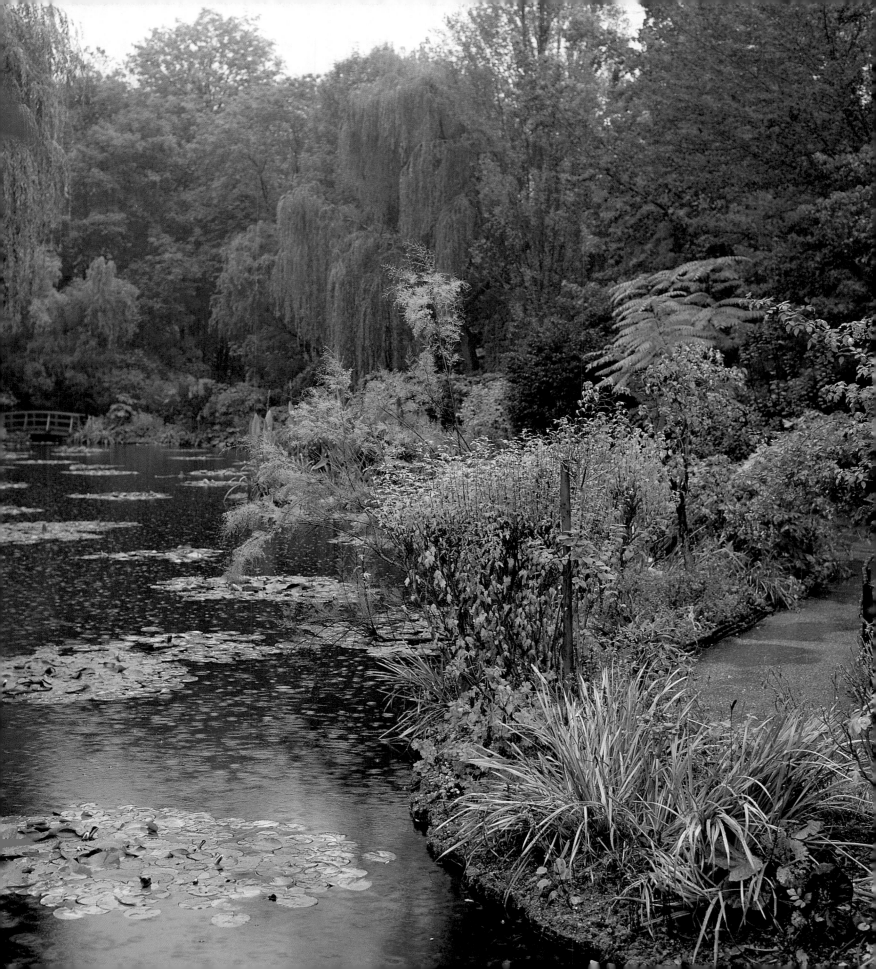

THE MAGIC OF MONET'S GARDEN

HIS PLANTING PLANS AND COLOR HARMONIES

DEREK FELL

FIREFLY BOOKS

A FIREFLY BOOK

Published by Firefly Books Ltd. 2007

Copyright © 2007 Derek Fell, David Bateman Ltd

First printing

Publisher Cataloging-in-Publication Data (U.S.)

Fell, Derek.
The magic of Monet's garden / Derek Fell.
[160] p. : col. ill., col. photos. ; cm.
Includes index.
Summary: The secrets of Monet's breath-taking color harmonies and application to the home garden through color photographs and detailed planting plans.
ISBN-13: 978-1-55407-277-4
ISBN-10: 1-55407-277-8
1. Monet, Claude, 1840–1926 — Homes and haunts — France — Giverny.
2. Gardens — France — Giverny.
3. Landscape gardening. I. Title.
759.4 dc22 ND553.M7F45 2007

Library and Archives Canada Cataloguing in Publication

Fell, Derek
The magic of Monet's garden / Derek Fell.
ISBN-13: 978-1-55407-277-4
ISBN-10: 1-55407-277-8
1. Monet, Claude, 1840–1926—Homes and haunts—France—
Giverny. 2. Gardens—France—Giverny. 3. Gardens in art.
I. Title.
ND553.M7F44 2007 759.4 C2006-906530-6

Published in the United States by
Firefly Books (U.S.) Inc.
P.O. Box 1338, Ellicott Station
Buffalo, New York 14205

Published in Canada by
Firefly Books Ltd.
66 Leek Crescent
Richmond Hill, Ontario L4B 1H1

Design: Trevor Newman

Printed in China through Colorcraft Ltd., Hong Kong

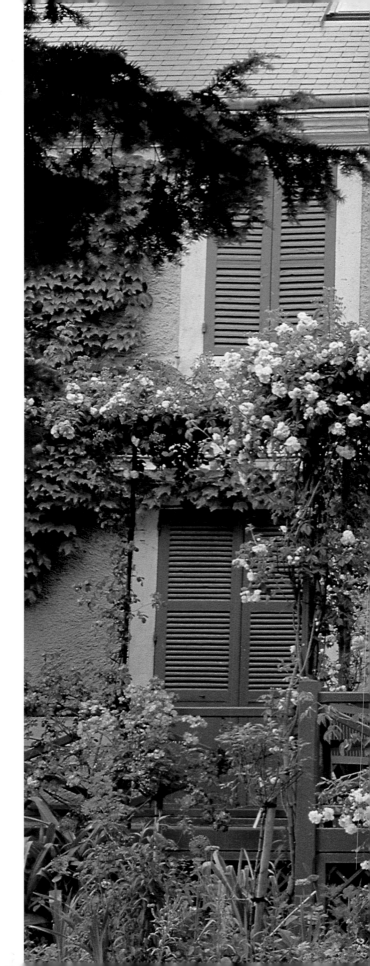

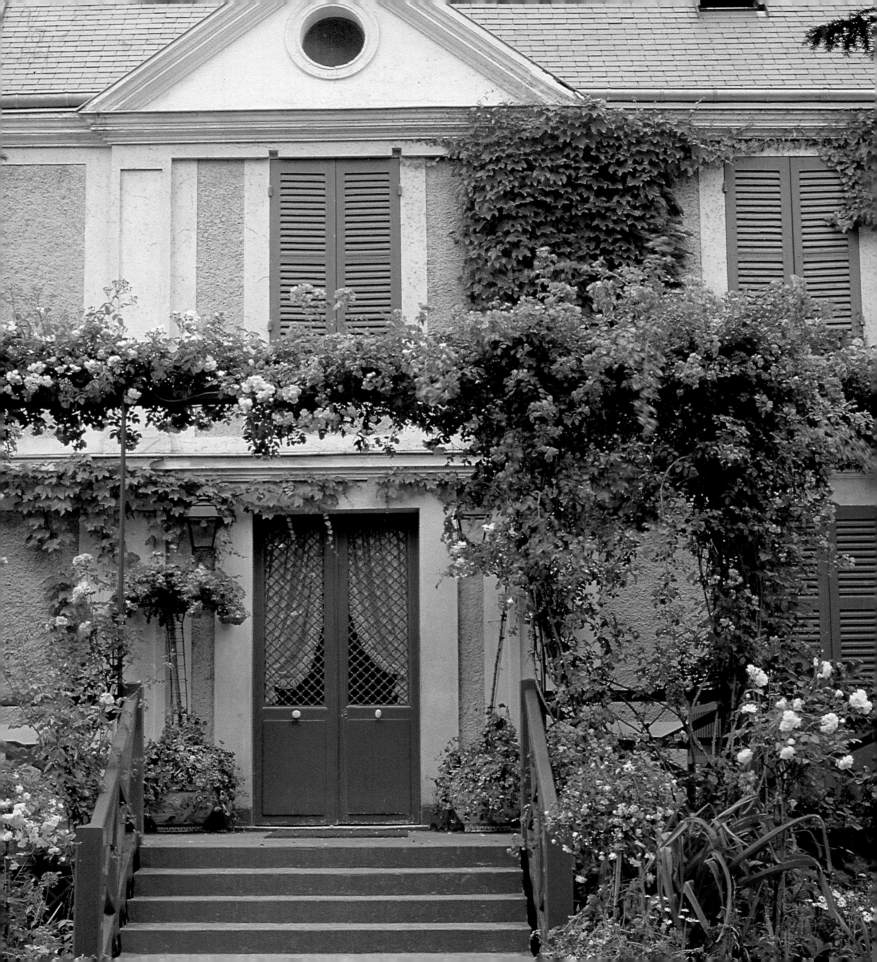

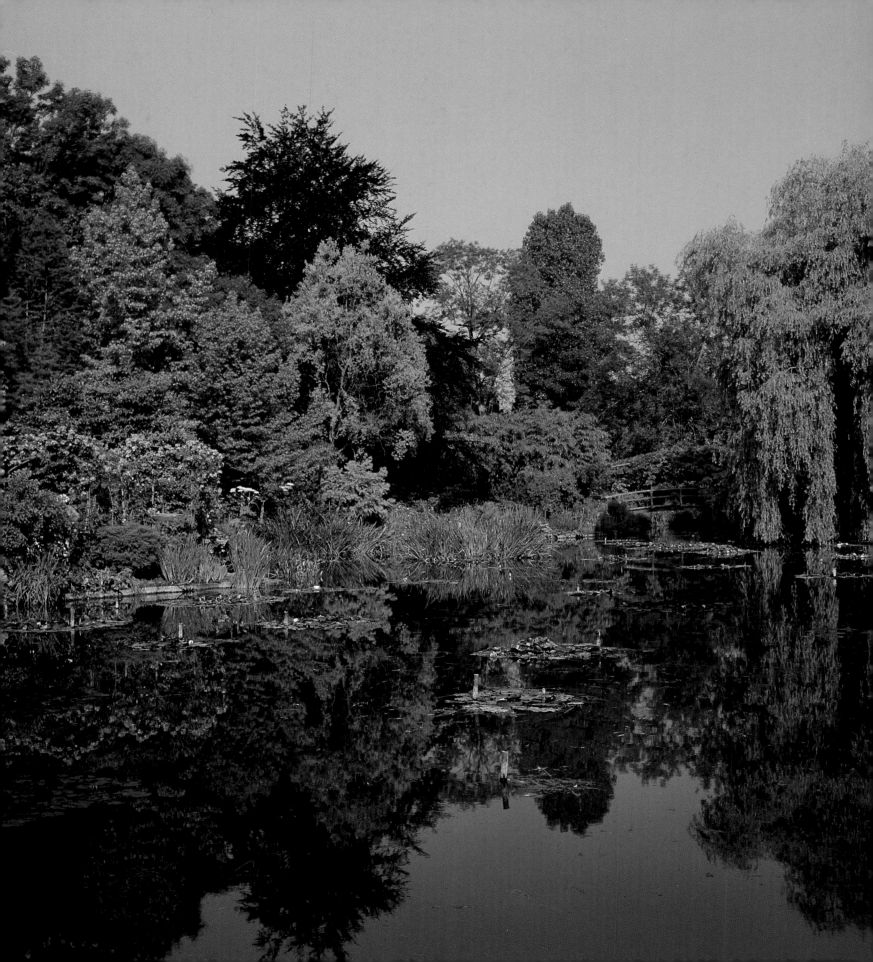

Contents

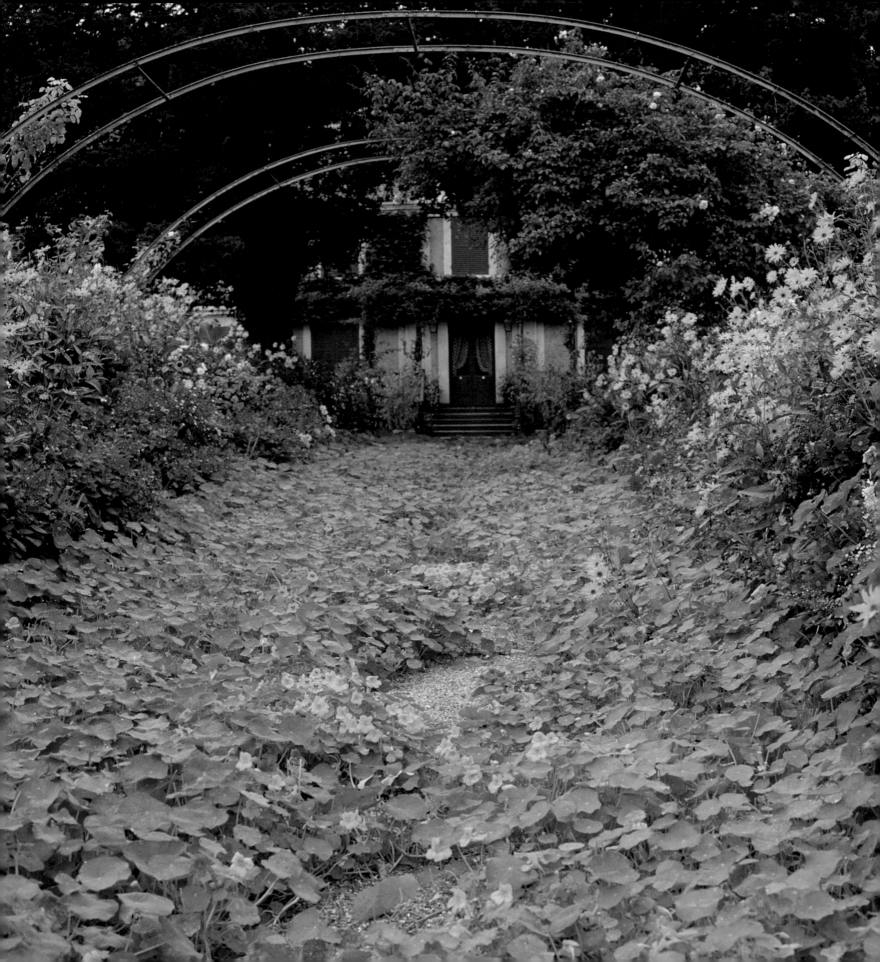

Introduction:

Monet's Love of Gardens

"I've grown used to the flowers in my garden in the spring and to the waterlilies in my pond on the Epte in the summertime. They give flavor to my life every day."

Claude Monet

CLAUDE MONET (1840–1926) is best known for his vibrant Impressionist paintings and a magnificent 5 acre (2 ha) garden that has been restored and was opened to the public in 1980. Using the sky and earth as his canvas, and flowers as paint, he considered his garden to be his greatest work of art.

Monet's garden today is the most visited garden for its size in the Western world. Hundreds of thousands of visitors each year are drawn to his home in the village of Giverny, an hour's drive northwest of Paris, to appreciate how he orchestrated an incredible succession of color, and to see how the great artist lived with his second wife, Alice, six stepchildren and two sons.

The Giverny purchase

Monet purchased the Normandy property in 1890 after his paintings began to sell to American buyers, ending years of financial hardship. The Giverny garden featured

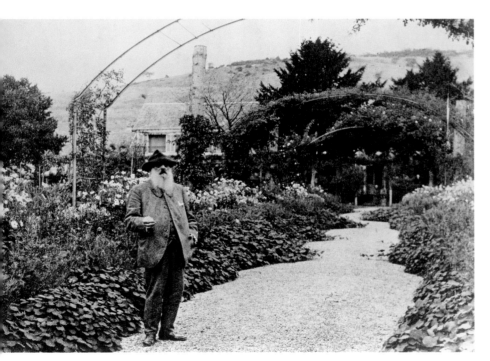

Above: Portrait of Claude Monet beneath his rose arches.

Previous page: Monet's Grande Allée is carpeted in nasturtiums by the end of summer.

heavily in his work for 40 years, until his death at age 86.

The garden the artist established at Giverny is so unique in its design principles and artistic expression that even the smallest part of it shown in photographs can be recognized immediately as Monet's. Probably no garden in modern times has inspired gardeners more than this one, with its wealth of planting ideas and structural accents. Monet's Grande Allée (a floral tunnel and wide gravel path leading from his house to the water garden), his spectacular color harmonies, and his canopied Japanese bridge are all examples of design innovations that now feature in gardens throughout the world.

The purpose of this book, therefore, is to identify the unique planting ideas that made Monet's garden such an extraordinary work of art, and explain how they can be used on a smaller scale to increase the enjoyment of today's home gardens.

Monet was born in Paris to middle-class parents. His father was a wholesale food supplier and soon after Monet's birth he moved his family to the Normandy port of Le Havre for the opportunity to provision ships of the French navy. In his teens Monet developed an interest in sketching cartoon portraits of people, and he even earned money from this pastime. His father had a garden and Monet helped to maintain it. "Gardening was something I learned in my youth," he said. "I perhaps owe having become a painter to flowers."

A chance meeting in an art supply store with Johann Jongkind, a Dutch painter of seascapes, and encouragement by an aunt, converted him to oil painting. In particular he sought to portray fleeting atmospheric moments, such as a stormy sea, the glitter of a wind-whipped bay and snowy landscapes. In fact, it was his painting of the harbor of Le Havre, on a misty morning, entitled "Impression, Sunrise" that spawned the word "Impressionism" to describe a painting technique that broke away from conventional standards by which art was judged at the time.

With the invention of the snapshot camera, many artists were no longer content to capture scenes realistically because nothing could be more realistic

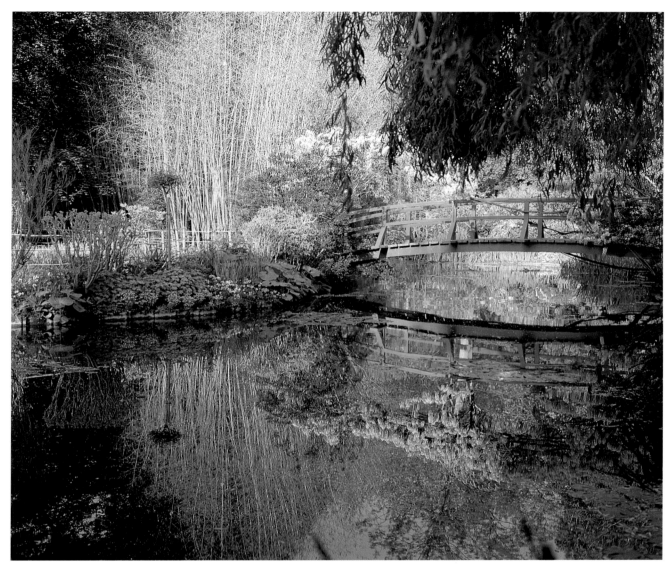

Above: A corner of Monet's pond in spring showing exquisite water reflections.

than a photograph, and so they challenged the long-held belief that paintings must be as realistic as possible to have any value. Influenced by the evanescent watercolors of the English painter J.M.W. Turner, Monet avoided sharply outlined shapes to portray objects, and used flickering brushstrokes to emphasize transient variations of reflected light. He also used complementary colors in close proximity to create images that are extremely bright or highly atmospheric, like morning mist, raindrops on a pond or a landscape tinted with snow. To explain his special painting technique, Monet told a journalist: "I paint what I see, I paint what I remember, and I paint what I feel." It was his desire to paint what he *felt* — what he perceived with his inner eye — that was different from conventional art, but when Monet's work was first exhibited at Impressionist exhibitions in Paris among other avant-garde artists, it provoked public ridicule, and took a long time to be understood.

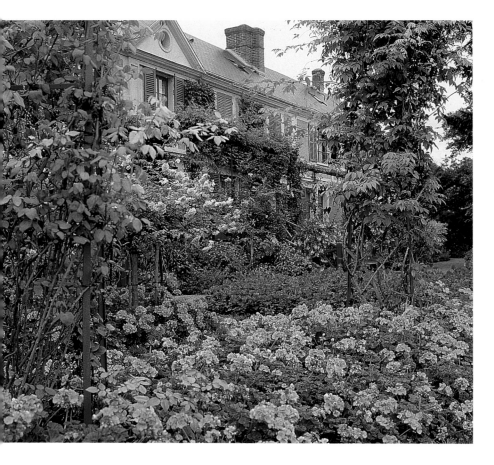

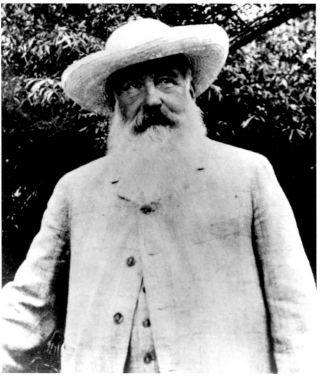

Above: Monet toured his garden three times daily.
Left: Geraniums and rose standards crowd island beds in front of Monet's house.

Inspiration from the garden

Monet was an astute observer of nature. He took long walks in the countryside in all kinds of weather, searching for motifs, and many of the sights he encountered in nature he realized could be applied to planting his garden. This included the recognition of especially beautiful color harmonies, like red, pink and silver, which he encountered in a meadow of red and pink poppies that mingled with the silvery leaves of wild sage, but also the sensation of glitter on the surface of water on a sunny day, when even the slightest breeze will ripple the water and produce a thousand pinpricks of light.

Monet was most successful at capturing the vibration in the atmosphere on a hot, humid day when heat waves produce a haze in the distance.

This sensation of imbuing scenes with a glimmering effect became known as the "Impressionist shimmer," and Monet realized that he could introduce a similar sensation of shimmer into his garden, mostly by using white airy flowers (see page 64). When Monet purchased his home at Giverny, he was already an accomplished gardener, having cultivated flower gardens on various rental properties, including a house at nearby Vétheuil, situated on a steep slope overlooking the River Seine. Here he planted yellow sunflowers with orange nasturtiums to contrast magnificently with the blue river reflections and summery sky. At first Monet planted his Giverny grounds with flowers to paint indoors as still-life studies on rainy days, but when he realized how much he could also manipulate color outdoors, he planted his garden to provide multiple motifs to paint.

Monet's summer island beds: red/pink/silver/green

*Rose standards, either
'Centenaire de Lourdes'
or 'Carefree Pink'*

Bedding geraniums, red

*Dianthus
gratianopolitanus
(Cheddar pinks)*

Other Impressionist gardeners

Among the great French Impressionist artists, Monet was not the first to plant a garden to paint. Monet's wealthy close friend Gustave Caillebotte was raised on a spacious family estate at Yerres, east of Paris, and its ambitious garden was a favorite Caillebotte motif. Caillebotte's most famous painting is entitled "Paris Street Scene on a Rainy Day," in which the architectural lines of a boulevard converge to show an exaggerated sense of perspective. When his parents passed away and the estate had to be sold, Caillebotte moved to Petite Gennevilliers, beside the River Seine, west of Paris. Here he established a beautiful garden with long narrow beds that produced strong lines of perspective. He included espaliered fruit trees among his flowerbeds to heighten the perspective, and planted predominantly hybrid

flowers such as chrysanthemums the size of soccer balls and dinner-plate sized dahlias to gain maximum color impact. He even erected a greenhouse in order to grow orchids and start seedlings for his garden. Monet and Caillebotte attended flower shows together, visited plant breeders, evaluated the latest plant introductions, and from Caillebotte Monet developed a sophisticated taste for gardening. Caillebotte died prematurely of a brain aneurysm at age 46. Monet was subsequently inspired to use his friend's layout of plant bands to create similar long lines of perspective when he designed his Giverny garden (see page 20). He also purchased a greenhouse like Caillebotte's. The Caillebotte garden at Petite Gennevilliers no longer exists, a victim of industrial development, but the family estate at Yerres is now maintained as a public park.

Monet's Garden at Giverny

1. Main house and first studio

2. Livestock pens

3. Third studio (The Waterlily Studio)

4. Gardener's cottage

5. Flowerbeds (plant bands)

6. Gravel exhedera and Monet's curved benches

7. Lower entrance

8. Grande Allée

9. Tunnel from Clos Normand to water garden

10. Plant nursery

11. Flowerbeds (plant bands)

12. Greenhouse and cold frames

13. Second studio

14. Top entrance and espaliered wall with pear trees

15. Entrance to water garden

16. Japanese bridge

17. Waterlily pond

18. Smaller bridges

19. Boat dock and rose arches

20. Bamboo grove

21. Stroll path

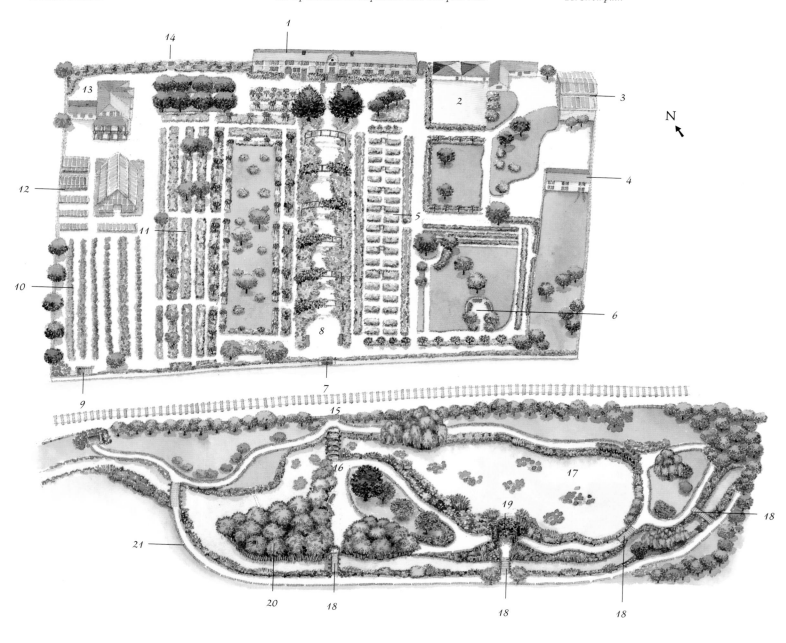

Two other famous French Impressionists who planted a garden to paint were Pierre-Auguste Renoir, and Paul Cézanne, both close friends of Monet. Before they established their own gardens they visited Monet at Giverny, but the gardens they subsequently established are as different from Monet's as their individualistic painting techniques, even though they all embraced Impressionism. Near Nice, Renoir established a highly informal garden within an ancient 5 acre (2 ha) olive orchard and wildflower meadow, and called this Les Collettes. He also planted a rose garden because the colors of the flowers were similar to the flesh tones of women and children he liked to paint.

For most of his life Cézanne had his father's estate, the Jas de Bouffan at Aix-en-Provence, to paint. When the property, with its park-like garden, was sold after the death of his parents, Cézanne established a half-acre (2400 sq. m) studio and garden, Les Lauves, on a hill overlooking the city and within sight of his favorite motif, Mont Sainte-Victoire. Essentially a labor-saving woodland garden, Les Lauves contains few flowers (except in terracotta planters close to the house), but uses lots of foliage colors to create a tapestry effect. Although Monet also loved foliage effects, and used them effectively in his water garden (see Chapter 4, "Monet's Water Garden"), he was innovative in seeking more ephemeral effects. He especially sought plant partnerships that might not last more than a day or two, and even water reflections that changed from moment to moment, but endured long enough for him to capture an impression on canvas.

Monet's two passions

Monet became passionate about gardening and declared he was good for only two things in life — "painting and gardening."

After Monet's death, the Giverny property was cared for lovingly by his widowed stepdaughter, Blanche, but after her death it passed to his surviving son Michel, who allowed everything to fall into ruin. On Michel's death in 1970, the property was deeded to the state, and its administration supervised by the Académie

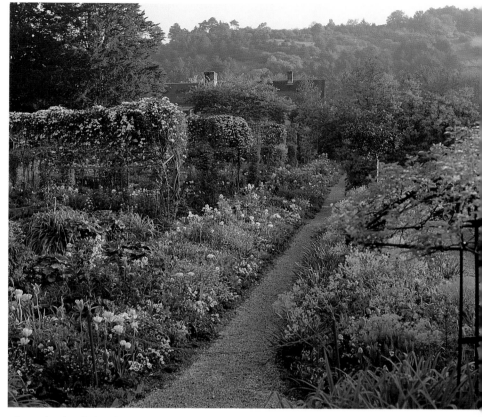

Above: Plant bands show long lines of perspective from the bottom of Monet's flower garden.

des Beaux Arts, which preserves other historic places, such as Versailles Palace. Through generous donations from mostly American art patrons, starting with a million dollars from the late Lila Acheson Wallace, publisher of *Reader's Digest* magazine, the house and garden have been faithfully restored.

Since Monet struggled into his 40s to gain artistic recognition, and felt insecure even into old age, he wrote little about his painting technique or garden philosophy, and told one of his art patrons, the Duc de Trévise: "Don't ask me for advice. I give none of it to anyone." Nevertheless, his Giverny garden attracted journalists, art connoisseurs and horticulturists, who recorded their conversations with him and took photographs, so that the garden visitors see today is faithful to his oeuvre and serves as an inspiration to millions.

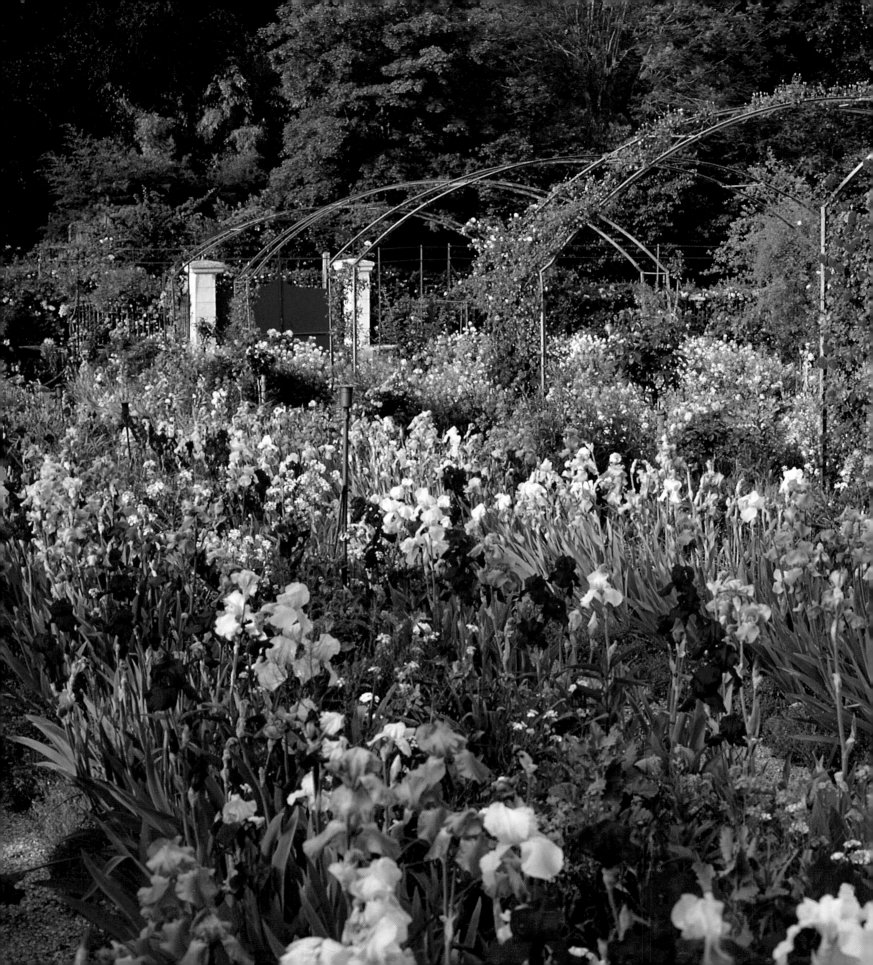

1
Monet's Flower Garden

"The same man we find to be somewhat laconic and cold in Paris is completely different here: kindly, unperturbed, enthusiastic. When he has reason to come into the land of the boulevards, his smile is more than a little mocking and sarcastic; in his garden, among his flowers, he glows with benevolence. For months at a time, the artist forgets that Paris even exists; his gladioli and dahlias sustain him with their superb refinements — and cause him to forget civilization."

Arsene Alexandre, "Monet's Garden," *Le Figaro*, 1901

Monet developed three independent garden spaces at Giverny: his flower garden, called the Clos Normand; his water garden with its collection of hardy hybrid waterlilies; and a vegetable garden on a separate property called the Blue House, for the façade color of the dwelling it contained. Moreover, each occupied approximately the same space — a little more than 2 acres (about 1 hectare).

The Clos Normand

The term "Clos Normand" in France describes a particular type of cottage garden popular in Normandy. Enclosed by walls or hedges to provide shelter from wind and to establish privacy, it is planted exuberantly with mostly annuals, perennials and roses, like an English cottage garden. Dominating the top of Monet's

Clos Normand is a large residence with pink walls that was once a farmhouse and cider mill. At various times the property had been an apple orchard and a plum orchard, and after moving in Monet immediately cleared it of ailing fruit trees to begin planting a flower garden.

Monet purchased the farmhouse in 1890 when his paintings began to sell at high prices. He used white stucco impregnated with brick dust to make the walls look pink. Never one to hoard his money, after purchasing essentials to practice his craft and care for his large family, he spent his newfound wealth mostly on his garden. At first he enlisted the help of his children to weed and water, but eventually he employed a head gardener and up to eight assistant gardeners.

Previous page: Beds of mostly bearded iris extend on both sides of Monet's Grand Allée in the Clos Normand flower garden.
Right: The Blue House — site of Monet's vegetable garden — and rose 'Complicata' in foreground.

Above: Perennial yellow sunflowers and red cactus-flowered tuberous dahlias flower in autumn.

But Monet was no dilettante gardener, paying others to do his bidding. The art critic Octave Mirbeau described him in shirt sleeves, suntanned and happy, "his arms black with compost." During periods away from home he left meticulous notes to his head gardener on what to do. Cartloads of compost and peat were needed to keep the beds in good heart, since the indigenous soil is heavily alkaline from surface limestone and only constant application of composted manure and peat creates the slight acidity Monet needed for his plants' profuse flowering.

In a February letter from a painting trip, he wrote: "Sow approximately 300 pots of poppies, 60 pots of sweet peas, approximately 60 pots of white argemone (prickly poppy) and 30 yellow. Start blue sage and blue waterlily in a pot (greenhouse). Plant dahlias and water iris. From the 15th to the 25th start the dahlias into growth. Take cuttings from the shoots before my return; think about the lily bulbs. If the peonies arrive, plant them immediately, weather permitting, taking care to protect the young shoots from cold and the sun. Do the pruning — don't leave the roses too long except for the older, thorny varieties. In March sow the grass, prick out the nasturtiums, and take good care of the gloxinias, orchids, etc, in the greenhouse as well as the plants in the cold frames. Plant the borders as agreed. Put wires up for the clematis and the rambling roses. In case of bad weather you can make reed mats — but make them lighter than the earlier ones. Plant the rose shoots from the water garden in the manure around

the poultry yard … plant immediately the perennial sunflowers in good sized clumps and activate the chrysanthemums into growth …"

It was unusual for Monet to be away in February. As soon as a warming trend set in after the garden's winter dormancy he wanted to be on hand to supervise plantings and see the new flowering season unfold. "Come February, spring will be here and Monet will refuse to budge," wrote Alice.

In 1924, two years before his death, Monet told a visitor: "My garden is slow work, pursued with love, and I do not deny that I am proud of it. Forty years ago, when I established myself here there was nothing but a farmhouse and a poor orchard … I bought the house, and little by little, I have enlarged and organized it … I dug, planted and weeded myself; in the evenings the children watered … As my situation improved, I expanded until I was able to cross the road and start a water garden."

Monet's stepdaughter, Blanche, wrote about the garden she cared for after his death: "It was his only distraction after the exhausting, draining process of his painting."

Art critic Louis Vauxelles, in "An Afternoon with Claude Monet," for *L'Art et les Artistes* magazine, in December 1905 noted: "Notwithstanding his sixty years, Claude Monet is robust and hearty as an oak. His face has been weathered by wind and sun; his dark hair is flecked with white; his shirt collar is open; and his clear steel-gray eyes are sharp and penetrating — they are the kind of eyes that seem to look into the very depths of things … He has the exquisite and affable manners of a gentleman farmer."

Gradually Monet saw in his flower garden a convenient subject to paint as well as an uplifting creative experience. Situated close to the River Seine, it is often imbued with morning mist and other atmospheric conditions such as bright sunlight from the direction of hills behind the house, high cloud cover, apricot-colored sunrises, brilliant orange sunsets, dustings of snow and colors sharpened by frequent rainfall.

Perspective and plant bands

To make best use of the changeable light and the plant partnerships he intended to create, Monet decided to use long, straight flowerbeds leading from the entrance of his house to a railroad track that marked the bottom of the flower garden. This arrangement of narrow parallel beds (called plant bands) produces long lines of perspective that on misty mornings disappear into infinity. These plant bands he had admired at the home of his friend Gustave Caillebotte, who collected Impressionist art. Caillebotte was himself an Impressionist artist and master of painting long lines of perspective. In an early painting a dramatic sense of perspective shows in straight lines of vegetables in his family's large *potager* (kitchen garden). He went on to paint similar converging lines evident in metal bridges and Paris streets. After he left the family estate and established

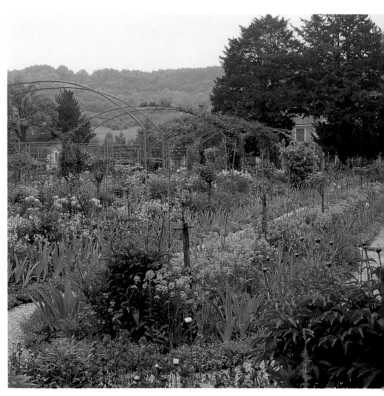

Above: Overall view of the flower garden shows long lines of perspective.

his own home and garden, he used long lines of espaliered fruit trees and flower borders to create narrow passages and vistas.

Monet decided his own flower garden should feature a similar geometry of converging plant bands. Though this basic design is highly formal when seen devoid of vegetation in winter, the plantings burgeon out into the paths to soften the harsh lines by late spring. Conversely, when the plant bands are viewed from the side, the straight lines disappear from view to create waves of color like a wheat field sparkling with dozens of varieties of meadow flowers. And so Monet had the best of both worlds in his design — from the top of his garden a basic formal layout with lines of perspective converging in the distance, and from the side an informal riotous sea of color, each flowerhead positioned like a dab of paint in an Impressionist painting.

Brilliancy

One of the visual sensations that sets Monet's garden apart from others is the brilliancy of its planting. To achieve optimum brilliancy the shade (tonality), brightness (value) and saturation (intensity) of floral colors are considered. With very few exceptions, foliage and bark coloration cannot match the brilliancy of flowering plants. That is why Monet used masses of tulips, bearded iris, gladiolus, dahlias and perennial sunflowers — tulips for red, pink, orange and yellow brilliancy in early spring; bearded irises for blue, violet, purple, yellow, orange and white brilliancy to follow the tulips; gladiolus for their red, yellow and orange brilliancy in midsummer; dahlias for red, yellow and orange brilliancy into autumn months. This succession of brilliancy Monet heightened by choosing vigorous, large-flowered hybrid varieties for the backbone of his garden.

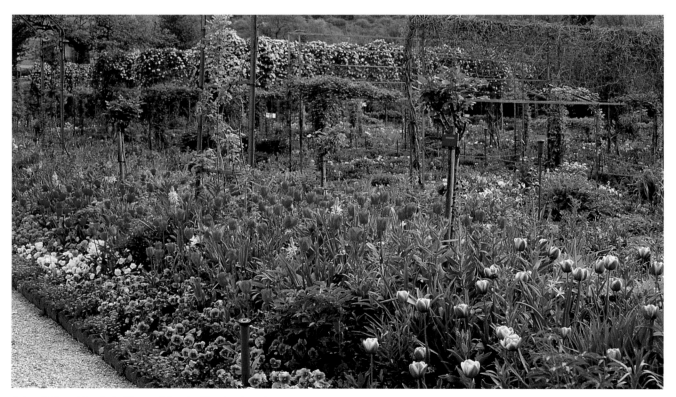

Below: Tulips add to the brilliance of the mixed borders in spring.

The importance of hybrids

Several books about Monet's garden state that Monet disliked hybrids, and that is why he used a lot of wildflowers in his mixed borders and shunned double flowers for the same reason, but nothing could be further from the truth. He did indeed use a lot of wildflowers like wayside poppies and ox-eye daisies, but these were to temper the powerful, physical presence of his flamboyant hybrids. And while it's true he used a lot of single flowers for their translucent petals when backlit, he filled his garden with double-flowered dahlias for the brilliancy they produced and as bold backgrounds for the more ephemeral flowers. In addition to his dahlias, all Monet's tulips were hybrids — as were his roses, his bearded irises, his gladiolus and the waterlilies in his water garden.

The fact is that Monet's garden could not be what it is — a feast of brilliant color — without an overwhelming use of hybrids. Indeed, hybrids were so important to his plant palette that he traveled abroad — to Holland and England — to inspect the test gardens of plant breeders so he could be the first to use a new color or color combination. By their very nature (mostly crosses between species) hybrids produce flowers that are bigger, bolder and brighter than the wild kinds.

The first garden hybrids were undoubtedly roses. The crossing of the single pink *Rosa eglantine* with two climbing roses and a fragrant red *R. gallica* in the 1700s produced a race of roses in all shades ranging from white to crimson. Further crossing between these offspring by the Dutch produced a large red rose with 100 petals, known throughout France as the "rose of Provence" or the "painter's rose."

Monet obtained his plants from many sources. Georges Truffaut, editor of France's leading garden magazine, *Jardinage*, owned a nursery and supplied Monet with many perennials and woody plant varieties; Moser & Fils, famous for the hybrid clematis 'Nelly Moser', was another French supplier. Monet obtained hybrid peonies from Blackmore & Langdon in England, and toured the test plots of English seedsmen Thompson & Morgan, who sold seeds of annuals to Charles Darwin. Monet's sons even hybridized an Oriental poppy they called 'Claude Monet', since lost to cultivation.

Wildflowers: "The soul of the garden"

A garden composed entirely of hybrids, despite their size and brilliancy, can look unnatural and so, to soften this overbred look, Monet filled his garden with diminutive wildflowers. These are so important to the visual impact of his Clos Normand that Monet called them "the soul of the garden."

Monet liked to explore the countryside in search of meadows, swamps and woodlands filled with wildflowers to paint. Sometimes a meadow featured one type — daffodils, ox-eye daisies or poppies, for example; at other times a meadow could be spangled with many kinds of wildflowers of different heights and myriad colors. The mixed flower meadow could have been the inspiration for Monet's mixed borders, especially when the long beds are viewed from the side, and seen as

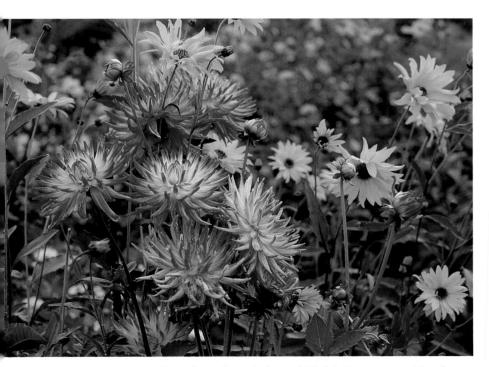

Above: Cactus-flowered tuberous dahlia hybrid among perennial sunflowers.

Left: Red corn poppies and purple bread seed poppies self-seed among Monet's mixed flower borders.
Below: The Corn Poppies *(1873)*
Musée d'Orsay, Paris
This meadow of wild corn poppies was one of many wildflower plantings Monet discovered during walks into the countryside. He collected seed of wild poppies and other wayside plants to sprinkle throughout his garden. Note the silvery light on the meadow grasses. The partnership of red, green and silver Monet transferred to his flower garden, using red geraniums and Cheddar pinks (a silver leaf dianthus) for the silver.

waves of color like rolling surf. He collected seed from wayside plants and scattered them throughout the Clos Normand in company with his cultivated varieties and hybrids.

From local woodland he introduced yellow primroses, blue violets and yellow leopard's bane daisies; from the marshes he dug up the yellow European flag iris; from cliff walks near Dieppe he collected seed of wild purple foxgloves and pink ragged robin; and from local meadows he collected seed of scarlet corn poppies and white ox-eye daisies. Even rosebay willow herb, a North American wildflower that has made itself at home along railway embankments and just about every pile of rubble in Europe, was used — "brought in for its tall shafts of pure pink color" according to Stephen Gwynn, in *Country Life* magazine. Wildflowers were scattered around to come up where they pleased, for it didn't matter if the odd color intruded on a color harmony; it was the overall painterly impression that mattered.

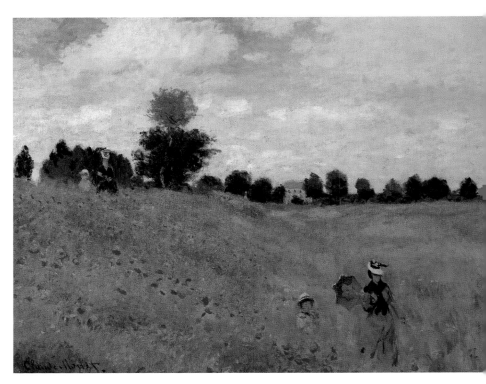

Color harmonies

The careful placement of colors, and their effect when partnered, is so important to the visual excitement of Monet's garden that Georges Truffaut made special reference to it: "What strikes the visitor most is the harmony that results from putting together the most opposite colors (on the color wheel) and the taste that has directed the framing of the floral marvels."

Above: Asiatic hybrid lilies and yellow loosestrife produce a hot-color harmony.

Monet's garden did not happen overnight, with all its nuances of planting picture-perfect from the beginning. It took time, and probably a lot of mistakes. In his task Monet was aided not only by the wisdom of his friend Caillebotte, but also the writings of Edwardian garden designer Gertrude Jekyll, and two French garden writers, J. Decaisne and C. Naudin, who covered the subject of color harmonies exhaustively in their seminal book entitled *Manuel de l'amateur du jardin*, first published in 1864. This followed the publication by the French chemist Michel-Eugène Chevreul of his book entitled *The Principles of Harmony and Contrast in Colours*, about the scientific relationship between colors.

Though Monet felt that an understanding of the "laws of colors" was good for artistic development, he insisted that his color harmonies were not taken from studying a color wheel. Rather they resulted from his observations of nature. Monet owned copies of these books and also subscribed to *Country Life* for whom Jekyll wrote a monthly garden column full of plant wisdom and especially the effect of particular plant partnerships. Her views about plant partnerships are so similar to Monet's some writers have speculated they may have met and exchanged ideas during one of his visits to England. A eulogy to Gertrude Jekyll, written by Professor Christopher Tunnard for an architectural publication shortly after her death in 1932, even compared her life to that of Monet. "Both had an almost primitive love of the soil, a passion for gathering from Nature nourishment to sustain burning convictions and long cherished beliefs … Both suffered from failing eyesight and both achieved greatness through work and love of tools and methods they employed." The fundamental difference between them, Tunnard believed, was that Monet's garden was as great as his paintings, while Jekyll's paintings were inferior to her plantings. Monet was more successful in using light to infuse his garden with the Impressionist shimmer.

Tunnard accorded Jekyll the honor of calling her the first horticultural Impressionist, a description more deserving of Monet now that we know more about his planting philosophy.

Examples of Entwining Colors Using Flowering Vines

Arbor:

blue/yellow/orange color harmony

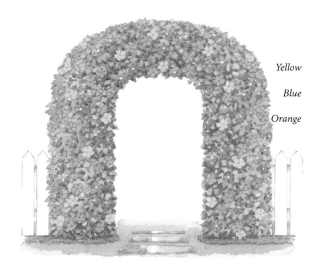

Yellow

Blue

Orange

Morning glory 'Heavenly Blue'

Climbing nasturtiums, yellow and orange

Trellis:

purple and red entwined vines

Red/purple

with yellow

centers

Climbing rose 'American Pillar'

Clematis 'Jackmanii'

Fence Decoration

pink/yellow/red

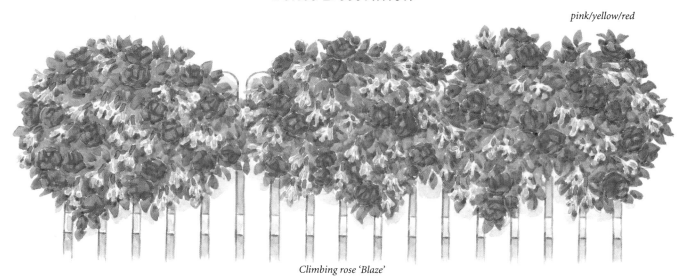

Climbing rose 'Blaze'

Honeysuckle 'Gold Flame' (pink and yellow bicolor adds shimmer)

Actually, there are many differences between Monet's innovative use of color and Jekyll's — his use of vines to create lace-curtain effects, his liking for flowers with translucent petals, his pond plantings for reflective qualities, his liking for blue to improve shady areas are but a few examples of how Monet's finesse as a colorist goes well beyond Jekyll's color theories.

Monet's stepson, Jeanne-Pierre Hoschedé, recalled in a memoir published after Monet's death: " ... bit by bit, Monet enlarged his garden, or rather he modified and harmonized it with great simplicity, and in marvelous taste. After dealing with that part of the garden surrounding the house, he turned his attention to the orchard. The west side became lawn, laid out in the English style, constantly watered and regularly cut . . . "

On the subject of color harmonies, Hoschedé wrote: "Monet knew exactly what he wanted from the plants he bought and planted in specific places. In fact he knew well in advance that when they were in full flower they would have a certain relationship with their adjacent plants, and with the garden as a whole. In this way he achieved exactly the effects he intended, rather as he painted a picture, but in this case not with colors taken from his palette, but with flowers judiciously chosen for their individual colors, mixing them or isolating them in clumps, the whole marvelously planned."

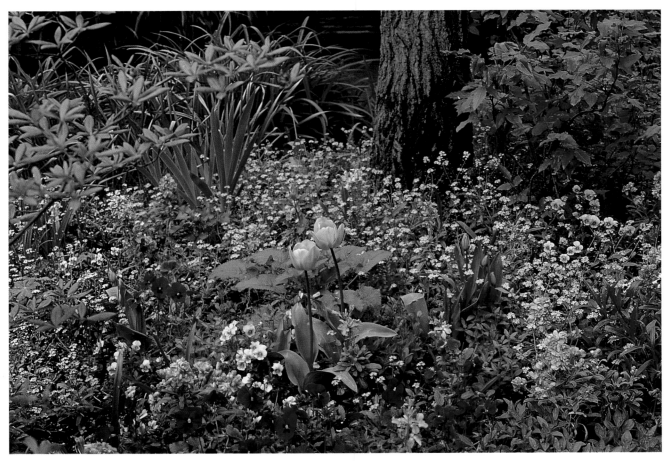

Above: Blue forget-me-nots are used to improve a shady flowerbed beside the pond.

Monet realized that in addition to mixing colors on his palette, planting flowers in color proximity and allowing them to be mixed by the eye could result in a brilliancy more intense than if planted haphazardly. "You can work wonders if you know how to play the floral keyboard, and if you are a great colorist," noted a French journalist after he visited Monet's garden.

The most important color harmonies in the Clos Normand are hot- and cool-color harmonies, whereby borders of flaming red, orange and yellow flowers (hot colors) alternate with borders of pastel shades of blue, pink and purple (cool colors). Also evident are color contrasts. These color contrasts mostly feature yellow and purple, orange and blue, and red, pink and green. Monet was so fond of red glaring out from vigorous green foliage that he planted the entire length of his boundary railing at the bottom of his garden with the Chilean flame creeper, a perennial nasturtium. Less obvious color harmonies include black and white, black and orange and the use of silvery foliage to improve the red and green contrast (see page 50).

Cluster:
blue/pink/white

Fuchsia 'Deutsche Perle'
(pink and white hybrid — bicolor adds shimmer)
Cineraria, blue and white hybrid (bicolor adds shimmer)
Cineraria, pink and white hybrid (bicolor adds shimmer)

Barrel Planter:
blue/purple/mauve — cool-color harmony

Hydrangea 'Nikko Blue'
Gypsophila 'Gypsy'
Nierembergia 'Purple Robe'
Euphorbia 'Diamond Frost' (to add shimmer)

Oriental Pot:
red/orange/yellow — hot-color harmony

Gladiolus, red, yellow and orange
Nasturtium, Whirlibird Series, yellow and orange

Framing elements

The "framing" referred to in Georges Truffaut's foregoing remarks on color harmonies is the arrangement of trellis and arches strategically positioned along the paths, mostly flat metal rods painted green to support flowering vines so they can scramble up the vertical uprights and along the straight or arched horizontal tops. Six wide arched trellises span Monet's Grande Allée, the broad gravel path leading from the house to the bottom of the Clos Normand and forming a main central axis. These support a variety of climbing roses to create a floral tunnel. Along parallel paths between the plant bands on either side of the Grande Allée, Monet positioned rectangular trellises, and these mostly support mountain clematis to create a lace-curtain effect when the vines flower profusely in spring.

Framing is one of the more significant design features in Monet's flower garden because the framing helps to give the garden depth. In the same way that Monet carefully considered frames for his paintings, so he introduced appropriate frames for his garden vignettes. In both the Clos Normand and the water garden, framing is achieved with tree branches as well as vines.

Monet's success at orchestrating so many visual sensations by using flowers like paint inspired Roger Marx to write in *La Gazette des Beaux Artes*, in June 1909: "Claude Monet's heart beats responsively as soon as he comes into contact with the intimate life of the out-of-doors. His enthusiasm animates his vision; he causes us to know and to love beauty everywhere, a beauty that eludes both a casual glance and scientific examination with lens and compass. It would be difficult to resist the appeal of an artist of such extraordinary sensitivity, who is so steeped in his work that he succeeds in making us share his own emotion, joy and humanism."

Fleeting effects: Floral and atmospheric

One must realize, too, that in this "outdoor studio" Monet often planted for a particular effect, and once that desired effect was captured on canvas, he would simply move to another motif in a different part of the garden. This explains why some of the plant partnerships seen in archive photographs are difficult to understand — sunflowers planted beside apple trees with nothing to hide the long bare stalks, and blue delphiniums massed along a narrow bed, with nothing else to complement them. But to Monet these plantings made perfect sense, for he wanted to paint orange sunflower heads and ripening yellow apples against a clear blue sky, and blue delphinium spires to contrast with the pink house façade. Being a pragmatist, Monet considered the base of the border needed no embellishment because it would not show in his painting. Many of his poppy plantings lasted briefly, but the brevity was immaterial. He considered his bearded iris display so short-lived he would invite his friends to view them on a particular day, at a particular time, fearful that a day earlier or a day later the peak flowering would be over.

Fleeting atmospheric effects also appealed to Monet as a painter, and every plant earned space in his

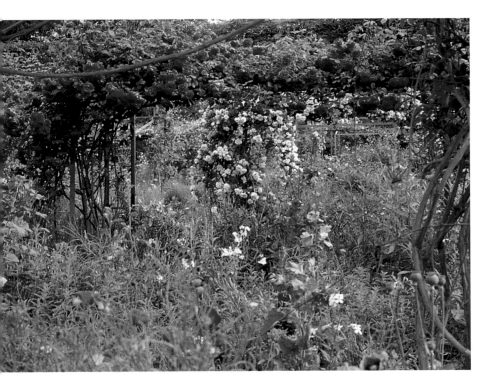

Above: Climbing roses frame parts of Monet's flower garden.

garden for a particular reason: dusky pink valerian because the color looks sensational in mist; Siberian wallflowers because when wet from a shower of rain the orange petals glow with a saturated intensity; the airy white flowers of dame's rocket because they produce the best shimmering appearance when scattered about randomly; the ephemeral flowers of yellow flag irises because they look like butterflies in flight and suggest movement; pink cosmos because the petals are translucent and add a twinkling sensation when backlit; bluebells and forget-me-nots because their blues are the most natural and alluring in shade, just as orange and yellow flowers steal the show in sunlight; ox-eye daisies and foxgloves because of their wild, wayside appearance; purple smokebush because it produces the illusion of a shadow pattern on a sunny day; sweet peas because they add fragrance and their tall stems take floral color to a great height, filling Monet's entire field of vision with color. There are many more reasons Monet chose particular flowers, learned from his skill as a painter and his acute observation of the natural landscape.

Indeed, an unfamiliar plant would be first tested in a special nursery bed and if it produced a quality he admired, he would find a permanent position for it in the garden. He was especially critical of double flowers, for example double hollyhocks, because the singles of this species have cupped, chalice-like flowers with translucent petals that shine like a Chinese lantern when backlit. However, double dahlias were acceptable because they produced great big globs of color high on tall stems, and the petals have a high gloss, a dazzling effect. He was critical of variegated foliage because too often on a plant it produces a sickly appearance, but sometimes — such as with variegated bishop's weed and variegated miscanthus grass — it produces a misty appearance from a distance. He did not care for the small-flowered French marigold, but gave his blessing to African marigolds because their yellow petals shine with such brilliance. "They

seem to grab all the sunshine and hand it right back to you," noted one observer of the Africans.

When Stephen Gwynn, a British garden writer, saw the garden it took his breath away. "I saw a long, low farmhouse, having in front of it a dazzle of flowers, all common, all chosen for their brilliancy: snapdragon, African marigold, campanula, gladiolus and the like. What struck me at once was that there was no arrangement in uniform masses. The painter had his garden before him like a canvas … and the effect he aimed at was the effect of the whole. All was a flicker of bright color … nothing was let stray, yet the whole effect seemed as careless as a wheat field where poppies and corn cockle have scattered themselves. All fell together like a pheasant's plumage or a peacock's; and remembering how many colors this master found in the shimmering warmth of a sunlit haystack, I could feel a little of what he was after in creating that ordered space of vibrant light and life … "

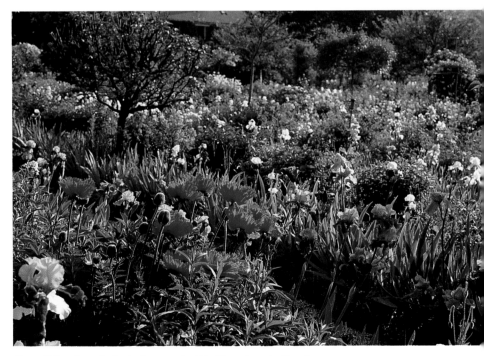

Above: Oriental poppies in the foreground add brilliance to a planting of mostly bearded irises.

The Grande Allée

Of all the planting schemes in Monet's Clos Normand, the Grande Allée is the most impressive, many times imitated but never equaled. Essentially, it is a broad path sloping down from the front door of Monet's house to a garden gate at the bottom of the property. It consists of a series of six metal spans that arch over the gravel path. Climbing roses trained up and over the arches meet in the middle and bloom most of the summer.

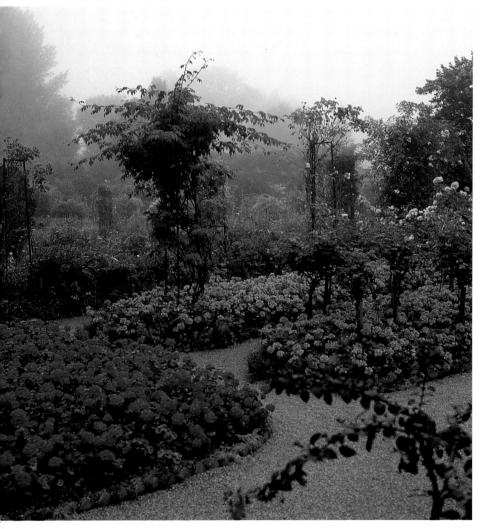

Above: Red and pink geraniums massed in island beds in front of Monet's house.

The broad path beneath the arches is 10 feet (3.5 m) wide. The arches span 22 feet (6.7 m) between 13 foot (4 m) uprights. From the bottom of the Grande Allée the view of the house entrance is framed by the arches.

Mixed borders line the path. In French they are called a *massif*, meaning a flowerbed that is mounded in the middle. Massifs usually feature plants that are continuously flowering or are planted for a succession of bloom using seasonal kinds so that when one flowering plant fades, another takes its place. This is exactly what happens in Monet's mixed borders. The flowerbeds that flank the Grande Allée are 7 feet (2.1 m) wide and mounded in the middle to 2 feet (61 cm) high. In spring they are predominantly planted with tulips and pansies, followed by annual sunflowers and blue sage in summer, with a grand finale of tall purple New England asters and taller yellow perennial sunflowers to create a purple-and-yellow color harmony in autumn.

Beneath the annuals and perennials in the massifs, annual nasturtiums with mostly yellow and orange flowers creep across the path and by the middle of summer meet in the middle. The combination of roses to form the roof, asters and sunflowers the sides, and nasturtiums across the path effectively creates a floral tunnel that was a favorite subject for Monet to paint.

Leaf tunnels, using chestnut trees, hornbeam and beech, have long been a feature of French gardens, especially as driveways to estates such as chateaux and vineyards, but a floral tunnel where flowers produce a thousand pinpricks of color is a Monet original. One writer speculated that Monet got the idea of using nasturtiums to creep across the path from the name of a Paris boulevard, Boulevard des Capucines; but in a painting entitled *The Artist's Garden at Vétheuil* (1881), Monet depicted nasturtiums creeping across a steep flight of steps, a common feature of coastal gardens in the south of France and North Africa where the artist traveled. The transition from a steep flight of steps at Vétheuil to a gentle slope in his Giverny garden is a natural progression.

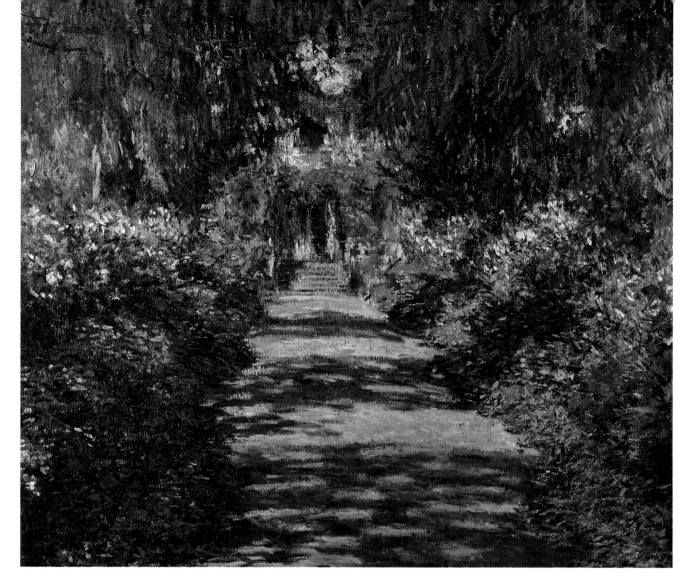

Above: Garden Path at Giverny *(1902)*
Mr. and Mrs. David L. Schiff
This hot-color harmony depicts a view of Monet's Grande Allée from the house, looking down toward the bottom of the flower garden. For a view from the opposite direction, see page 123. Note the heavy use of black stipple in the sun-drenched flower border to suggest pinpricks of shadow. Monet introduced many plants featuring orange flowers with black seed disks into his mixed borders to create a similar black stipple effect.
Right: Monet's Grande Allée viewed from the bottom of the garden and from the side.

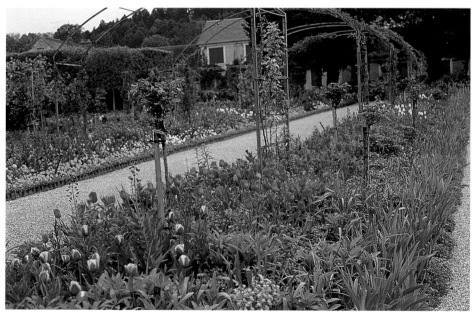

Structures and ornamentation

Benches

Apart from benches and trellises, there is very little ornamentation in Monet's Clos Normand garden. There are no sundials, statuary, balustrades, fountains or any other form of decoration, mainly because he wanted nothing to detract from the beauty of the plants and the natural contours of flower stems, vines and tree branches.

Monet wanted places to sit and enjoy looking at parts of the flower garden. He particularly admired a garden feature from Greek and Roman times known as an exhedera — a circular space with a rim of benches facing inward so a large group of people can sit outdoors and hold a meeting. There is an exhedera in the Clos Normand shaded by an empress tree and another in the water garden, within a semicircle of bamboo. The water garden exhedera features curved stone benches, while the Clos Normand exhedera has three wooden green benches with curved seats, each capable of accommodating six people. Monet discovered the design for this bench in the grounds of Versailles Palace, and he may have had the Versailles carpenters build the benches for him since he often went there to paint. At Versailles the bench is located in an area known

Above: An Empress tree and curved slatted benches encircle a gravel space to form an exhedera.

as the Petit Hameau, a quaint village of cottages and a snuff mill, where Marie-Antoinette, the last Queen of France, liked to go to escape the formality of the court. It has a commanding view of a waterlily pond similar to the pond Monet later installed at Giverny.

The original Versailles bench — still used at Versailles today — is unpainted, but Monet painted his replica benches green to match his house shutters.

Gates, trellises, walls and fences

These structures within a garden are often considered functional components, with little thought given to ornamentation, except to choose rustic designs for a cottage garden and formal designs for more structured gardens. Monet realized that formal construction and straight lines, seen through frames of greenery, offered a good contrast to the informality of his plantings. Therefore, his gates all are regular shapes with a criss-cross pattern, matching a similar gate design in Caillebotte's garden. Most sections of wall are covered with trellis in a criss-cross pattern to support espaliered pears, and the fence at the bottom of the Clos Normand he changed from a solid stone wall to a chest-high wall topped with metal railings through which he threaded vines. All these structures he painted green to echo the house shutters, house trim and wooden benches.

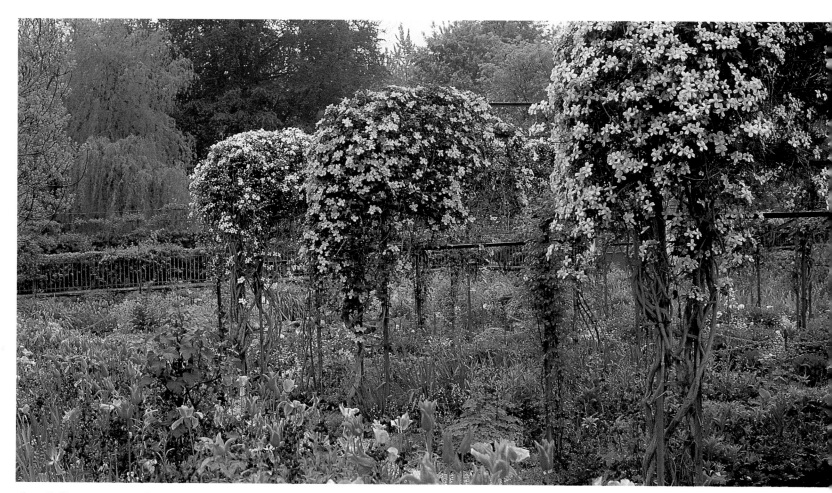

Above: Trellises support spring-flowering Clematis montana *to form a lace curtain effect.*

Containers

A feature of the Clos Normand, especially close to the house, is the use of various types of planter. In particular, Monet favored two kinds of containers — white, barrel-shaped urns with a blue willow-pattern design from the Orient, and square, box-shaped containers known as Versailles planters. The heavier ones have casters for moving around, and these are used at Versailles Palace in the orangerie to grow citrus fruit and palms. Monet favored them for growing fuchsias, dripping with pink and white pendent blooms, and also blue potato vine. Both the tender fuchsia and blue potato vine are moved to the greenhouse to survive the winter.

In the willow-pattern container Monet grew an assortment of flowers, including spire-like gladiolus, blue agapanthus, Oriental lilies and tree-form rose standards.

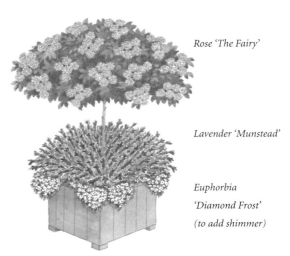

Versailles Planter:
pink/blue/white

Rose 'The Fairy'

Lavender 'Munstead'

Euphorbia
'Diamond Frost'
(to add shimmer)

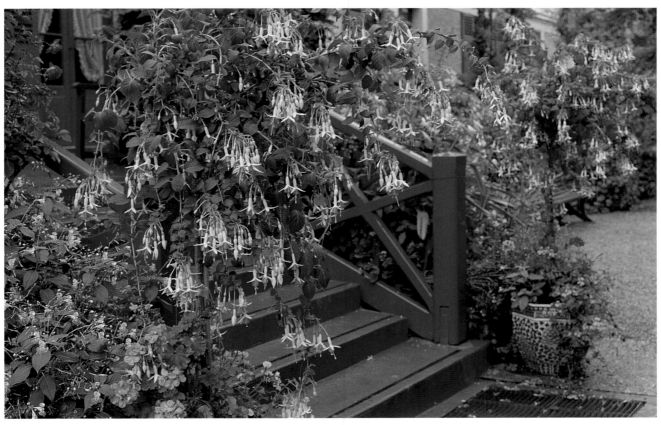

Above: Fuchsias in Oriental pots stand sentinel at the entrance to Monet's residence.

The greenhouses and cold frames

Today, to keep Monet's garden vibrant with color from April until November, 180,000 annuals and a similar quantity of biennials are raised from seed under glass. Biennials, such as viola, Canterbury bells, wallflowers and forget-me-nots are then transplanted from the greenhouses or cold frames to nursery rows in late summer for transplanting into permanent positions within the garden in early spring. Heating elements beneath the cold frames provide warmth for seedlings of African marigolds, Mexican sunflowers and pansies. In addition to a Dutch greenhouse similar to one used by his friend Caillebotte in his Petite Gennevilliers garden, Monet acquired two smaller greenhouses and sets of cold frames to raise thousands of plants.

The main greenhouse has a tropical zone and a temperate zone so Monet could grow a wide assortment of tender plants in all seasons. In the tropical zone he grew orchids that were moved to the house when they bloomed, and also tropical waterlilies in tubs, since the water in his pond was too cold to grow them outdoors. Before installing his greenhouse, Monet consulted with the director of the Jardin des Plantes in nearby Rouen, where a beautiful Victorian-style conservatory and several greenhouses still grow tropical plants to perfection.

Monet's neighbor, Mrs. Lilla Cabot Perry, recalled that when the heating system was installed in the main greenhouse and Monet filled it with tropical plant species, he worried about its efficiency. To satisfy his concern, he decided to sleep in the greenhouse overnight. When his wife and the rest of the family learned about this, they all decided to sleep in the greenhouse like happy campers, and the heating system worked fine.

Right: Pots of cineraria daisies are hardened-off in cold frames before transfer to the mixed borders.

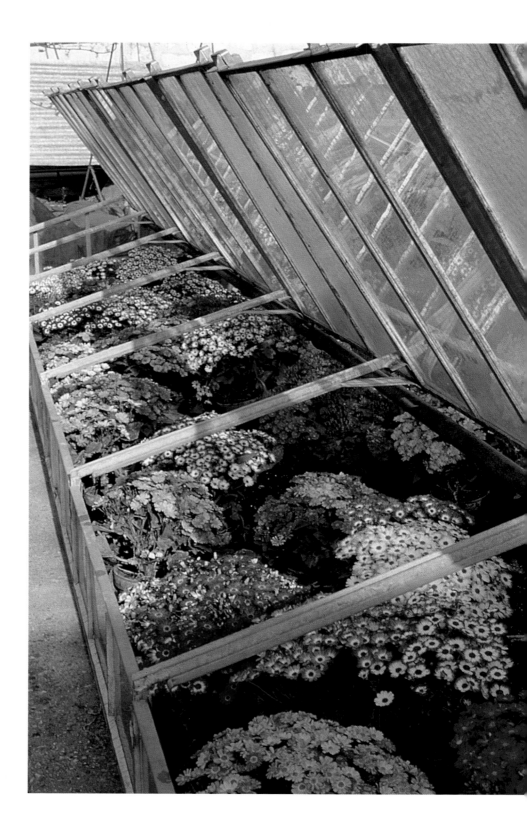

Birds and butterflies

Monet liked to rise early, even before the sun was up, so he could paint the effects of early morning light on his garden and in the adjacent countryside. Often he would work alone on several canvases at once, moving from one to the other as the light changed. He appreciated the music of a dawn chorus, and would return to the house when the sun was up to eat breakfast. He encouraged songbirds to his garden, not only for their melodious song but also for insect control. He placed nesting boxes throughout the Clos Normand and the water garden. He also liked to hear the sound of a rooster crowing in the early dawn, of chickens clucking after they laid eggs and male turkeys making their distinctive mating "gobble" sound. They brought a farmyard atmosphere to the property. Their pens are tucked unobtrusively at the edges of the garden, on the north side, screened by plants such as tall hollyhocks and azaleas.

Butterflies provide movement, and in a painting of the garden entitled *Gladioli* (1876) he showed 21 sulfur butterflies flitting among the flowers. Most of the flowers in Monet's garden attract butterflies in search of nectar, particularly annuals. However, the plant that draws them like bees to honey is the butterfly bush, which grows wild along the hillsides around Giverny. The flowers resemble lilac, in mostly lilac colors, and are produced freely from early summer to autumn frost.

Left: Bird feeder in a gnarled crabapple tree.

Opposite: Single-flowered white hollyhock contrasts dramatically with a smokebush in the background.

A garden of shining exuberance

The final touch that sets Monet's garden apart is the exuberance of its plantings. Take any square yard and you will invariably see not just two plants in partnership, but sometimes six or seven flowers intermingling. One or two varieties may be the main attraction, but other supporting players in the background or foreground invariably sparkle like a galaxy of stars. Moreover, the exuberance is over the entire 5 acres (2 ha) of cultivated space, both in the Clos Normand and parts of the path in the water garden.

How this is achieved is interesting, for today when the gardeners set the transplants into position, they deliberately crowd the plants into the mixed borders. Moreover, there is no teasing the root ball apart to free roots, or patting the soil over the root ball to ensure a firm footing — that takes too long. Instead, overplanting in the fertile, well-drained soil allows the fittest plants to survive and shine through.

One tedious chore which is practiced daily is dead-heading — the removal of spent flowers, so the plant's energy is concentrated on making more new flowers to extend the exuberant display.

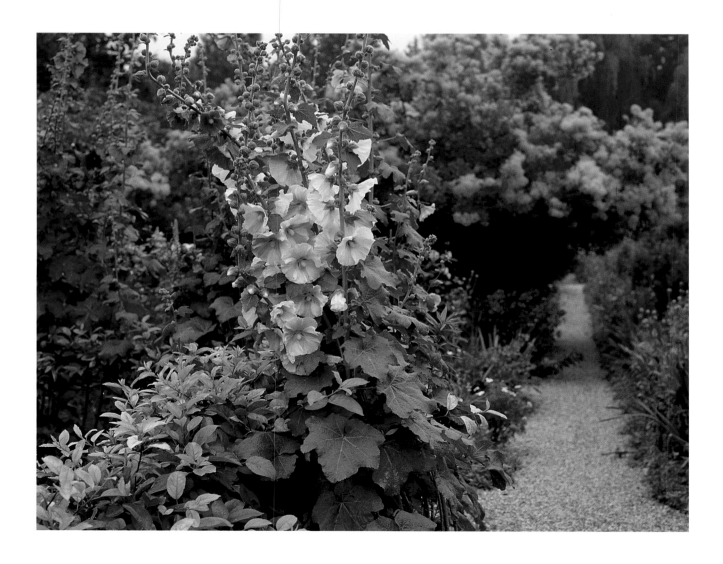

2
Monet's Color Harmonies

"After painting, Monet's chief recreation is gardening. In his domain at Giverny, and in his water garden across the road … each season of the year brings its appointed and distinguishing color scheme."

Wynford Dewhurst, art historian

WHENEVER MONET DISCOVERED a beautiful color combination in the landscape he would not only wish to paint it, he would recreate a similar color harmony in his garden using mostly cultivated flowers as paint. Hence, the pastel colors he observed along the shores of the Mediterranean during a painting excursion — from white limestone cliffs, pink house façades and blue water — he recreated in his garden using pink tulips with white petal tips, and blue forget-me-nots, among other plant partnerships.

The laws of colors

It was Sir Isaac Newton, the English mathematician, who first identified the colors of light, using a prism. These numbered seven and matched the colors of a rainbow (red, orange, yellow, green, blue, indigo and violet). However, it was Michel-Eugène Chevreul, director of dye quality control at the Gobelin tapestry workshops in Paris, who published the first chromatic wheel showing the scientific relationship between colors and how all colors are linked to just three primary

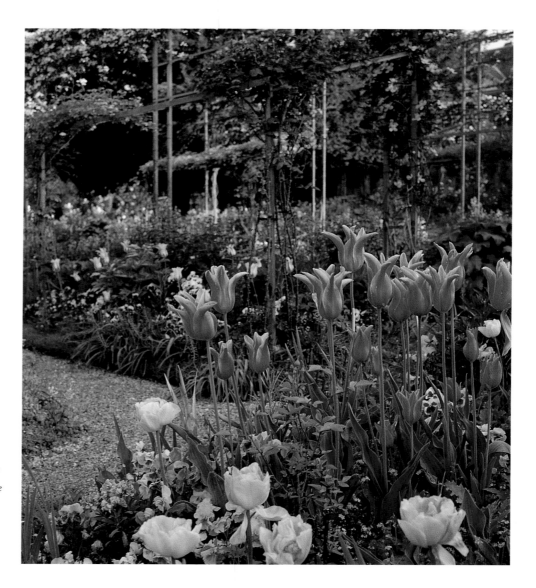

Previous page: Moss-covered wisteria trunk surrounded by pink and blue shade-loving plants in the water garden.
Right: Bicolored tulips add sparkle to a pink and blue corner of the flower garden.

colors: red, yellow and blue. His arrangement of these colors and the variations they produce when mixed allow artists to see how certain colors complement each other when placed together, especially on fabric designs, but also in paintings and flower arrangements.

Chevreul stated that all colors are affected by changes in light and by the colors of objects placed next to them. He noted that two complementary colors entwined, as in a ball of wool, have the same effect on the eye as if they were mixed, and that white had the effect of brightening any color it was placed next to. In his flower garden Monet loved to plant two vines together so their colors entwined, for example a pink climbing rose threaded with a purple 'Jackmanii' clematis.

Hot-color and cool-color harmonies

In his book about color relationships, entitled *Principles of Color*, Chevreul showed that colors opposite each other on his color wheel produced the best contrasts, such as yellow and purple, orange and blue and red and green. He also declared that colors could be classified as "hot" or "cool" in their visual effect. Yellow, orange and red made the strongest hot-color combination, and are assertive in their influence, while green, blue and purple are a cool-color combination that tended to be recessive. Monet realized that hot colors are intensified by the light of a setting sun, and so hot-color harmonies in Monet's garden are positioned where the reddish tones of a sunset make them glow like hot coals.

These hot colors — yellow, orange and red, also the cool colors of green, blue and purple — are adjacent to each other on the color wheel and are therefore known as analogous color harmonies. Another type of analogous color harmony is any monochromatic grouping, for example that of an all-white garden, or one all yellow or all red. Though this could prove to be monotonous, by using different tones the color

Above: Mixed hot-color border relies heavily on Siberian wallflowers and pansies.

Hot-color harmony

Yellow

Orange

Red

sensation can be enlivened, for example by adding shades of pink to a red theme, also by introducing cream-colored flowers and silvery-gray foliage to an all-white theme.

Gertrude Jekyll's color theories

Monet was an avid reader of French and British garden magazines as well as mail-order seed and nursery catalogs. He read articles by the British garden designer Gertrude Jekyll, and owned her books in which she explained color theories. Jekyll had abandoned a career as a painter through poor eyesight, and independently formed color theories as a result of studying Impressionist paintings.

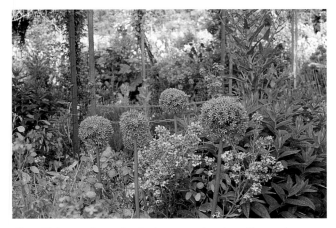

Above: Pink monochromatic color harmony using giant allium as the main feature.

Cool-color harmony

Blue

Mauve

Purple

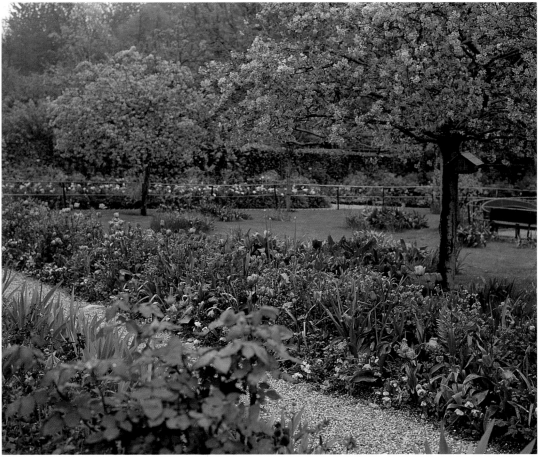

Above: Cool-color harmony combines purple and mauve tulips with blue pansies and blue forget-me-nots.

Jekyll rebelled against the prevailing British and French gardening tradition of carpet bedding and park-department formality — a style of planting that used geometric blocks of color in island beds — in favor of a more informal, exuberant style that became known as cottage gardening. She likened a collection of plants to a box of paints — they represent nothing until they are judiciously placed in an artistic arrangement pleasing to the senses. She liked to design long, wide herbaceous borders in attractive color harmonies, using not only perennials, flowering bulbs and annuals, but also small trees and shrubs.

Though color coordination was her strength, Gertrude Jekyll was also a pioneer of designing with foliage. She advocated planting in drifts of color, favoring color harmonies she admired in Impressionist paintings, particularly yellow and blue, but also blue and pink. She designed her borders so that one color would lead into another, usually starting off with some silver-foliaged accents, merging into blue and violet, pink and red, orange and yellow, and finally into silver again. She designed her gardens for walking so that as visitors strolled from one garden space to another, or along a border, there would be continuous interest. She planted for succession of color so that as one plant went out of bloom it was covered over by a later-flowering kind.

Jekyll's style was also associated with the use of strong architectural elements. On many of her

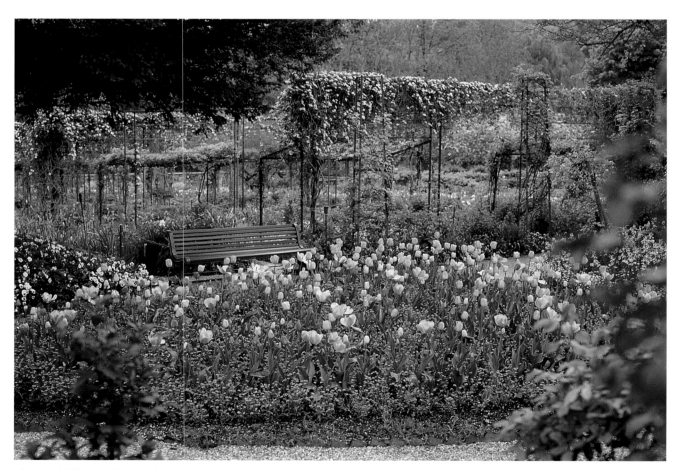

Above: Pink, blue and white color harmony uses tulips and forget-me-nots in island beds.

garden projects she collaborated with the great British landscape architect Sir Edwin Lutyens, who was fond of brick walls, flagstone patios, stone retaining walls, wide paths dissected with channels, brick pergolas with wooden crossbeams and formal reflecting pools. Jekyll, therefore, planted to take advantage of Lutyens' stupendous backdrops, often using "architectural" plants like Scotch thistle and giant mullein.

The garden as a subject for paintings

Claude Monet, on the other hand, was a practicing painter to the end of his life. His garden was not a substitute for painting, as it was for Jekyll; it was a subject to be painted. He therefore conceived planting schemes with a minimum of ostentation, to be admired from a fixed viewpoint — a place where he intended to set up his easel when the effect he was looking for was achieved. He used plants in long brushstrokes of color, rather than Jekyll's shorter drifts. Above all, Monet

Above: Yellow patrinia creates a misty effect above a hot border of tulips and pansies.

designed many parts of his Clos Normand for fleeting effects. He loved tall sunflowers with large, yellow heads for their commanding presence and pleasing contrast with blue sky, even though the heavy heads soon go to seed and might look best for only a day or two. When a particular planting was finished, he would move on to paint another part of the garden. His water garden, on the other hand (see Chapter 4, "Monet's Water Garden"), was designed for a visually exciting experience from start to finish, through the use of a stroll path similar to those encircling ponds in the historic Imperial gardens of Kyoto.

The color in Monet's garden is mostly produced using monochromatic, adjacent and opposite color harmonies. However, he often put his own spin on these partnerships by introducing another key color. For example, he agreed with Chevreul that red and pink — adjacent colors on the color wheel — make good companions, but Monet discovered they are improved by the addition of silver, using gray, silvery or silvery-blue foliage. Similarly, he developed special uses for black flowers, and flowers with black in their coloration such as violas. He used them to make a black stipple effect, to introduce the illusion of pinpricks of shadow.

Color theories applied to the garden

Two garden writers, J. Decaisne and C. Naudin, undoubtedly fired Monet's imagination with their book *Manuel de l'Amateur du Jardin* in which they applied Chevreul's color theories to the garden. For example, they stated that the combination of two primary colors, whether mixed or placed close to each other, will produce a compound color. Red and yellow, for example, will appear orange; blue and red will produce purple, and yellow and blue fuse to make green.

They pointed out that the placement of colors in twos, threes and other multiples produces visual effects that can be pleasant or unpleasant to the eye. Basically all primary colors — red, yellow and blue — contrast pleasantly. Similarly, all complementary colors (opposites on the color wheel) also contrast pleasantly, such as yellow and purple, blue and orange, or red and

green. The three secondary colors (purple, orange and blue), they asserted, also make good partners in a flowerbed.

All colors are made brighter by the proximity of white, they added. Moreover, white improves poor color pairings, such as garish red and orange, dull red and purple, and dark blue and purple. Conversely, they noted that with the exception of white, all colors are weakened by the proximity of black. Monet did not consider this bad, however, for as already noted he liked to pair black with white or with orange, and also loved to use black flowers for a stipple effect.

Decaisne and Naudin noted that all primary colors with their tones (for example red, dark pink and light pink; also blue, light blue and dark blue), are enhanced by the presence of white. The number of pleasant triad combinations is numerous, but the authors decided that generally the best effect in a triad combination was achieved if one of the colors is white, for example blue, pink and white.

Color strength: An important consideration

When evaluating plants for his garden, the strength of color was important to Monet. For example, in the garden today a preference is made for the violet-blue lavender known as 'Hidcote' over the lighter blue 'Munstead' to produce a misty effect. One might think the reverse would be true, but in the harsh light of summer, in full sun, 'Hidcote' is better because the powder blue of 'Munstead' becomes washed out.

Shade (tonality), brightness (value) and saturation (intensity) are also important to achieve one of the most important sensations in a flower garden — brilliance. This is why Monet used gladiolus for red, pink, yellow and orange brilliancy; dahlias for the same reason; and African marigolds for yellow and orange brilliancy.

The Impressionist painters used all the effects discussed above to enliven their paintings. Vincent van Gogh, who held Monet in high regard as an artist, shared similar views about color harmonies in the garden, and wrote about them repeatedly, often using

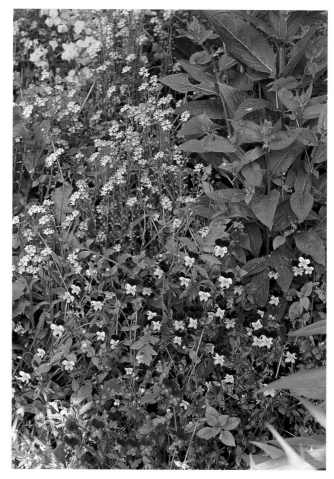

Above: Violas with maroon, almost black, petals add a stipple effect to mixed plantings.

plant partnerships to illustrate his observations of color harmonies. In one of his letters he expressed color in terms of the seasons: "Spring is tender young shoots of wheat and pink apple blossom. Autumn is the contrast of yellow leaves with shades of violet. Winter is white and black silhouettes. If summer is taken to be a contrast of blues with the orange of golden, bronze grain, it is possible to paint a picture in complementary colors for every one of the seasons."

View Monet's paintings of landscapes of different seasons and you will find these same color harmonies, in nature and in his garden.

Monet's favorite color harmonies

Blue, pink and white

During a visit to the French Riviera, Monet wrote home: "What I will bring back from here is sweetness itself, white, pink and blue." White was evident in the limestone mountains bordering the Mediterranean. Pink is the color of residences he discovered at communities like Antibes; also, pink is the color of sunrises and sunsets that tint the mountain peaks in the early morning and late afternoon. Blue came from the clear blue sky and its reflection in the Mediterranean.

This triad color harmony is the one most commonly encountered today at Giverny, starting with pink tulips with white petal tips, underplanted with blue forget-me-nots in a large oval island bed in front of the main entrance to the house. Later it is evident in the long borders using blue, pink and white pansies in

Blue, pink and white color harmony

Blue

Pink

White

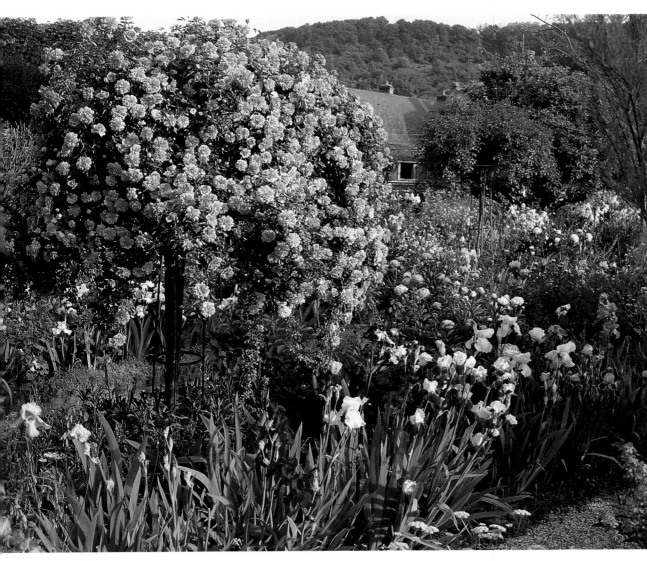

Above: Pink rose standard among blue and white bearded iris.

Monet's late spring mixed border: red/white/blue

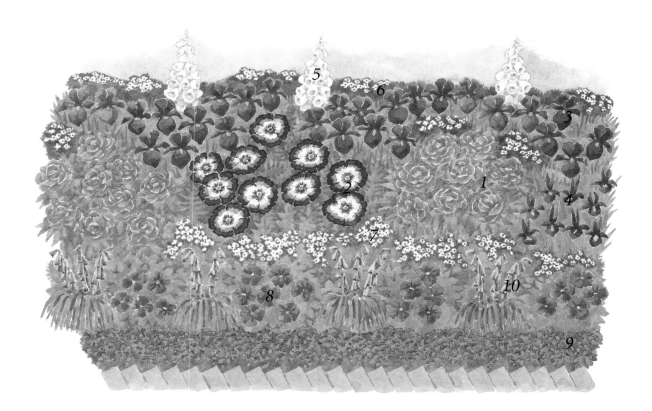

1. Peonies, red
2. Oriental poppies, scarlet
3. Bearded iris, blue and mauve
4. Dutch iris, blue
5. Foxgloves, white
6. Dame's rocket, white (to add shimmer)
7. Forget-me-not, white (to add shimmer)
8. Viola, blue
9. Aubrieta, pink
10. Bluebells

company with blue Dutch iris, white bearded iris and pink honesty. Some of the borders surround a rectangle of lawn planted in the middle with pink flowering crabapples that echo the pink in the cool borders.

Significantly, Monet painted his house façade pink, using brick dust on white stucco, to emulate houses he had seen on the French Riviera, and to echo the pale pinks in his blue, pink and white plantings. In Monet's time the pink façade eventually became completely covered with Virginia creeper, but today the entire front façade of the house remains relatively free of it.

At another property he owned in the village, where he cultivated a 2 acre (1 ha) vegetable and fruit garden, Monet painted the house façade blue, then planted pink roses and white coral bells adjacent to

create the blue, pink and white color harmony. Blue is not a common color for flowers because most blossoms must contrast with blue sky in order to attract pollinators. Therefore, most blue flowers are either low growing, like forget-me-nots and bluebells, to contrast with earth or green grass, or they are luxurious vines with lush green foliage as contrast, such as 'Heavenly Blue' morning glories and blue potato vine. In addition to sky blue, there are lighter tones such as powder blue and lavender blue, and darker shades such as violet blue and indigo blue. Monet especially liked sky-blue flowers, available among delphinium, larkspur, cornflower, grape hyacinths, forget-me-nots, Dutch iris and perennial asters.

Yellow and blue, yellow and purple

Yellow and blue in nature is commonly seen when yellow autumn leaves are reflected in blue water. During one of his Riviera painting excursions, Monet recognized the allure of orange and blue, opposites on the color wheel. In 1884, from his hotel on the shores of the Mediterranean, he wrote to his wife: "I'd like to paint some orange and lemon trees standing out against the blue sea, but can't manage to find any the way I want them … As for the blue of the sea and the sky, it's beyond me."

In the spring in Monet's garden, blue and yellow is present in small vignettes, for example partnering violet-blue bearded irises and blue pansies with yellow Siberian wallflowers. Yellow and purple is most evident in late summer and autumn when the long borders of the Grande Allée flower with masses of perennial yellow sunflowers and purple New England asters.

Yellow is a common color in plants. It is the color of the sun and contrasts well with green leaves as well as blue sky. Monet especially liked the clear yellow of lily-flowered tulips, daffodils, sunflowers, dahlias and waterlilies.

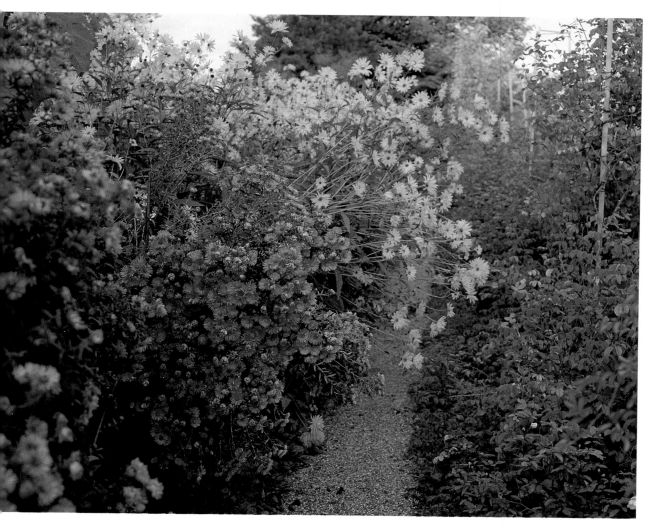

Above: Purple New England asters and yellow perennial sunflowers.

Yellow, blue and purple color harmony

Yellow

Blue

Purple

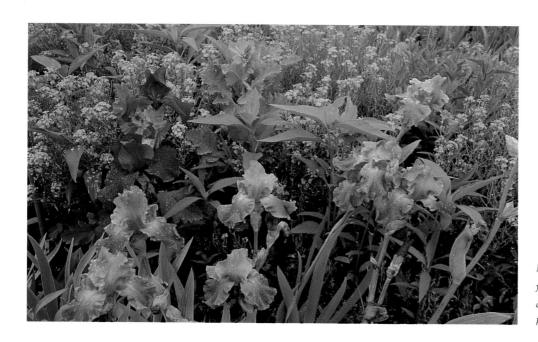

Left: Blue bearded irises and yellow Siberian wallflowers create a yellow and blue color harmony in a mixed border.

Monet's late summer mixed border: blue/yellow/orange

1. *Dahlia, orange cactus-flowered*
2. *Perennial sunflowers, yellow*
3. *New England asters, blue*
4. *Yellow cosmos*
5. *Yellow rudbeckia*
6. *Orange and yellow African marigolds*
7. *Salvia 'Victoria', blue*
8. *Blue* ageratum *'Horizon' (tall)*
9. Impatiens balfourii *(for shimmer)*

*Orange
and blue
color harmony*

Orange

Blue

Orange and blue

These opposites on the color wheel appear in Monet's garden in early spring when orange tulips and Siberian wallflowers bloom among blue forget-me-nots, blue pansies and blue Dutch iris. However, since yellow and orange, and blue and violet, are adjacent on the color wheel, Monet partnered all four to create what art critic Wynford Dewhurst described as "the gold and sapphire of an artist's dreams."

Orange is not as prolific in plants as yellow, but it is most striking in Mexican sunflowers, gladiolus, dahlias, African marigolds and African daisies. Monet also valued orange flowers with black petal markings, such as pansies, or black seed disks such as black-eyed Susans.

Red and green, red and silver

Most garden plantings contain green from the chlorophyll in leaves, and so one of the simplest color harmonies you can achieve in a garden is to plant red flowers with green leaves in a container. Monet did this with red gladiolus, red geraniums and red fuchsias. Red is considered to be the palette's most assertive

Below: Field of Poppies *(1885)*
Museum of Fine Arts, Boston
(Juliana Cheney Edwards Collection)
A good example of a red, green and silver color combination found in the countryside. The silver is produced by drifts of silvery wild sage. Painted near Giverny, the scene inspired Monet to create a similar red, green and silver color harmony in island beds along the porch of his house (see page 51).

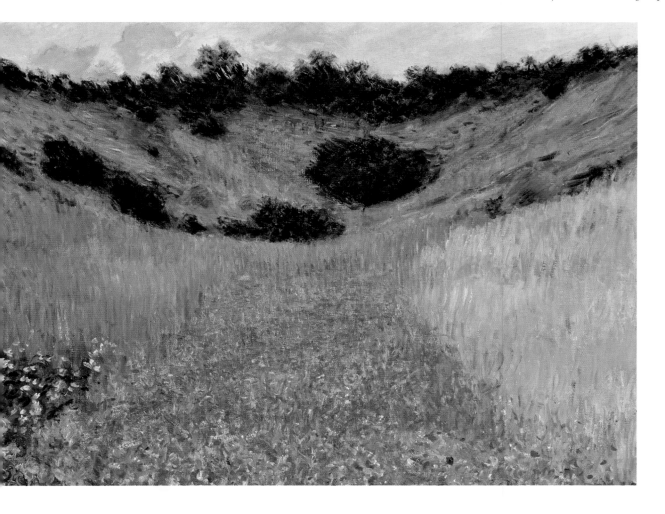

*Red, green,
silver and pink
color harmony*

Red

Green

Silver

Pink

Monet's tapestry effect around the pond using mostly foliage

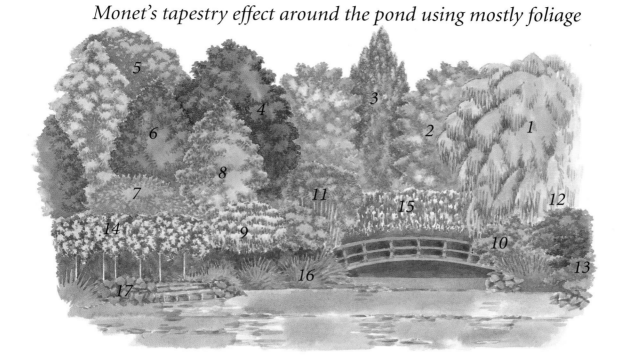

1. *Weeping willow*
2. *Ginkgo*
3. *Poplar*
4. *Copper beech*
5. *Chestnut*
6. *Liquidambar*
7. *Japanese cherry*
8. *Birch*
9. *Laburnum*
10. *Smoke bush*
11. *Bamboo*
12. *Japanese maples*
13. *Azalea*
14. *Climbing roses on arches*
15. *Wisteria on bridge*
16. *Iris foliage*
17. *Coltsfoot foliage*

color. It glares at the world with an angry passion according to artist Vincent van Gogh. After observing wild red and pink poppies growing in close proximity to silvery wild sage in a green meadow, Monet realized the combination could be improved upon for garden display. Today, at Giverny, the red, pink, silver and green color combination follows the spring planting of pink tulips and blue forget-me-nots in the oval island beds in front of Monet's porch. Red and pink bedding geraniums with matte green leaves are massed within an edging of silvery foliage from cottage pinks, while a central line of repeat-blooming tree-form 'Centennaire de Lourdes' rose standards add to the pink highlight.

Red flowers predominate in summer and autumn. The theme can even persist into winter months with the colors of berries such as firethorn and winterberry. A red as intense as any flower is present in autumn leaves of some deciduous trees — Japanese maple, sumac and liquidambar — which are planted around Monet's pond for a rich autumnal display.

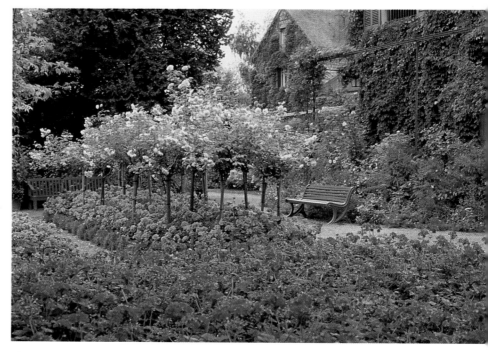

Above: Rose standards 'Centennaire de Lourdes' tower above pink and red geraniums.

Pink is a tint of red, and it is a common color among flowers. Monet liked to use it with red and green, and also red and silver.

White in the garden

A garden planted only in white flowers is undoubtedly one of the most popular monochromatic color themes used today in parks and gardens. It is most often associated with weddings. At twilight and under the light of a full moon it is especially romantic. The Japanese first pioneered the idea of moon gardens, using pale limestone rocks, white gravel, pools to reflect the moon and high-arched moon-viewing bridges. Evening gardens are popular in India where the Hindu bride of the great Mogul emperor, Akbar, designed a garden of reflecting pools for nighttime viewing. She filled it not only with pale-colored waterlilies and white lotus blossoms but also plants like white jasmine with perfumed flowers.

The famous British writer and gardener, Vita Sackville-West, designed perhaps the best known of all white gardens at her home, Sissinghurst Castle, in the Kentish countryside. At first she was a little skeptical of its success. In her newspaper garden column she wrote: "It is amusing to make one-color gardens … For my part I am trying to make a gray, green and white garden. This is an experiment that I ardently hope to be successful, though I doubt it. One's best ideals seldom play out in practice, especially in gardening … Still one hopes. I cannot help hoping that the gray ghostly barn owl will sweep silently across the pale garden next summer in the twilight."

From his Impressionist painting technique Monet was well aware that white played a prominent role in making solid colors sparkle and look brighter. Gertrude Jekyll explained it well when she wrote: "It is a curious thing that people will sometimes spoil some garden project for want of a word. For instance a blue garden, for beauty's sake, may be hungering for a group of white lilies, or something of the palest lemon-yellow, but is not allowed to have it because it is called the blue garden, and there must be no other flowers … Any experienced colorist knows that blues will be more telling — more purely blue — by juxtaposition of rightly placed complementary color."

The sophisticated use of white is key to understanding Monet's garden design. He avoided big splashes of white, which can result from using a white mophead hydrangea, for example, or big clumps of white summer phlox, white cushion chrysanthemums or white azaleas. Unless the individual flowers are separated on airy sprays, like dame's rocket and white forget-me-nots, so they can have other colors showing in the background, the massing of white alone tends to create an objectionable white hole in the landscape.

As a result of painting snow scenes early in his career, Monet realized that in nature all-white expanses are improved by having a touch of another color present. Even in a snowscape, for example, there are black highlights, such as a tracery of tree branches

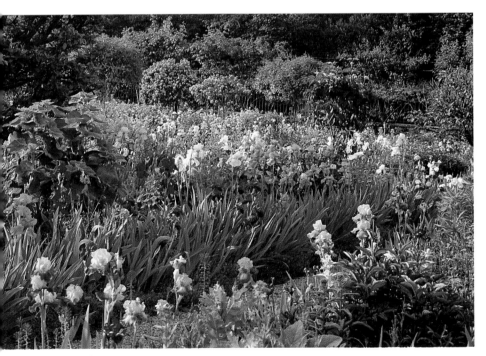

Above: Touches of white from dame's rocket enliven a planting of bearded irises.

silhouetted against the snow, and a blue cast in shadow areas when the sky clears. His favorite colors to partner with white were black or maroon, in addition to blue and pink.

More flowers have white petals than any other color, and in general it goes well with most other colors except yellow, unless the intention is to have a moon-viewing garden (where white and pale yellow show up well in moonlight). Many yellow flowers, such as bearded irises and tulips, have white petal tips that add to the shimmering appearance Monet liked, so yellow flowers with a glimmering of white are used extensively in his garden.

Although monochromatic white borders feature today at Giverny, both in the Clos Normand and the water garden, the most common use of white is to produce a shimmering effect.

The Impressionist shimmer

Monet understood the importance of white in making his paintings vibrant, and also the potential of white to make his garden unique by giving it a shimmering or glittering appearance all through the growing season. This was achieved not by planting white in large drifts, but by sprinkling white liberally throughout the garden, especially using plants with delicate, airy flower panicles that can be seen through, such as dame's rocket and feverfew. This aspect of Monet's garden contributes so much to its visual impact that it deserves a special chapter to itself (see Chapter 3, "Impressionist Shimmer").

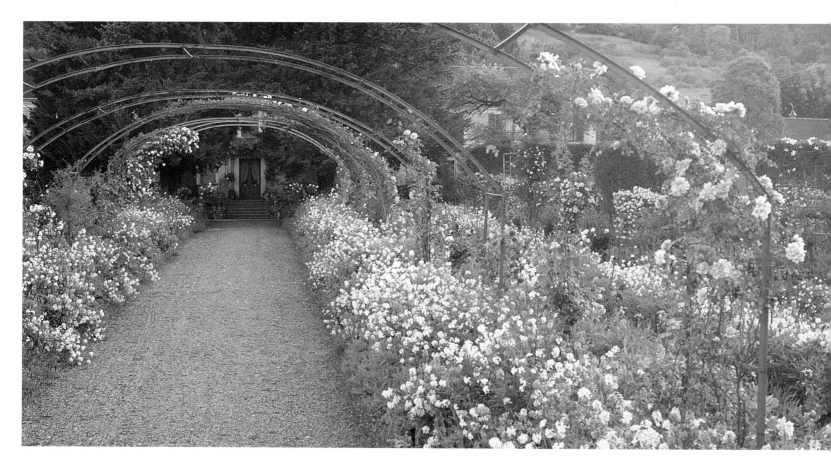

Above: White dame's rocket flowers along the Grande Allée to produce a shimmering effect on a misty day.

Black in the garden

Black is the absence of all color, and there is a misconception that Monet hated black. Following behind the hearse at Monet's funeral, Georges Clemenceau, French premier, was upset to see a somber black shroud covering the coffin of "the painter of light," as he once described his artist friend. Stepping forward from the procession, he grabbed the shroud and pulled it aside, stating, "Black was not part of Monet's palette."

While it is true that Monet used black sparingly, he did appreciate its value as a contrast to white, and he stunned the art world with a beautiful black and white color contrast in his snowscape entitled *The Magpie*, showing a black and white bird sitting on a wattle fence in a garden covered with snow. To honor this painting, which prompted a flurry of snow scenes among other Impressionist painters, Monet's garden today invariably features a black and white color theme somewhere, starting in spring with black tulips partnered with bicolored white and black pansies.

Monet appreciated the use of black mostly as a stipple effect, and so he liked to plant tiny black flowers like black-faced violas among brighter flowers. He also liked to see strong contrasts of sunlight and shadow, and deliberately chose to paint at times of the day when shadows improved a composition, such as early morning or late afternoon. At these times the sun is low and it pencils shadows from trees long distances across meadows, lawns and paths. So, in his mixed borders many of the white flowers feature a black seed disk in the center.

All-black flowers are rare. Those Monet grew include black scabiosa, black violets, black tulips and black bearded iris. On a dull day these may seem to be truly black, but in sunlight they are maroon. Black is also present in tree branches, which is why Monet liked trees and shrubs with dark branch silhouettes, and deliberately exposed them for contrast with their surroundings.

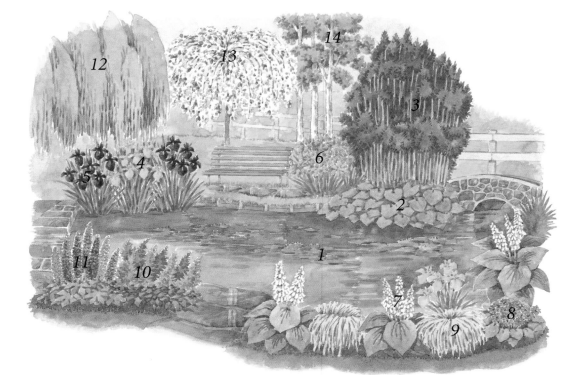

Small pond at Cedaridge Farm inspired by Monet's garden

1. Waterlilies
2. Japanese coltsfoot
3. Bamboo
4. Iris, yellow flag
5. Iris, blue flag
6. Daylilies
7. Hosta sieboldiana
8. Primula
9. Sedge grass 'Bowle's Golden'
10. Astilbe, pink
11. Russell lupins, bicolored red and white
12. Weeping willow
13. Weeping cherry
14. River birch

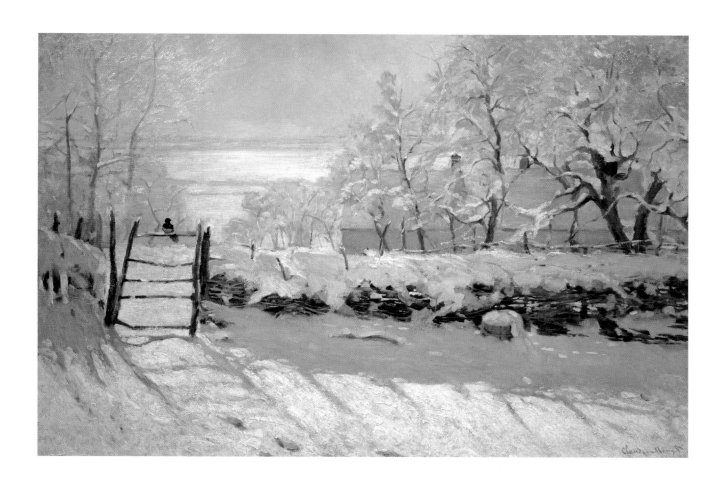

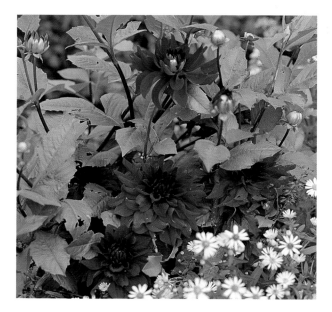

*Black and white
color harmony*

White

Black

Above: The Magpie *(1869)*
Musée d'Orsay, Paris
*Monet's most famous black and white
color harmony contrasts a black and
white bird in a garden covered with
snow. Although the impression is
black and white from black branch
silhouettes, note how shadows are
painted blue — Monet's favorite color
for planting in shade.*
*Left: Dark hybrid tuberous dahlia
'Nuit d'Eté' ('Summer's Night')
contrasts with white asters.*

Black and orange

In nature the most common contrast of black and orange occurs when the black silhouette of tree branches is seen against an orange sunset. Black is partnered with orange throughout Monet's garden, starting in spring with black-and-orange pansies, and continuing into summer using orange black-eyed Susans. While orange used alone in the garden can be garish, the proximity of black will tone it down like black stipple in a painting. In nature Monet noted that although black is rare in flowers, many orange flowers have black centers, such as annual sunflowers and African daisies. Today, at Giverny, at the height of summer when orange flowers are plentiful, the garden features a monochromatic orange border with black accents deliberately introduced by selecting flowers with black centers.

Black and orange color harmony

Yellow

Orange

Black

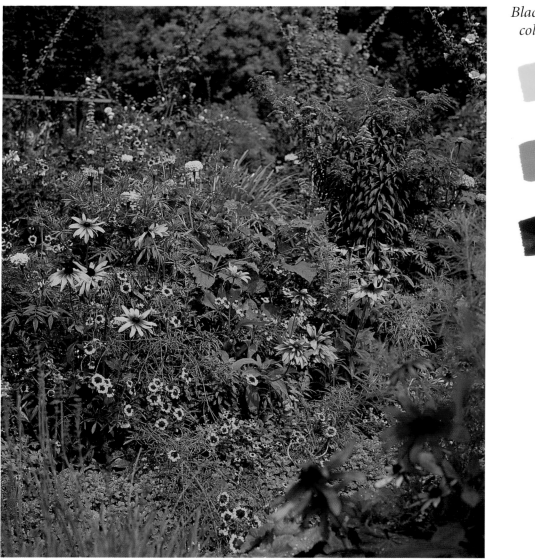

Above: A predominantly orange mixed-flower border with black highlights.

Blue in the shade garden

Blue sky has a calming effect on the senses while clear blue water suggests comfort and safety. Blue tends to draw people toward it, like a pool of blue water, and blue in shady areas is especially alluring. Monet even painted shadows blue on his canvases, such as *Field of Yellow Irises* (1887), and in shady parts of the garden he delighted in planting drifts of blue flowers such as Spanish bluebells, violas and forget-me-nots to create the impression of a tranquil pool. These pools of blue at Giverny today can be seen under trees in the Clos Normand flower garden and also along the shady stroll path surrounding Monet's pond.

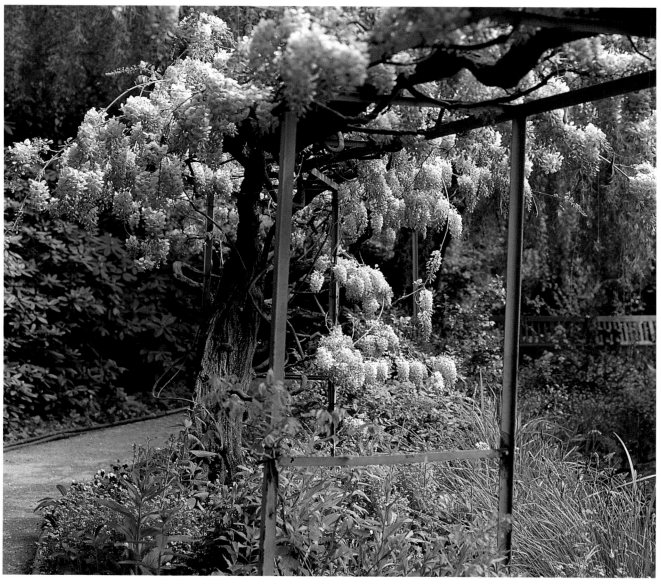

Above: This shady part of the water garden features blue wisteria and an underplanting of blue flowers.

Green in the garden and the fascination of foliage

Monet loved to paint foliage. He was fascinated by the infinite permutations of leaf colors, their varied shapes and sizes and the distinct personality evoked by a tree through the arrangement of its branches and the color and arrangement of its leaves. For example, he liked the weeping willow for its curtains of slender green foliage and the common mullein for its spirelike habit and feltlike silvery-green leaves.

He liked the ability of some plants to display russet colors in autumn, such as sumac and liquidambar, and he liked the wintry silhouette of woody plants with snaking branches, such as Japanese floribunda cherry and tree peonies. "I am the painter of open spaces and lone trees," he once declared. On a painting excursion to the Britanny coast one early spring, he sat painting a rugged hawthorn tree with sinuous branches shaped by harsh wind and salt spray. A storm began so he retreated to the shelter of a nearby inn. When he returned to the tree several days later to finish his painting, he was dismayed to see the hawthorn had leafed out, obscuring its silhouetted branches. To make it look desolate and windblown again, he hired local residents to bring ladders and strip the tree of its leaves.

Green is perhaps the most misunderstood color in the garden. Indeed, many novice gardeners don't even consider it a color since green is generally the background against which most floral colors must contrast in order to attract pollinators. The Impressionists knew differently. Painting mostly outdoors, *en plein air,* they realized that trees are often the dominant live forms in the landscape,

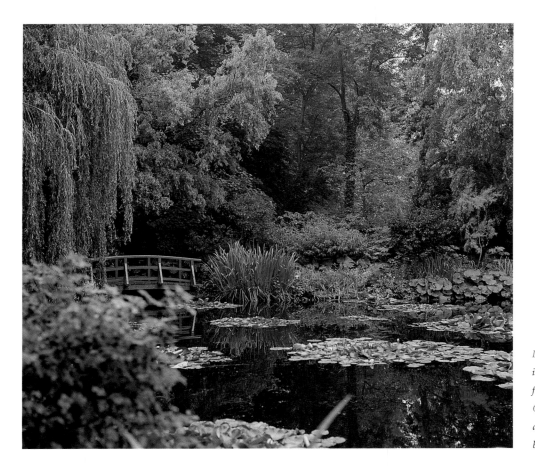

Left: This small arched footbridge is at the opposite end of the pond from the canopied Japanese bridge. Opposite: Yellow, orange and red azaleas seen against a green foliage background.

and green produces nuances of tone like few other colors. There are the black-greens of juniper needles, the blue-greens of sword-shaped iris leaves, the silvery sheen of olives and the underside of poplars, the lime-greens of delicate mimosa foliage and even the bronze-greens of a purple smokebush.

Monet produced a rich tapestry of greens as a panorama across the skyline of his water garden, and so today visitors can see the columnar form of silvery-green poplar foliage contrast with the billowing, weeping form of willows; the black-green spirelike shape of a spruce stabbing the sky beside the cloudlike form of a copper beech; and the yellow-green of a golden locust tree beside the mint green of a chestnut. Monet also chose low-growing woody plants — like Japanese maples — for foliage color to get variation in his leaf tapestry.

Blue foliage

Plants with bluish (or glaucous) leaves make good contrasts with golden and yellow leaves; for example, 'Blue Angel' hosta beside yellow barberry or Bowles golden grass. Blue foliage also makes a good background for yellow flowers, such as yellow flag iris against blue hosta foliage. Blue fescue grass, a good groundcover for sunny spaces, and blue rue, a bushy foliage plant suited to similar positions, have blue tints as colorful as many blue flowers.

Bronze foliage

Sometimes bronze foliage is described as purple or plum. It is present in a wide range of perennials, such as 'Bishop of Llandaff' dahlia, and woody plants, such as purple smokebush, and even tall

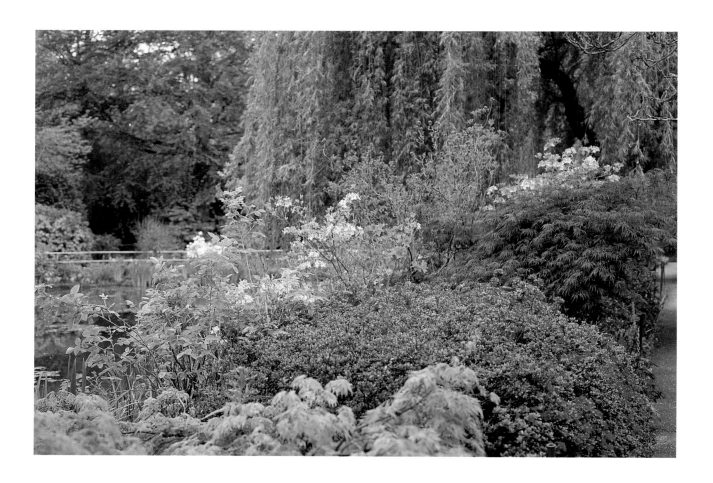

trees, such as the copper beech. Its main visual benefit is to produce a shadow effect in saturated sunlight so a planting of mostly green-foliaged plants doesn't look washed out. Bronze foliage makes a particularly good contrast for pink and red flowers.

Silver or gray foliage

Plants with gray foliage generally come from coastal locations. Sometimes the gray is better described as silver because plants like lamb's ears, for example, produce a silvery sheen on sunny days. Silver looks good with green leaves, and also as a background for pink and red flowers. For an all-foliage contrast consider silvery variegated 'Morning Light' miscanthus and the erect red leaf blades of 'Red Baron' Japanese blood grass.

White foliage

Monet didn't like white foliage because he thought it looked anemic. In his landscape he mostly wanted strong greens and bronze. White leaves are produced mostly from variegation, whereby the white forms an edging to a leaf. However, the gardeners at Giverny today make a few exceptions, notably a planting of yellow 'West Point' lily-flowered tulips edged with 'Varigatum' bishop's weed. The ivy-shaped leaves of bishop's weed and its white edging look silvery from a distance.

Yellow or gold foliage

Some plants have such bright yellow leaves, for example golden barberry, that they rival yellow flowers in sheer brilliance. In general Monet did not care for yellow variegation for the same reason he disliked white variegation — its sickly-looking appearance — but yellow sedge grass and yellow moneywort can be good backgrounds for blue flowers such as forget-me-nots.

Glossary of color definitions

The following are definitions used in the art world to describe sensations of color and gradations of light, particularly in relation to plants and gardens.

Analogous harmony A grouping of two or more adjacent colors on the color wheel; for example, green, yellow and orange.

Bicolor A flower with two colors in its petals. For example 'Candystripe' creeping phlox has rosy-red stripes on a white background.

Chroma Intensity of color ranging from weak to strong, affecting its saturation, purity and brilliance. Tulips, with their rich iridescent and clean colors, exhibit a stronger chromatic effect in the landscape than iris, for example. Even though the color range of iris may be greater, their chroma tends to be weak compared to tulips.

Complementary harmony Colors seen directly opposite each other on the color wheel. When placed together they enhance each other, for example orange calendulas planted beneath blue bearded iris.

Contrast Striking difference in color — for example, black and white, red and green. Though black is a rare color in flowers, it is used effectively with white and orange at Giverny.

Cool colors Restful colors that seem to recede into the landscape; for example, blue, green and purple.

Dimension of color Every color has three expressions or dimensions — hue, value and chroma.

Harmony A pleasant combination of colors; the opposite of anything discordant, garish or shocking.

Hot colors Red, orange and yellow are considered hot colors. They are assertive, dramatic and forceful in the landscape.

Hue Mostly used to describe a pure color, for example red, blue and yellow, though it is also used to describe color ranges within a pure color, such as red, pink and crimson.

Intensity Saturation or strength of color. In nature the intensity of a color will be affected by light and other environmental conditions such as mist and cloud cover. For example, orange petals will intensify after a shower of rain or in the light of a setting sun.

Iridescence A shimmering, shining quality, like satin. Petals of California poppies and clarkia have a sheen, or iridescent quality. The iridescence is often diminished in double flowers, which is why Monet preferred singles.

Monochromatic harmony A single color used mostly to create a border. In Monet's garden today popular monochromatic borders include white, orange and pink.

Polychromatic harmony A multicolored harmony using a wide range of colors. Though difficult to achieve using a variety of plant species, it is usually most satisfying when the color range comes from a single plant family, such as primroses and iris. Monet's bearded iris borders are sometimes polychromatic.

Shade The effect of adding black to a pure color; for example, maroon is created by adding black to pure red.

Texture The physical characteristic of a surface — such as a leaf, which can be smooth and lustrous like a rhododendron, or covered in hairs and velvety like lamb's ears.

Tint The effect of adding white to a pure color; for example, pale pink.

Tone The effect of adding gray to a pure color; for example, silvery-blue.

Translucence The quality of a surface that allows passage of light through it, without being transparent, making it glow or shine like a Chinese lantern. Oriental poppies and Oriental lilies, with their large petals, have especially good translucent qualities.

Value The lightness or darkness of a color. For example, deep pink and light pink are degrees of lightness emanating from red.

Variegation Normally refers to leaves that are bicolored, usually green and white or green and yellow. Variegated bishop's weed is white and green, and from a distance looks like silver. Monet expressed a general dislike for variegated leaves since many of them look sickly.

Above: A color wheel showing the three primary colors (red, yellow and blue) and how they relate to each other.

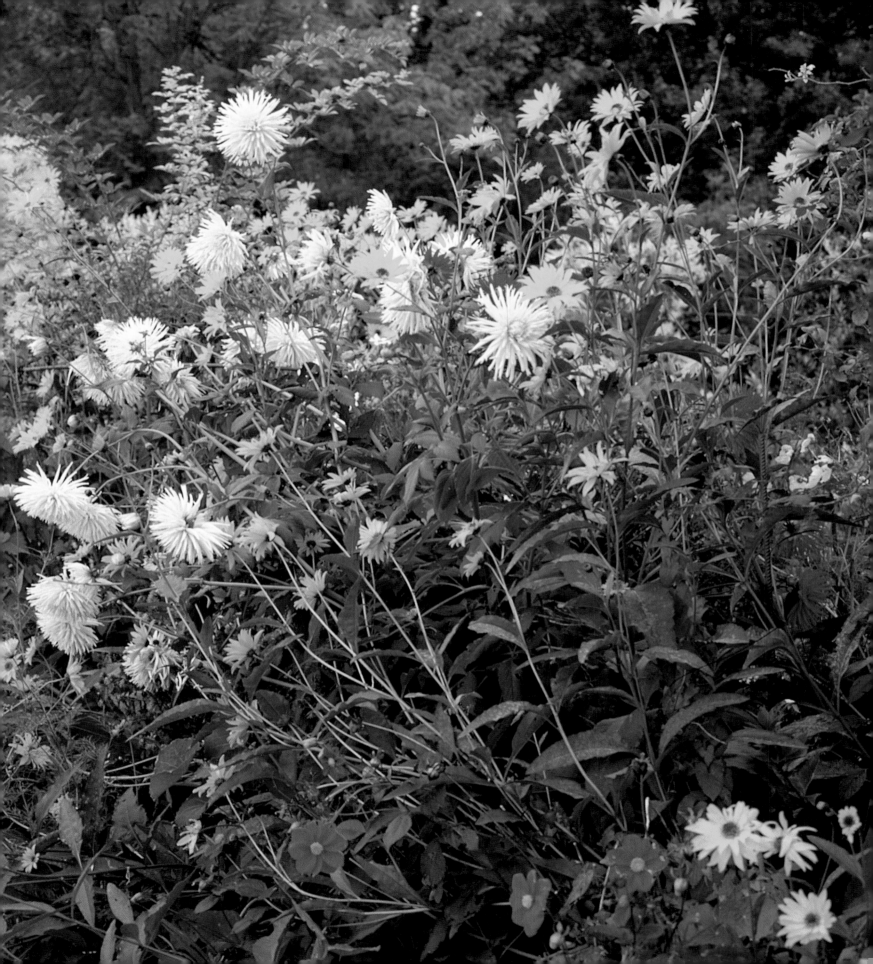

3
The Impressionist Shimmer

"The dahlias are stars that tremble and twinkle
atop fragile branching stems … the air is filled with
so much glimmering, so much quivering."

Octave Mirbeau, art critic

N o PAINTER OF THE Impressionst era captured the many moods of water as successfully as Monet, particularly the sensation of shimmer from wavelets reflecting thousands of pinpricks of light. Monet even owned a "studio boat" with a canopy to shade his easel and canvas so he could row out into the middle of rivers and lakes to obtain special viewpoints.

Impressionist painting is readily recognizable for its brightness. Paint was usually applied to the canvas with flickering brushstrokes, often using pure color straight from the tube. Art critic Clement Greenberg described an Impressionist painting as "a foaming, pouring, shimmering profusion like nothing else in painting; pictures that are spotted and woven with soft, porous colors, and look in themselves like soft bouquets of flowers."

Achieving garden shimmer

Monet took the Impressionist's idea of a glittering, sparkling, glimmering, shimmering visual experience into his garden, and it is the sensation of shimmer that identifies his garden more than any other feature. It is amazing how many ways Monet discovered to create a shimmering effect in his garden through planting. While his techniques essentially use a lot of white, this must not be seen as a solid mass. There must always be sufficient space between the blossoms to make the individual blossoms seem like a white stipple effect in a painting. The artist achieved the impression of shimmer in various other ways. The following analysis describes some of his most successful efforts.

Airy white flowers

Delicate touches of white or pale yellow throughout Monet's garden are mostly achieved through flowering plants that have their flowers widely spaced on a tall flower stalk, like dame's rocket, or widely branched on a mounded plant like white forget-me-nots.

White flowers that are used in Monet's garden to create a shimmering effect include: *Astilbe* x *arendsii*

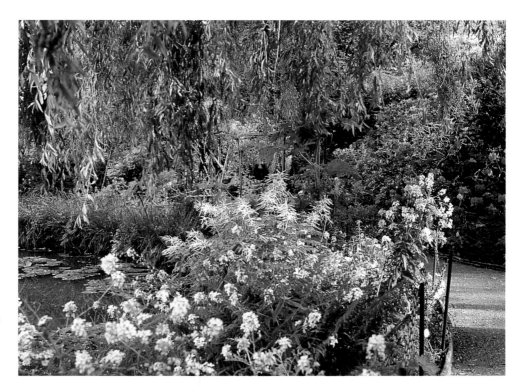

Previous page: Cactus-flowered dahlias and perennial sunflowers in the late summer garden.
Right: This white border edges Monet's pond.

'Snowdrift'; baby's breath (*Gypsophila elegans*); bearded iris (*Iris germanica* hybrids); coneflower 'White Swan' (*Echinacea purpurea*); corn cockle (*Agrostemma githago*); cornflower (*Centaurea cyanus*); daisy, ox-eye (*Chrysanthemum leucanthemum*); dame's rocket (*Hesperis matronalis*); feverfew (*Tanacetum parthenium*); forget-me-nots (*Myosotis sylvatica*); foxglove (*Digitalis purpurea*); foxtail lily (*Eremurus himalaicus*); heath aster (*Aster ericoides*); larkspur (*Consolida ajacis* syn. *C. ambigua*); *Linaria maroccana*; *Nicotiana alata*; *Penstemon digitalis*; Siberian flag iris (*Iris sibirica*); snapdragon (*Antirrhinum majus*); strawflower 'Pierot' (*Rhodanthe anthemoides* syn. *Helipterum anthemoides*); and wandflower (*Gaura lindheimeri*).

Bicoloration

Shimmer can result from planting certain bicolored flowers, like tulips and bearded irises. Among hybrid tulips are a number with white petal tips, such as the late-flowering variety 'Sorbet', and lily-flowered 'China Pink'. Blue bearded irises, where the lower petals (the falls) are blue and the upper petals (the standards) are white, include such varieties as 'Tollgate'. Alternatively, the lower petals may be bicolored blue and white, such as in the iris 'Stepping Out'.

Flowers in Monet's garden with white in their bicoloration include the following: bearded iris (*Iris germanica* hybrids); *Celosia spicata* 'Flamingo'; daisy, English (*Bellis perennis*); impatiens (*Impatiens balfourii*); meadow foam (*Limnanthes douglasii*); lupine, Russell (*Lupinus* hybrids); *Mina lobata* (*Ipomoea lobata*); pansy (*Viola* x *wittrockiana*); *Phlox drummondii* 'Twinkle'; snapdragon (*Antirrhinum majus*); spider flower (*Cleome hassleriana*); and tulip (especially cottage and lily-flowered).

Translucent petals

Shimmer occurs when flowers with translucent petals twinkle once they are backlit, especially tall flowering plants like white and pale pink cosmos, and daisylike flowers, such as marguerites. When flowers with translucent petals cluster atop tall stems rather than

Above: Bicolored 'Candy Stripe' cosmos appears to be streaked by an artist's brush.

Above: Example of a cosmos bloom with translucent petals.

adhere to low-growing foliage, the sun more effectively makes the petals glow like a Chinese lantern.

Tall flowers in Monet's garden with translucent petals include the following: *Cosmos bipinnatus* and *C. sulphureus*; dahlia, single-flowered (*Dahlia* hybrids); hollyhocks, single-flowered (*Alcea rosea*); marguerites (*Argyranthemum frutescens*); and poppy, Oriental (*Papaver orientale*).

Lace-curtain effects

Monet liked lace. All the windows of his house feature lace curtains, and he even wore shirts with lace fronts and cuffs. He took the "lace curtain" effect into his garden by planting white flowering vines to climb up metal trellis, and drape their flowering stems down like fountains of spray. The mountain or anemone clematis (*Clematis montana*) is a particularly aggressive flowering vine that produces masses of starry flowers in white or pale pink (*C. m.* 'Rubens'). Silver fleece or lace vine (*Polygonum aubertii*), white rambler roses and white wisteria are also effective at creating a lace curtain to add to the shimmering appearance.

Flowers used in Monet's garden to produce a lace-curtain effect include sweet peas (*Lathyrus odoratus*); morning glory 'Pearly Gates' (*Ipomoea tricolor*); climbing roses (e.g., 'Purity'); *Wisteria floribunda* and *W. sinensis*.

Iridescence

A select number of flowers have a satinlike sheen to their petals so that in sunlight they shimmer. Godetia, clarkia or satin flower, in mostly pink, and California poppies in mostly orange, are good examples, as are certain varieties of African daisies in rainbow colors. They do not have to be white to create a shimmering appearance; many are shades of yellow, orange, pink and red.

Flowers in Monet's garden that display a special iridescence include the following: California poppy (*Eschscholzia californica*); *Gazania rigens*; godetia (*Clarkia amoena*); hollyhocks (*Alcea rosea*); *Lavatera trimestis* 'Silver Cup'; mallow (*Malva sylvestris*); and tulip (especially Darwin hybrids).

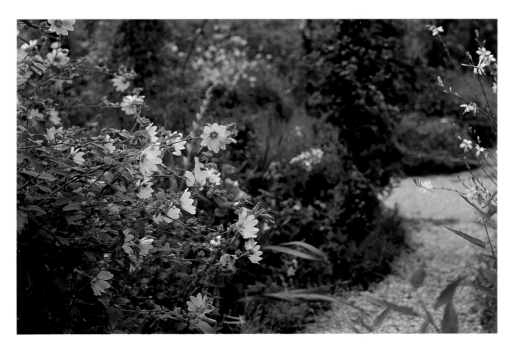

Left: Mallows (foreground) show an irridescent sheen in one of Monet's mixed flower borders. Opposite: Monet's Japanese bridge uses white wisteria to produce a lace curtain effect over a canopy. A blue wisteria, entwined among the white, blooms later.

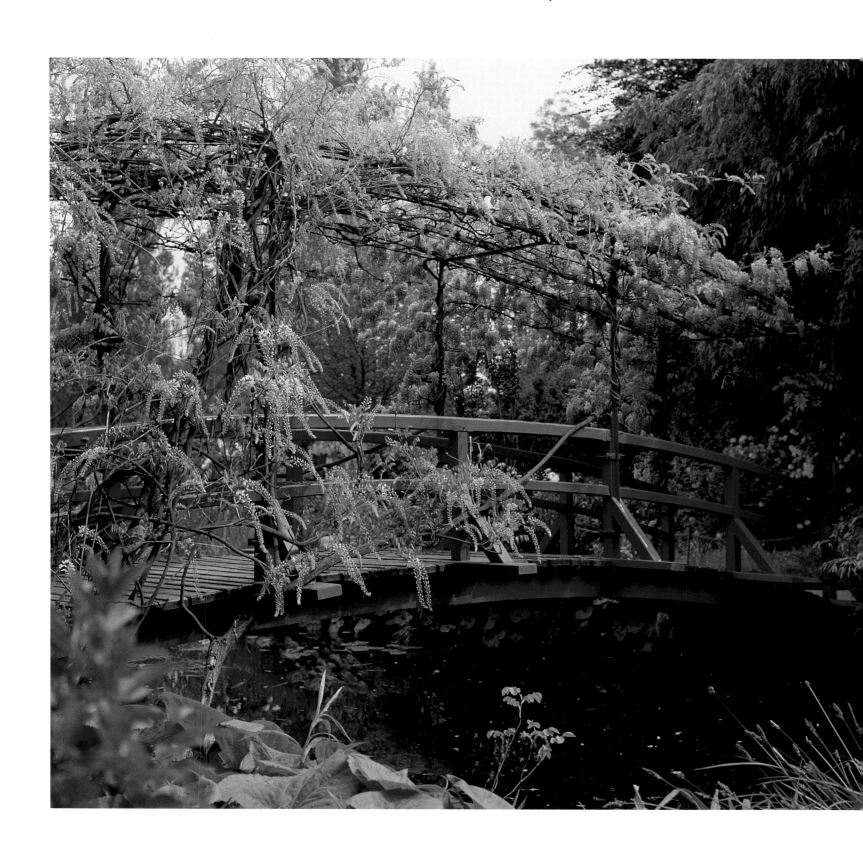

Underplanting

The Impressionist shimmer can be made by tall flowers like dame's rocket and vines like silver fleece, and also from low-growing species used as an underplanting. White forget-me-nots and white English daisies are good examples. Flowers suitable for underplanting include: *Anemone blanda*, white; *Aubrieta deltoidea*, white; English daisy, white and bicolored white and pale pink (*Bellis perennis*); *Euphorbia* 'Diamond Frost'; forget-me-not, white (*Myosotis sylvatica*); *Galium odoratum*, white; grape hyacinth, white (*Muscari armeniacum*); London pride, white and pale pink (*Saxifraga* x *urbium*); starflower, white (*Triteleia uniflora* syn. *Ipheion uniflorum*); and viola, white (*Viola tricolor* and *V. cornuta*).

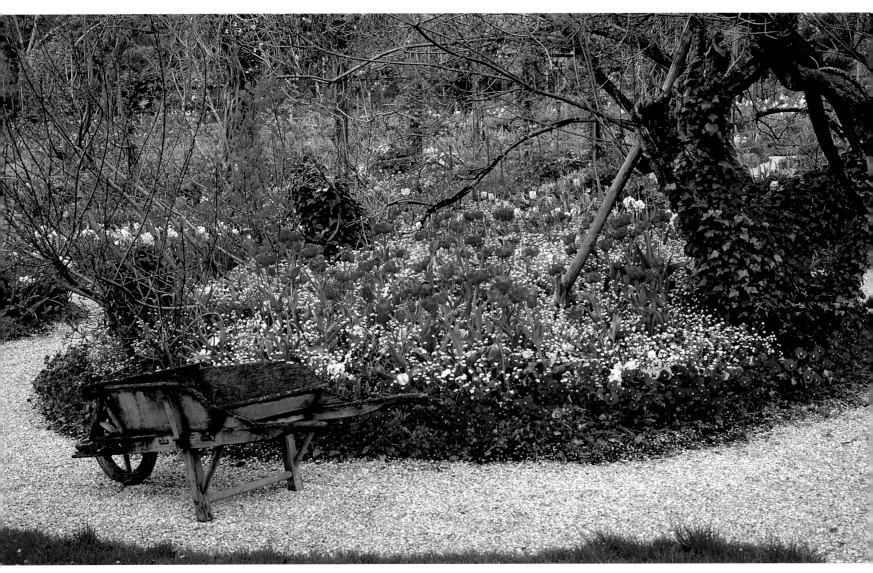

Above: White forget-me-nots under tulips create a shimmering appearance in a circular flowerbed.

Black and white flowers

When flowers include black in their petal composition, the result is a "twinkling" effect. Usually the black is present at the base of the petal as a blotch (e.g., in the Oriental poppy 'Perry's White') or at the very center as a seed disk (e.g., in the African daisy 'Zulu').

Black and white flowers used in Monet's garden to produce a twinkling effect include: African daisy 'Zulu' (*Venidium fastuosum*); columbine 'Magpie' (*Aquilegia* hybrid); delphinium 'White with Black Bee' (*Delphinium elatum* hybrid); *Echinacea purpurea* 'White Swan'; Gazania hybrid 'Daybreak', white; *Nemophila menziesii* 'Penny Black'; *Osteospermum* hybrids; pansy 'Dynamite' (*Viola* x *wittrockiana*); *Scabiosa atropurpurea* 'Ace of Spades'; sunflower 'Moonshadow' (*Helianthus annuus*); Swan River daisy (*Brachycome iberidifolia*); and viola Penny Series, white (*Viola cornuta*).

Black and yellow flowers

Many yellow flowers have a black zone around the base of the petals, or a black button center formed by black stamens or a black seed disk, for example in black-eyed Susans and sunflowers. The presence of black as a contrast to the yellow produces a twinkling sensation similar to the combination of black and white.

Flowers in Monet's garden with black and yellow include: black-eyed Susan (*Rudbeckia hirta*); *Calendula officinalis* Kablouna Series; *Chrysanthemum carinatum* 'Carnival'; *Dimorphotheca pluvialis* 'Spring Flash'; *Gazania* hybrid 'Daybreak Bright Yellow'; pansy hybrid cultivar 'Yellow with Blotch'; *Rudbeckia hirta*; *Sanvitallia procumbens* 'Mandarin Orange'; and viola hybrid cultivar 'Tiger Eyes'.

Brilliance

The purity of color in flower petals can have a dazzling effect even if the petals are not iridescent. Dahlias and gladiolus are prime examples.

Flowers grown in Monet's garden for their brilliance include: catchfly (*Silene schafta*); dahlia hybrids; daylilies (*Hemerocallis* hybrids); delphinium hybrids; gladiolus hybrids; lilies, Asiatic and Oriental hybrids, marigold, African (*Tagetes erecta*); and nasturtiums (*Tropaeolum majus*).

See-through plants

Certain flowers are used in Monet's garden to veil the bolder colors of other plants. This veiling can produce a shimmering effect. For example, patrinia — a wayside flower from Provence — has tall stems with yellow flowers that form a billowing flower cluster. It blooms in early spring.

Flowering plants in Monet's garden that can be used to veil bolder colors include: campion (*Silene vulgaris*); *Cirsium rivulare* 'Atropurpureum'; columbine

Left: Maroon flowers such as dahlia 'Nuit d'Eté' ('Summer's Night'), contrast with white cosmos.

Following pages: An example of the Impressionist shimmer using mostly dame's rocket among bearded irises.

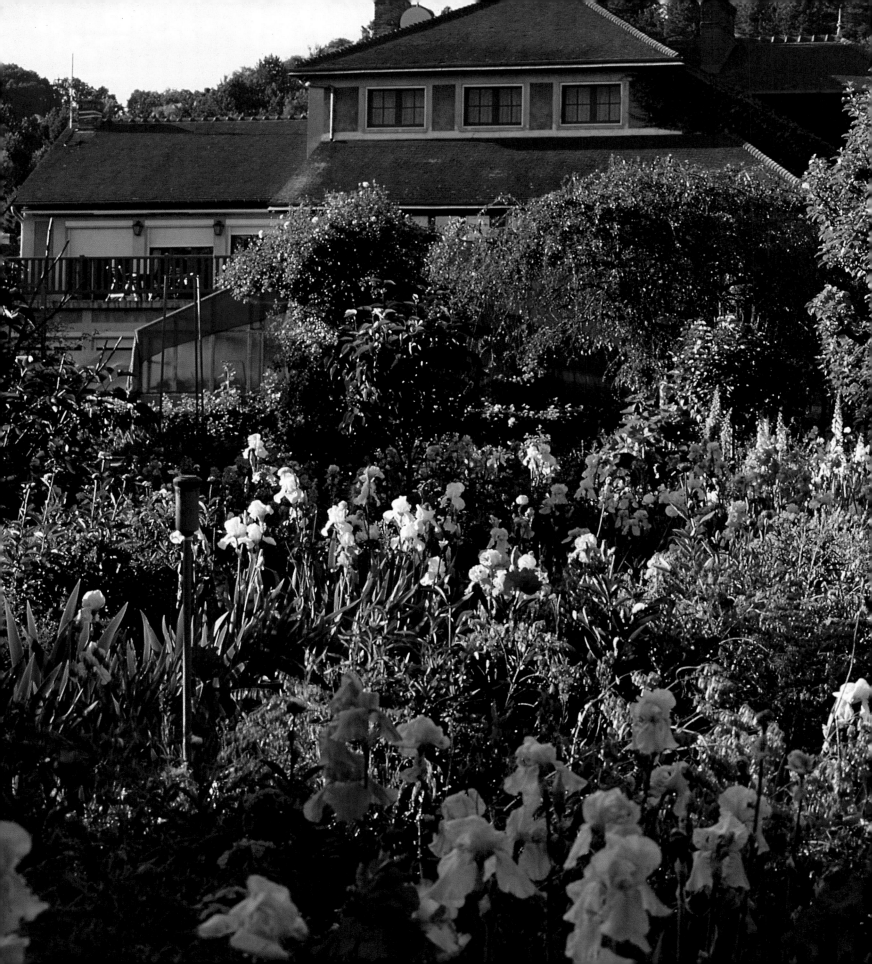

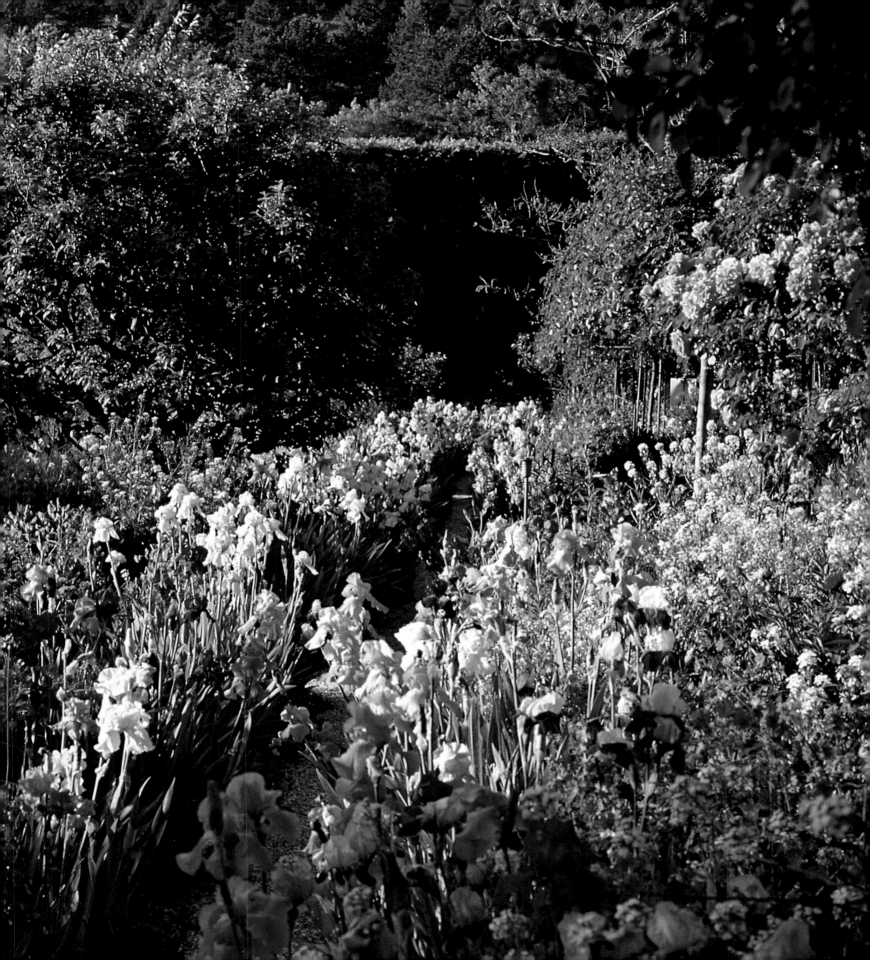

(*Aquilegia* hybrids); *Knautia macedonica*; lavender, English (*Lavandula angustifolia*); meadow rue (*Thalictrum aquilegifolium*); *Patrinia scabiosifolia*; *Penstemon eatonii*; *Salvia coccinea* 'Lady in Red'; sweet peas (*Lathyrus odoratus*); valerian (*Centranthus ruber*); verbascum hybrid 'Southern Charm'; *Verbena bonariensis*; and *Verbena hastata* 'Pink Spires'.

The effect of sunlight on shimmer

No Impressionist painter understood the effect of light on color as acutely as Monet. So captivating was the influence of light on a landscape that he often had two canvases in progress when painting a scene — one for sunshine and the other for cloud cover. As he gained more experience he realized that certain conditions could produce even more gradations of color and so in his later years he would work on four canvases simultaneously to capture the lighting dynamics of a scene. Some of these fleeting moments might last only a matter of minutes, but he was so skillful at applying paint to canvas, that is all the time he needed to render the right effect.

In addition to painting in sunlight and under cloud cover he painted willows muted by mist, a dormant garden tinted with snow, poplar leaves trembling in the wind, autumn leaves shining from a shower of rain, pine trunks tinted red by a setting sun, and heat waves rising from an expanse of water on a hot day.

Background color and shimmer

Monet paid special attention to background colors. He painted the façade of his house pink allowing blue flowers — such as blue delphinium with black centers — to contrast well in front of it. He painted all his structures green so they echoed the rich greenery of his garden and allowed the airy white flowers to stand out to perfection. He also added dark foliage colors to backgrounds to enhance the shimmer and also to break up the monotony of bright green.

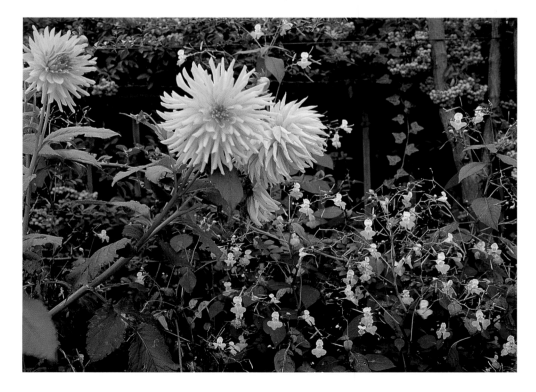

Left: Cactus-flowered dahlia veiled by Impatiens balfourii. *Opposite: When plants are used to create a shimmering appearance, the effect is heightened by backlighting.*

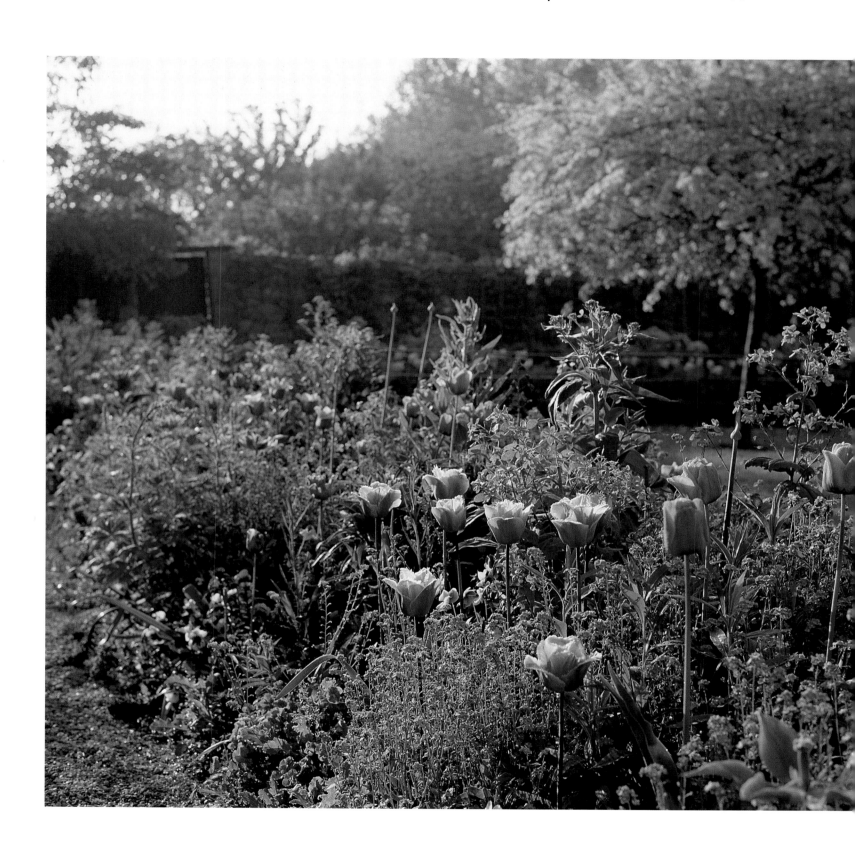

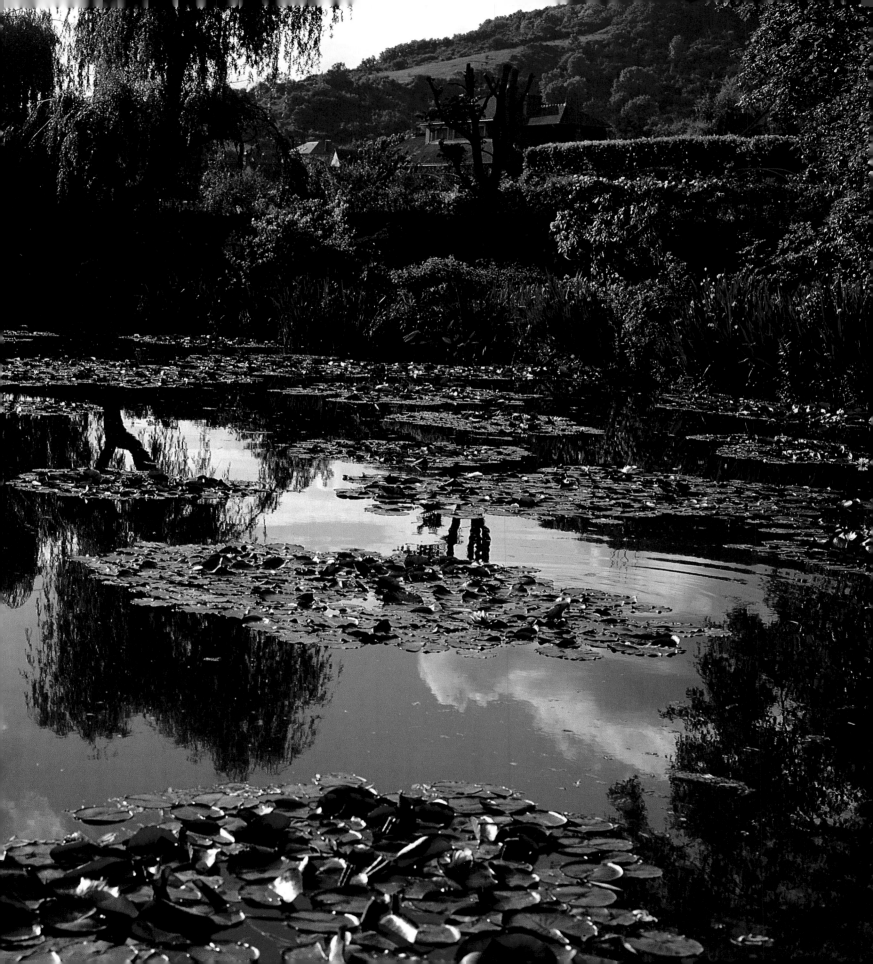

4

Monet's Water Garden

"It took me a long time to understand my waterlilies. I had planted them for the pure pleasure of it, and I grew them without thinking of painting them … You don't absorb a landscape in a day … And then, all of a sudden I had the revelation of the enchantment of my pond. I took up my palette. Since then I've had no other motif."

Claude Monet

AFTER 10 YEARS perfecting his Clos Normand flower garden and its rich source of subjects to paint, at the age of 53 Monet decided to create a water garden on a low-lying, swampy piece of ground immediately beyond the railroad tracks at the bottom of his property.

Originally, the entrance to this new garden was at the bottom of the Grande Allée and through a pair of gates aligned with a canopied, arched footbridge called the Japanese bridge. Though the gates still provide entrance to the water garden, they are closed to visitors. The railroad tracks have since been replaced by a highway that leads from the nearby market town of Vernon to Paris, but thanks to a generous donation by American publisher and art collector Walter H. Annenberg, a subterranean tunnel today connects the Clos Normand to the water garden so visitors do not have to cross the busy highway. The tunnel comes up in the corner of a *bocage*, or woodland, planted with mostly shade-loving tulips in spring and impatiens in summer. A winding path follows a stream to the wisteria-canopied Japanese bridge that crosses a corner of the pond, and immediately visitors are struck with the refined Japanese-style landscape confronting them.

Japanese inspiration

When Monet was asked by a magazine writer the inspiration for his Impressionist paintings, Monet replied: "If you really must find an affiliation for me, select the Japanese of olden times: their rarefied taste has

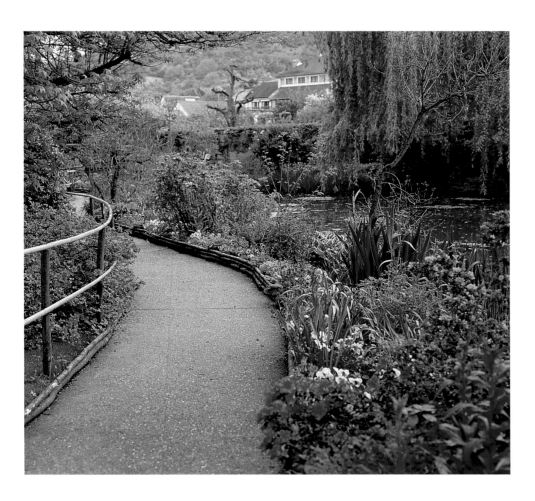

Previous page: Monet's pond in summer with islands of waterlilies.
Right: Part of the stroll path that encircles Monet's pond.

always appealed to me; and I sanction the implications of their aesthetic that evokes a presence by means of a shadow and the whole by means of a fragment."

Monet collected Japanese woodblock prints, and today these can be seen decorating the walls of his house. Some show Japanese water gardens overhung with weeping willows, the pools decorated with waterlilies, and the whole scene framed by wisteria vines that coil up into trees and along trellis. He also read a great deal about Japanese culture and art in magazines, and he was fortunate to have as a neighbor Mrs. Lilla Cabot Perry, an American Impressionist painter who had lived several years in Japan when her husband accepted a teaching position at the University of Tokyo. She had studied Japanese art and garden design, and

helped Monet plant his water garden with indigenous Japanese plants. She also put Monet in contact with Japanese nurseries.

Further describing the genesis of his water garden, Monet wrote: "There was a stream, the Epte, which came down from Gisors on the boundary of the property. I opened up a ditch so I could fill a little pond that I had dug in my garden. I love water, but also I love flowers. That's why, when the pond was filled, I wished to decorate it with plants. I took a catalog and made a choice off the top of my head. That's all."

Later, however, when he realized how enchanting his pond was, Monet improved it, and even hired a Japanese nurseryman to advise him where to obtain difficult-to-find Japanese plants, such as tree peonies

Above: Japanese tree peony beside the wisteria covered bridge.

and Japanese maples, in order to enforce the illusion of stepping into a Japanese landscape.

Many of the traditional Japanese garden designers were Zen Buddhists and applied to landscape design the principle of *shibusa*, meaning quiet and refined taste, with its emphasis on creating serenity, nobility, conservatism, introspection and reserve — the opposite of anything loud, noisy, garish or bizarre.

These garden designers invariably sought symbolism expressed in the planting and shaping of trees, severely pruning evergreen shrubs into mounds to represent green hills, and drastically training evergreen trees into bonsai shapes to represent venerable old age. They sought symbolism in the placement of boulders to simulate rock outcrops and craggy islands. They were expert in the control of water, manipulating running water to create nature's music by guiding it over and

around rocks and crashing it from a great height. They also used still water as a mirror. A lexicon of terms describes different effects with water — "silver threads" for water that falls in long slender trickles, and "falling cloth" to describe a wide sheet of falling water.

Though Monet was undoubtedly aware of all these ancient design ideas from Mrs. Perry and his vast reading, he did not embrace them all. He preferred deciduous trees over evergreens so they could produce rich gradations of color through all the seasons and cloudlike skyline effects, not tortured bonsai shapes, and he did not incorporate waterfalls or splashing fountains into his water garden design. He understood the many moods of water — alluring and beautiful when it is clear and reflective, hauntingly mysterious when dark and opaque. It was the potential of a large, flat, smooth body of water that captivated him.

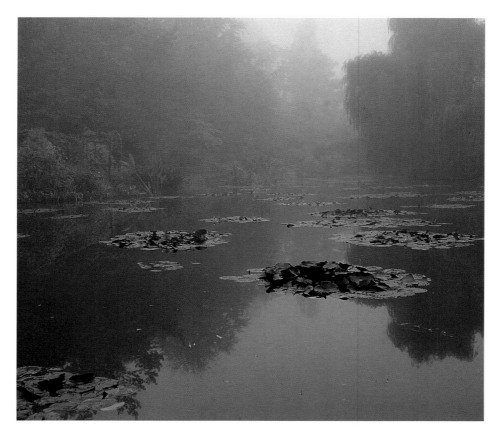

Left: Monet's pond and waterlilies shrouded in mist.
Opposite: Branch of the Seine near Giverny *(1897)*
Museum of Fine Arts, Boston (Gift of Mr. and Mrs. Walter Scott Fritz)
Monet was the master of painting water in its many moods, and he used a boat not only to paint viewpoints from midstream, but also from the middle of his pond. This is one of a series of paintings showing the nearby river in different degrees of mist. The proximity of the river to Monet's water garden also imbues his pond with an early morning mist.

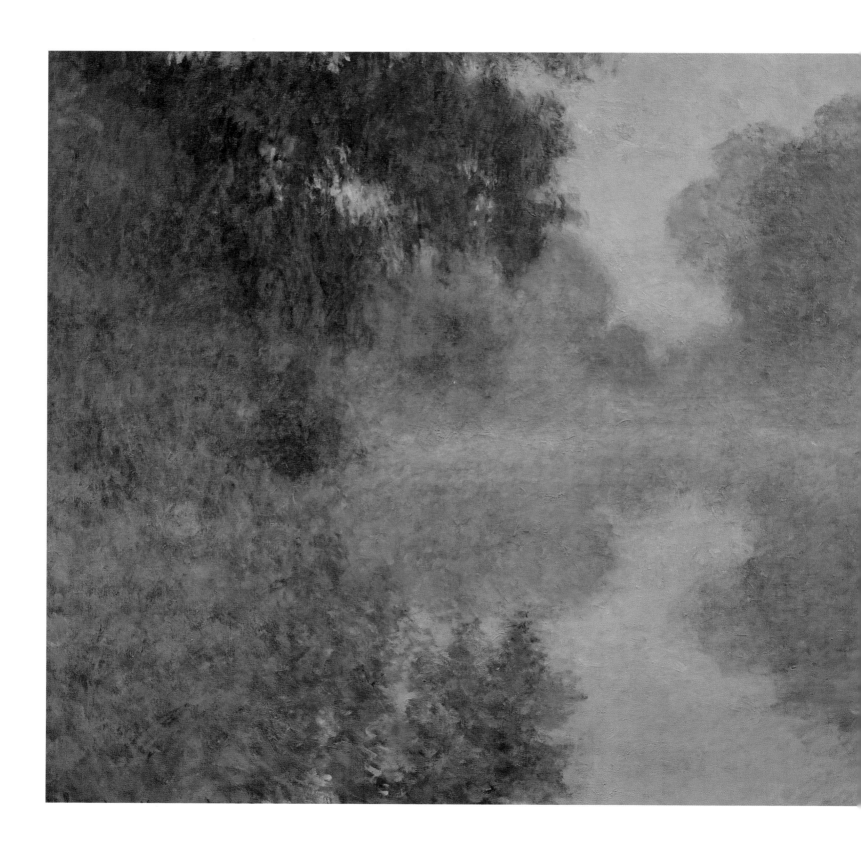

The pond is enlarged for aquatic plants

In 1893 Monet asked for local planning permission to enlarge his pond in order to grow aquatic plants. At first permission was refused for fear the plantings would pollute the water and poison livestock downstream. He was so angry at this refusal he ordered his transplants to be thrown into the river, but shortly after, the mayor was persuaded to intervene, and permission was granted. Excavation began and sluice gates were built at the intake and outtake to control water flow from the Epte.

In contrast to the formal design of the Clos Normand, the water garden is highly informal, composed of graceful curves rather than straight lines. "To have an elegant effect, there must be no symmetry in the water garden," wrote Félix Breuil, about Monet's water garden. "In summer the water irises were planted in acid soil, with an all-purpose fertilizer added … they were fed again in March."

The visitor to Monet's garden is first advised to see 19 massive waterlily panels, the *Grandes Décorations des Nymphéas*, housed in the Orangerie Museum near the Louvre, in the Tuileries Gardens, Paris. They are mesmerizing, more than 6 feet (2 m) high and up to 20 feet (6 m) long, composed of delicate pastel colors that evoke evanescent lighting effects at two different times of the day. Green lily pads and multihued waterlilies float like stars above water so clear and reflective the subject of the paintings is not so much the flowers but the exquisite reflections, caught in a single fleeting moment. These are framed by curtains of weeping willow foliage and slender, arching leaves of bamboo.

When visitors enter either of the two oval rooms housing the panels, they react as though entering the water garden itself. Their pace is slowed, their eyes register awe, voices talk in a whisper. It is Monet's ultimate masterpiece, his final magnum opus, apart from the garden itself.

The horizontal panels are a work of artistic genius so demanding of time and so sensitive to the visual nuances of nature, it is difficult to imagine how he overcame intense personal tragedy to complete them before his death. In 1911, the loss of his wife Alice 15 years before his own death, was devastating, as were the deaths of his eldest son, Jean, three years after Alice, and his lifelong friends Cézanne and Renoir, who struggled with him through the birth of Impressionism. He suffered bouts of intense despair, illness such as emphysema from chain-smoking, and the threat of blindness. When war with Germany was declared in 1914, his gardeners left and the garden suffered. Monet even feared for his life. "If these savages are to kill me, it will be among my canvases and life's work," he declared. In 1916, as World War I raged, he built a third studio to complete his waterlily panels.

The declaration of peace raised his spirits. A new gardening staff was hired, and the garden sprang to life again. "Make sure the compost is well rotted," he commanded, as beds were cleared of weeds and the soil brought back into cultivation.

Above: Approach to the water garden along the stroll path in early spring.

Highlights of the water garden

The stroll path

This path is a significant feature of Monet's water garden, for it encircles the pond and provides a visual adventure all along its length. Also called a trail, it is mostly overhung with tree branches or bamboo, the pond side planted with low perennials and shrubs with wide gaps made to observe the pond reflections from all angles.

"I have set up my easel in front of this body of water that adds a pleasant freshness to my garden; its circumference is less than 200 meters [650 feet] … soon I shall have passed my 69th year but my sensitivity, far from diminishing, has been sharpened by age …" Monet wrote.

In addition to painting the water garden through all the seasons and in all kinds of light, Monet enjoyed conducting visitors around like the emperors of old Japan, first taking them to the crown of the arched

Above: Stroll path overhung with weeping willow branches to create a leafy tunnel.

bridge for a high-elevation, panoramic view of the entire pond, then walking along the pond margin, pointing out design features and treasured plantings at every turn. Along the path are stretches of mowed grass or low, spreading groundcovers, such as sweet woodruff, to produce a clear window onto the pond.

Georges Truffaut provides a sense of how the water garden was planted when he wrote: "On one shore, forming a backdrop, there is a cluster of briary plants among which ferns, kalmia, rhododendrons and holly predominate ... there are abundant irises of all varieties along the edges of the pond ... Japanese iris ... add an oriental touch, which is further enhanced by such plants as Japanese tree peonies ... at the water's edge

are beds of meadow rue with leaves as lacy as some ferns, with pink and white fluffy flowers. There are also *Vanhouttei spirea* with white flowers mingling with tamarisks, whose pink and white blooms are as graceful, in May, as ostrich plumes ... in some corners of the garden are rhododendrons mingling with Chinese and American azaleas in colors ranging from shrimp red to pure white. Long stemmed rose bushes with garlands of blooms forming a frame are everywhere. The overall impression is delightful, one that arouses an intense ... awareness of artistry."

Maurice Guillemot, in the March 1898 edition of *La Revue Illustrée*, wrote that during a visit to Monet's garden he saw 14 paintings of the same study — a

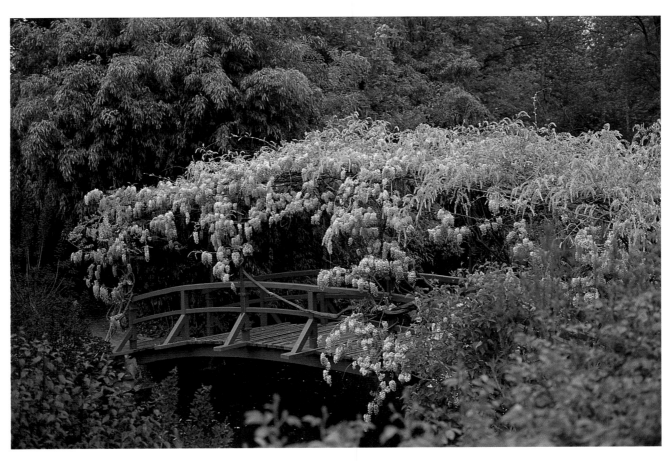

Above: View looking down on the wisteria-covered bridge in early May, showing the wisteria in bloom.

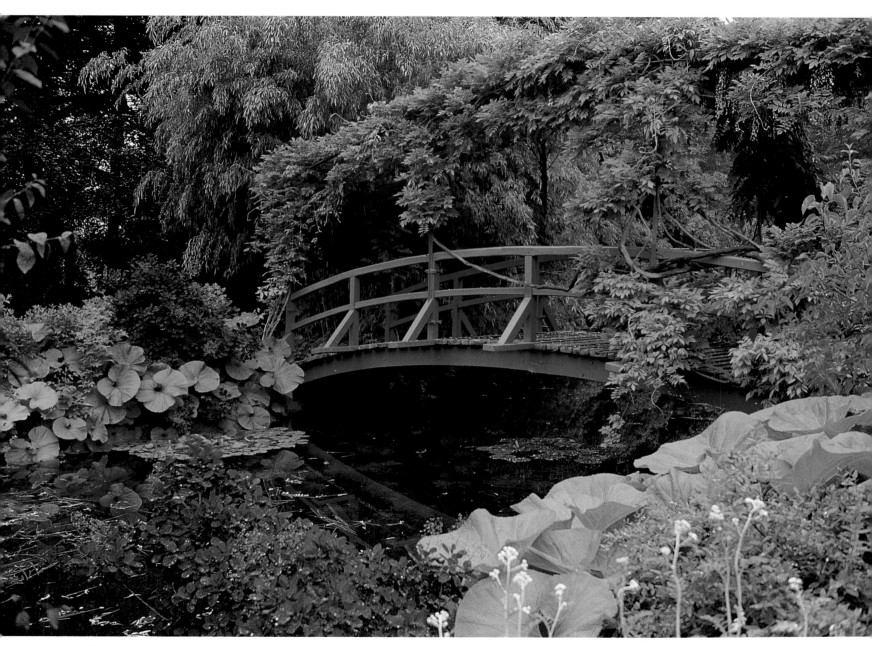

Above: Even when the wisteria flowers are finished, the bridge surroundings remain dramatic from foliage contrasts.

section of Monet's water garden — and that each was the translation "of a single, identical motif whose effect is modified by the time of day, the sun and the clouds."

Francois Thiébault-Sisson, in a June 1927 issue of *La Revue de l'Art Ancien et Moderne*, also noted the changing atmospheric effects of the water garden when he wrote: "We entered and my eyes widened in wonder … he had depicted the waterlily pond from the perspective of the path that encircles it, and each of the vantage points he had selected was enclosed in

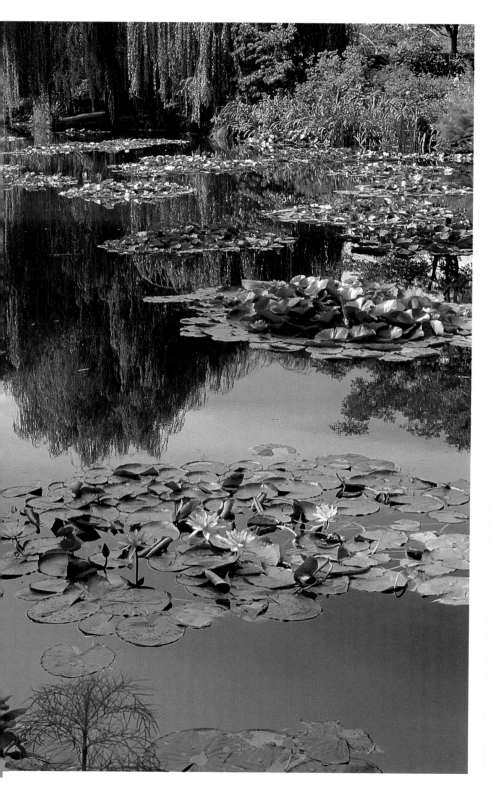

a framework of one of his canvases ... the whole scene shimmered with the brilliance of an already fading sun whose last rays were resplendent as floods of gold in a pearly gray and turquoise sky."

When the opera singer Marguerite Namara visited Monet she offered to sing for him in his water garden, and a piano was moved to the site for her to perform.

The cup garden

Conceptually, Monet's water garden is founded on a completely different design philosophy from that of his flower garden. With its long narrow beds running north and south, the Clos Normand is a highly formal layout that directs the eye along paths and avenues to the bottom of the garden, the long lines of perspective creating the illusion of infinity, particularly when viewed on a misty day. On clear days the eye is drawn along the paths and out of the garden into the surrounding countryside.

The water garden, however, is designed for introspection. The pond water acts like a mirror, and the stroll path encircling the pond offers views facing inward so that the eye is always being drawn to the pond's surface and its exquisite reflections. It is unlike most other French gardens that are designed with a lot of formality and straight lines to draw the eye along vistas. However, there are special observation points where Monet liked to set up his easel.

Traditional Japanese garden designers call this type of garden a "cup garden." The pond surface forms the bottom of the cup and the plantings on the banks are its sides. The elliptical shape of the arched Japanese bridge, when reflected in the pond, is a cup on its side; the rose arch above the boat dock another. Everywhere around the pond are framing elements — mostly arches or tree branches — to isolate a specific design feature, such as a wisteria arbor 6 feet (2 m) high and almost 35 feet (over 12 m) long, the blue blossoms presenting a bold brushstroke of color in spring.

Left: Beautiful water reflections on Monet's pond.

Opposite: View of the stroll path and pond from the crest of the bridge.

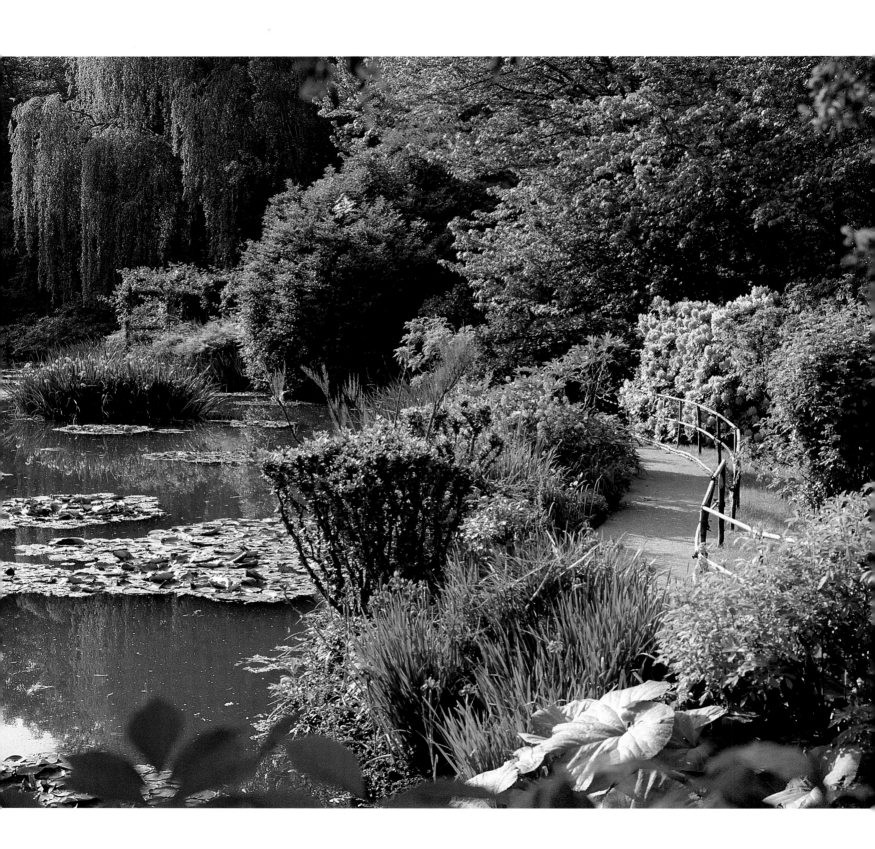

The Japanese bridge

The design for Monet's dominant arched bridge came from a Japanese woodblock print he admired, and he added a canopy of wisteria probably as a result of Mrs. Perry's description of a spectacular wisteria-canopied bridge at the Sento Imperial Palace garden, Kyoto, which has a flat span rather than arched; also it is made of stone rather than wood.

Monet's bridge span of 18 feet (6 m) in length by 6 feet (2 m) wide was originally painted white to reflect changing colors of light, but later he made it green to echo the color of his other garden structures. He surrounded both ends of the bridge with Japanese plants, including hardy bamboo, weeping willows, Japanese water irises, coltsfoot (or Japanese butterbur) — a bog-loving plant with huge heart-shaped leaves — and waterlilies.

The waterlilies

To give the garden a focus, and make the pond surface alluring, Monet planted hardy waterlilies in submerged concrete containers filled with soil (see page 87). They are planted in groups of three inside a wire basket that can be raised out of the sunken container for replanting, if necessary. Flowering begins in June, reaches a peak in July and August and diminishes in early September. Even the floating pads do not survive frost, but since the containers are located below the ice line the soil does not freeze and the waterlily roots remain dormant during winter. A pole shows the position of each grouping for winter and early spring inspection. The pond is kept clear of fish and waterfowl such as ducks, to protect the waterlily roots from being eaten.

Monet tried to grow tropical kinds such as the beautiful Australian blue waterlily, but his pond water

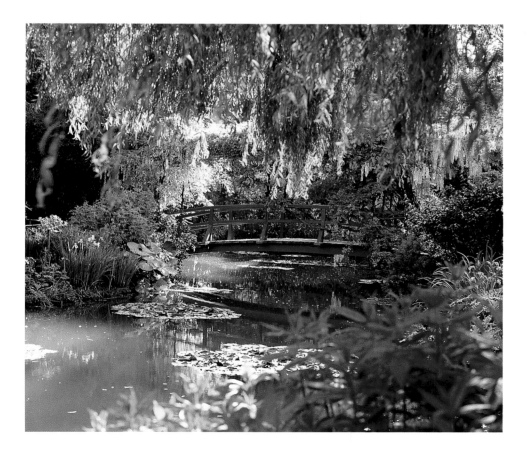

Left: Lighting around the Japanese bridge changes from moment to moment and season to season.

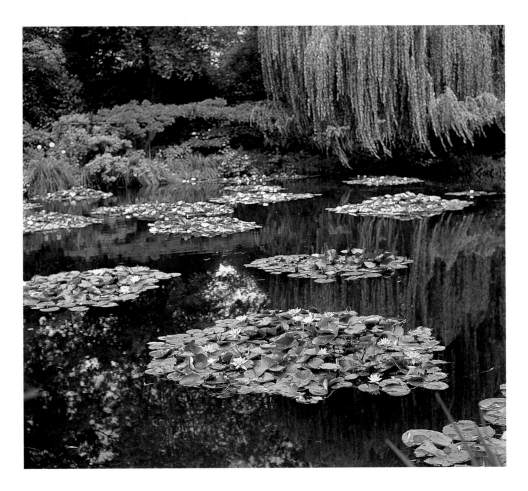

*Left: To retain a reflective body of
water, the waterlilies are pruned
almost daily.*
Below: Waterlilies and Clouds
(1903). Private Collection.
*In this composition Monet shows
no horizon line so the waterlilies
floating on the pond produce an air
of mystery. In earlier compositions
the horizon line is included to
provide a sense of place.*

proved to be too cold for them to flower. The same is
true of pink lotus. He did, however, manage to flower
both successfully in tubs in his greenhouse.

The hardy waterlilies include fragrant whites,
pink, rosy-red, yellow and orange. The groupings
are positioned sufficiently wide apart so the circular
leaves (called pads) form islands, and rigorous pruning
prevents their knitting into each other. Initially, when
he started to paint the waterlilies he showed the pond
margin behind them to establish a sense of place, but
later he discovered it was far more appealing to show no
horizon line, for without it there was a sense of mystery
to the painting. These canvases require some study to
realize the plants are floating on water and not floating
in mid air.

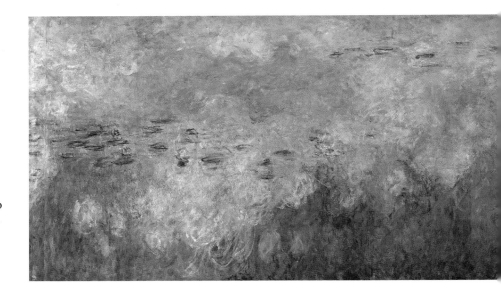

Maintaining the reflections

Reflections double the beauty of Monet's water garden, but to maintain a good reflective quality is difficult. Without daily cleaning of pond weed and pruning of the waterlily foliage, the pond loses its reflective quality, and the waterlilies would cover the entire surface of the pond before midsummer.

Though tall trees like weeping willows and poplars cast exquisite reflections, gaps must be kept clear by pruning so that openings to the sky reflect exquisite sunrises and sunsets.

Flowering plants like orange and yellow azaleas planted right at the water's edge cast strong reflections in spring, while Japanese maples, also planted at the water's edge, cast warm russet reflections in autumn when the leaves change color. Other plants with good autumn color include liquidambar, Siberian iris foliage and sumac. Blue wisteria and pink rambler roses are trained high on trellis to cast more subtle reflections.

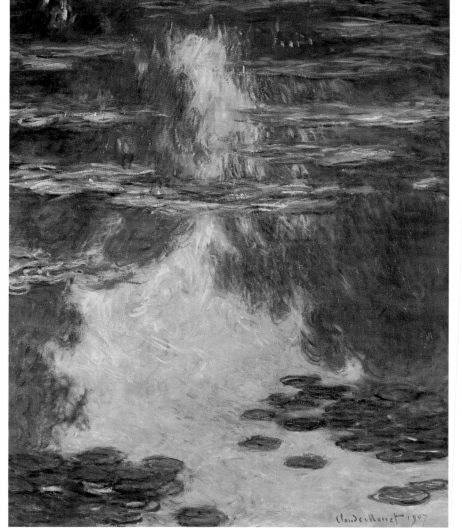

Left: Waterlily Pond *(1907)*

Bridgestone Gallery, Tokyo

Even though the lily pads are without blooms in this painting, the orange and yellow of an autumn sunset produces exquisite reflections. Note the absence of a horizon line. This makes the viewer study the subject carefully to understand the composition.

Below: Deciduous azaleas planted close to the water cast colorful reflections.

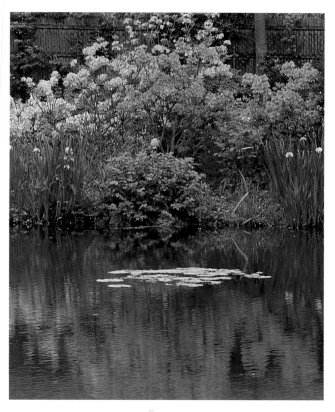

Waterside plants

When choosing plants for his water garden, Monet first considered indigenous plants, realizing that to create a feeling of Japan it was not necessary to use only Japanese plants. It was the spirit he sought, and if certain Japanese plants were unsuitable for his climate, like camellias and cycads, he realized it was better to use native shrubs and trees better suited to the area, like laburnum and European beech.

For the water garden he liked plants with soft colors (especially pink) as well as those with sculptural qualities like spiky Japanese iris foliage, billowing maidenhair ferns and handsome blue Japanese hostas with blistered, paddle-shaped leaves.

Monet planted the shallow margins of his pond with sedge grasses, arrowhead and water irises that, like waterlilies, can tolerate their roots permanently submerged. These not only serve as transitional elements between the floating flowers of the waterlilies and plants on the dry pond margin, but also add color to the water reflections. In particular he planted sweeps of blue and violet Japanese water iris and yellow European flag iris. A small island in the pond, sized about 12 feet (4 m) square, is planted entirely with yellow flag irises.

Monet so much liked to see pink reflected in the water that he planted on the banks clumps of smoky pink meadow rue and pink astilbe. Tall white giant hogweed blooms with blue Japanese iris and pink meadow rue to create a cool blue, pink and white color harmony that is especially alluring in mist or reflected in the water.

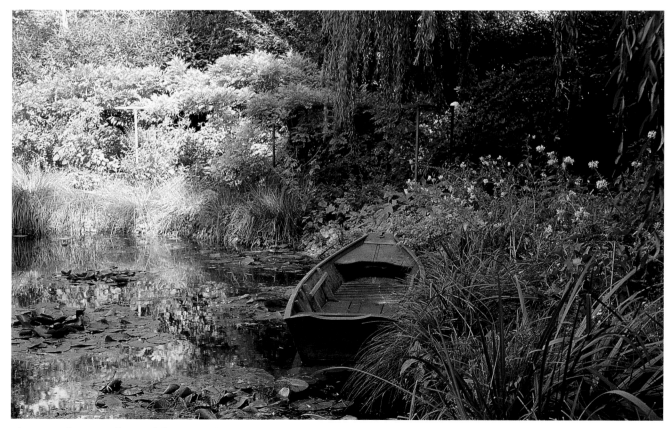

Above: Monet's green rowboat nestled among iris foliage and sedge grass. Note the contrast between sunlight and shadow.

The rowboat and boat dock

Monet not only disliked the Japanese tradition of severely pruning trees and shrubs into bonsai shapes, but also excluded Japanese ornamentation such as stone lanterns, stepping stones, stone towers, geisha statues, boulder accents, boathouses and teahouses. He did provide the pond with a boat similar in design to Japanese rowboats, with a sleek profile and sharp prow, and painted it green to echo the color of his structural accents. This he tethered to his boat dock by a rope that allowed the boat to drift slightly offshore. The boat dock is a flight of concave stone steps leading into the water, and mostly overhung with 'American Pillar' roses. A slatted bench also provides a good place to sit and admire the water surface.

Monet used the boat to paint viewpoints from the middle of his pond, and even today a gardener daily cleans the pond surface with a similar craft. Monet used the boat dock as a good place from which to paint his waterlilies showing no horizon line.

Because the pond surroundings are shaded by tall trees, including beech, poplars and bald cypress, Monet planted white flowers to introduce his trademark shimmer, and to echo the glimmering surface of the pond when riffled by wind. In addition to giant hogweed, single white 'Nevada' roses arch their canes out and into the water.

Foliage contrasts

In spite of a generous quantity of flowers planted around the pond, the water garden is more subdued and more tranquil than the Clos Normand flower garden. Much

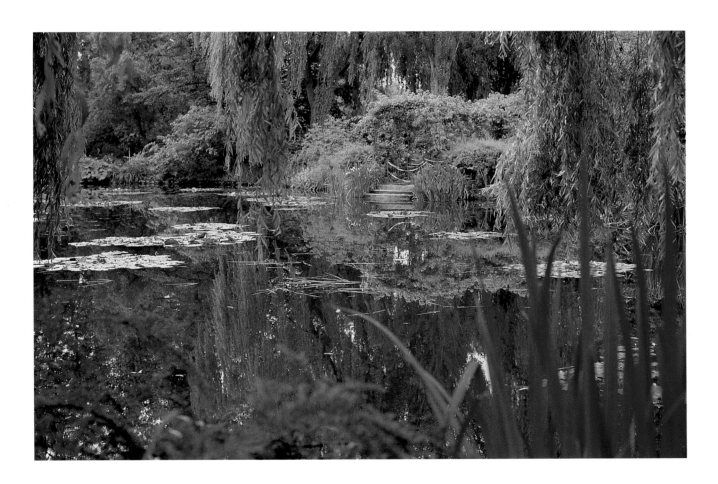

attention is paid to foliage contrasts, using leaf shapes, leaf texture and leaf colors for a restful visual experience. The skyline especially offers a visual feast of foliage colors and tree shapes: the dark green and spirelike habit of a spruce, the bronze of a mature copper beech and the silvery foliage of a poplar combine to create a tapestry with the soft, cloudlike form of weeping willows, as soothing to the senses as cushions of moss.

Leaf tunnels

An essential part of the visual thrill of walking around the pond is the sensation of entering a leafy tunnel. Some of these tunnels are low, dark and even eerie, overhung by thick arching bamboo canes and hemmed in by the huge velvety leaves of Japanese coltsfoot. In other areas trees are limbed high so the tunnel effect is more brightly lit and spacious, like entering the nave of a cathedral. At strategic intervals along the path a canopy of blossom is achieved from flowering trees like laburnum and vines like climbing roses.

The glory of the water garden today

After Gerald van der Kemp took charge of restoring Monet's garden, it was an enormous task to rescue the pond from many years of neglect. Muskrats had invaded the sides and it would not hold water, so steel pilings had to be driven all around the edge to make it virtually muskrat proof.

Today, even when the water garden is thronged with visitors, it is a magical place. The pond-side plantings help to veil the lines of people filing through, and the scale of the pond dwarfs human form. Gustave Geffroy summed up the glory of Monet's water garden when he wrote: "He discovered and demonstrated that … after traveling around the world worshiping the light that brightens it, he knew that the light came to be reflected with all its splendors and mysteries in the magical hollow [at Giverny] surrounded by the foliage of willows and bamboo, by flowering irises, through the mirror of water from which burst exotic flowers which seem more silent and protected than all the others."

Opposite: Rose arches above Monet's boat dock.

Right: The pond in early spring just as new waterlily foliage breaks the surface.

Following pages: When the waterlilies flower, the impression of a Japanese landscape is fully realised.

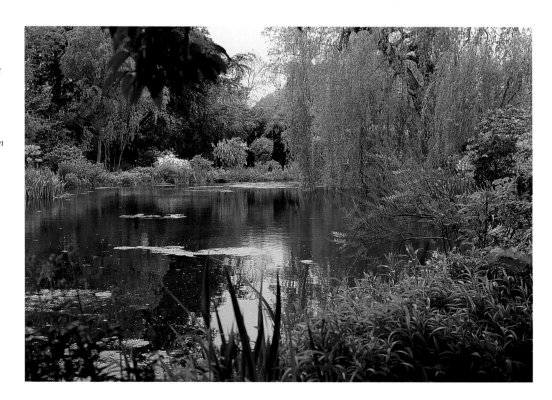

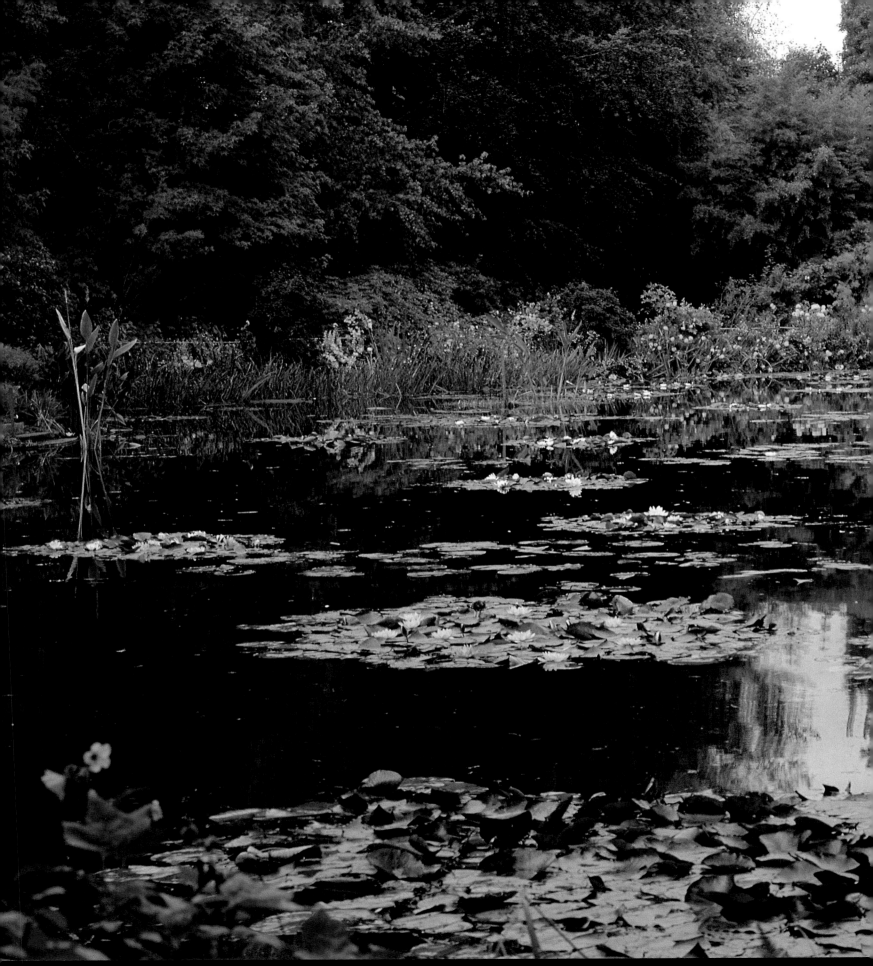

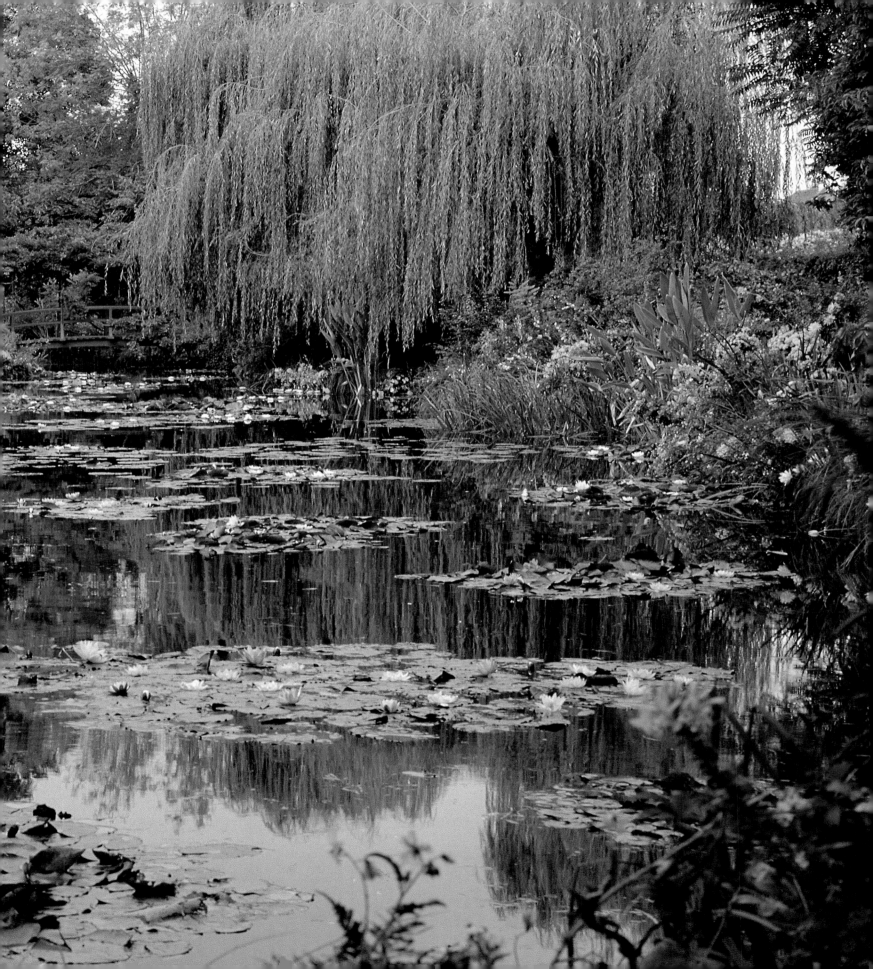

5
Monet's Favorite Plants

"Nasturtiums of all colors and saffron-colored eschscholzias collapse in blinding ruins on both sides of the sandy path. In the wide flowerbeds, covering the irises stripped of their blossoms, surges the surprising magic of the poppies, an extraordinary mixture of tones, an orgy of bright nuances, a resplendent and musical muddle of white, pink, yellow and mauve; an unbelievable kneading of blond flesh tones, on which the orange tones burst, the fanfares of burning copper ring out, the reds bleed and catch fire, the violet tones brighten, and the dark crimsons light up."

Octave Mirbeau, describing a visit to Monet's garden.

Monet was passionate about his garden. He wanted it to look beautiful, and he wanted it to look special. He treated the soil as a canvas on which to paint with flowers, and to create this masterpiece he used all the skills he learned as an Impressionist painter.

No plant was afforded space unless it had a special quality. It didn't matter if the plant was common or if it was scarce, he used both the familiar and unfamiliar. In his search for artistic merit, he would visit flower shows around Paris, also botanical gardens with test plots such as the Jardin des Plantes, in nearby Rouen, and he would visit specialist growers in England, Holland and France, especially cutting-edge plant breeders like Joseph Bory Latour-Marliac, the waterlily hybridizer.

Plant qualities that make Monet's garden unique

In particular, Monet sought flowering plants with a shimmering quality that set his garden apart. He was always seeking blue flowers to plant in shade, and all kinds of bicolored flowers, such as new bicolored tulips or bearded iris, since the bicoloration of two colors in proximity added to the painterly quality he wanted, as though his garden was a myriad brushstrokes in juxtaposition on a canvas.

He liked flowers with petals arranged like a daisy, for they twinkled when backlit like a galaxy of stars. He sought flowers with transparent petals, such as cosmos, so they glowed like Chinese lanterns when backlit. He wanted flowers with black centers like African daisies and sunflowers because the black acted like black stipple on a canvas. When he stepped into his garden and wandered its paths, as he usually did three times a day, he wanted to see color extended high above his head, and so plants like climbing nasturtiums and climbing roses were important. He also selected tall, tapering plants like gladiolus, hollyhock and foxgloves so that waist-level plantings could be connected to overhead floral displays, such as those provided by tall sunflowers. Climbers with delicate

Previous page: Bicolored pink and white tulips and blue forget-me-nots create a favorite Monet color harmony.

white flowers were especially desirable because these could produce the effect of a lace curtain when strung from high wires or overhead metal trellis, which is why he used lots of white wisteria, white fleece vine, white rambler roses and white montana clematis.

Flowers with a special satinlike sheen added to the garden's brilliance and shimmer, which is why he filled his mixed borders with Californian and Iceland poppies, and he was always on the lookout during country walks for wildflowers that could perk up his flamboyant hybrids. To ensure their continued presence, he collected seed of wayside corn poppies and ox-eye daisies to scatter randomly around his garden.

He sought plants with "see-through" qualities, like yellow patrinia and pink or red penstemon, because these wispy flowerheads can veil solid plantings. He avoided plants that presented a mass of white, like white peonies and white rhododendron, for he considered these so white-hot they made vacuous holes in the landscape.

Flowers with fragrance commanded his attention, for he liked his house to be filled with sweet-scented arrangements. He liked the fragrance of peonies so much he grew them in his vegetable garden as hedges around plots of cabbage, lettuce and melons. The costly gardenia-scented auratum lily he grew in pots close to his porch for the beauty of its flower and also its uplifting aroma.

Today's criteria for plant selection

Monsieur Gilbert Vahé, head gardener since the property at Giverny was restored, explained the Monet Foundation's planting policy as follows:

As far as possible we plant varieties which Monet himself cultivated, such as the roses 'Mermaid' (1918) and 'Belle Vichysoise' (1887), also the waterlilies 'Atropurpurea,' 'James Brydon' and 'William Falconer' from the Latour-Marliac nursery, near Bordeaux, and *Helianthus maximilianii,* a perennial sunflower from Texas that flowers in autumn. However, some varieties have been superseded by others offering improved blooms or longer flowering. Moreover, we know

that Monet frequently visited nurseries and progressive seed companies, inspecting their test plots for new varieties. For example, the rose 'American Pillar' ('*Pilier americain*' in French), is an American introduction which he might have discovered in the test garden at the Bagatelle Rose Garden, Bois de Boulogne.

In turn we constantly aim to reintroduce the exact varieties used by Monet. Our principal design objective is to faithfully recreate his harmonies of color and the shimmering effect which defines his garden.

Dominant plants in Monet's garden

Following are descriptions of the dominant plants in Monet's garden, and the special benefits he saw in them.

Apples

(*Malus pumila* and other species) Monet had a 2 acre (0.8 ha) fruit and vegetable garden that was located at the other end of the village, on a property he called the Blue House, because the stucco walls of its dwelling were painted blue (and still are). It had its own gardener, and was surrounded by a high stone wall. On the inside, against the walls to save space, he grew espaliered fruit trees, notably apples, pears, peaches and plums. He also trained pears up trellis against the garden wall, and he grew apples ornamentally, as cordons (ropes).

The cordon is a form of espalier, whereby the trunk of the apple tree is topped about 4 feet (1.2 m) from the ground, and a pair of side branches allowed to grow horizontally at the top. Next to it, at a distance of 6 feet (2 m), a shorter trunk is topped at 2 feet (60 cm), with its pair of side branches forming a second level. With the heights alternating, and the outstretched limbs allowed to overlap, the espaliered apples form a double row of "ropes" resembling fence rails. These flower in spring and fruit in autumn. The result is a decorative type of fence that's also functional because loads of apples are produced all along the branches in far less space than a normal apple tree requires.

Apple varieties featured in the Clos Normand today include French heritage types, such as 'Bennet', 'Royal Russett' and 'King of the Pippins', but there are

Above: Apples trained to form a fence.

also varieties introduced since Monet's death, including 'Golden Delicious' and the late ripening, tart-sweet variety 'Granny Smith'. The apples are harvested when ripe and stored in the cellar for consumption by the staff during autumn and winter.

The famous French heritage pear variety 'Comice', with pale green skin and juicy, aromatic, crisp white flesh, is trained against the wall that screens the property from the street. Also, a vigorous fig tree in a sunny, sheltered area of the poultry yard bears luscious fruit in late summer.

Apples and pears are hardy in zones 3–8, depending on variety.

Asters

(*Aster* spp.) The hardy perennial New England aster (*Aster novae-angliae*) is an important part of Monet's late summer and early autumn flower display both in the Clos Normand and along the margin of his pond in the water garden. In the Clos Normand tall purple varieties line his Grande Allée in company with yellow perennial sunflowers to create a pleasing yellow-and-purple color combination. In the water garden the smaller-flowered pale pink heath aster (*Aster ericoides*) forms clouds of bloom along the stroll path, the airy flower display reminiscent of mist.

The New England aster has been crossed with the New York aster (*Aster novi-belgii*) to produce a mixture of mostly red, pink, blue, purple and white, known as 'Michaelmas' daisies, and at Giverny it is planted liberally in mixed colors. Asters are propagated from cuttings and by dividing the roots. Hardy in zones 5–9.

Aubrieta

(*Aubrieta deltoidea*) Commonly called rock cress, this hardy perennial forms a cushion of four-petaled pink flowers in early spring just 6 inches (15 cm) high and twice as wide. Its velvety gray-green leaves are attractive even when the flowers have faded. Monet edged all his mixed borders in aubrieta, allowing it to spill into his gravel paths to soften the straight lines. In addition

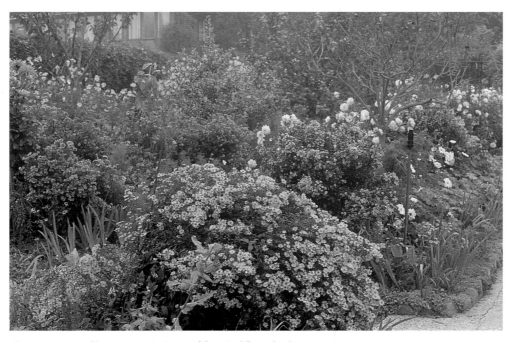

Above: Asters muted by autumn mist in one of the mixed flower borders.

to pink there is a white and a purple variety, but it is the deep pink that he grew exclusively as an edging. Propagate by division of established clumps; also easily raised from seed sown in summer of the previous flowering season. Hardy zones 4–8.

Bamboo

(*Phyllostachys* spp.) "A sizeable planting of bamboo emphasizes this oriental effect," wrote Georges Truffaut about the water garden. "These bamboos have become as big as trees, 21 to 24 feet (6.4 to 7.3 m) high, and form a dense colony where the artist has cleverly selected his most beautiful views."

In order to create a Japanese aura in his water garden, Monet used several kinds of hardy bamboo, including a dwarf, ground-hugging type, *Pleibolastus pygmaeus*; but *Phyllostachys aureosulcata*, the variety commonly called yellow groove bamboo, is the one that dominates the garden today. There are basically two types of bamboo — clump-forming and spreading. The clump-forming kinds are generally well behaved, growing slowly in an ever-widening circle. The more aggressive, spreading kinds radiate tough runners that can extend several feet (up to a meter) in a single season. They send up sprouts at 6 inch (15 cm) intervals and suffocate anything in their path. Yellow groove bamboo is an aggressive spreading kind and so it is confined to a corner of the pond beside the bridge where it can be controlled. Growing to 12 feet (4 m) high, it screens the water garden from an adjacent meadow. Though mostly green-stemmed with slender yellow horizontal stripes, the species is highly variable, sometimes having all green stems and in other selections all yellow.

Bamboo is evergreen and demands a sunny exposure. Though yellow groove thrives besides streams and ponds, it does not like its roots permanently wet. Monet also featured the hardy, decorative, black-stemmed bamboo, *P. nigra*, growing it in containers near the house to control its invasiveness.

Propagate yellow groove bamboo from any runner segment with a root mass. Hardy zones 5–8.

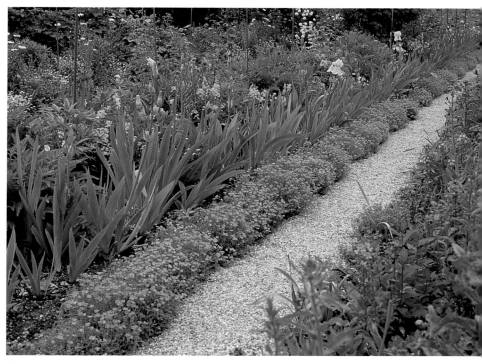

Above: Aubrieta used as an edging.

Above: Bamboo beside the Japanese bridge.

Bluebells, Spanish

(*Hyacinthoides hispanica*) Monet favored the Spanish bluebell over the English bluebell for shady parts of his garden because the Spanish type is more conspicuous, growing larger bells and more of them, on flower clusters held erect, up to 12 inches (30 cm) high. In Monet's water garden they are massed in lightly shaded woodland and beneath pink azaleas. They are also combined with pink English daisies and purple violas in the mixed flower borders of the Clos Normand.

Bluebells are best planted as bulbs in autumn to flower the following spring. Hardy zones 6–8.

Cherries, Japanese

(*Prunus* spp.) Monet liked Japanese flowering cherry trees for the same reason he liked crabapples — the avalanche of pale pink blossoms produced in early spring at the same time as his daffodils and tulips. They reminded him of orchards in bloom and contributed to his garden's shimmer. Several kinds of flowering cherry are strategically placed in the mixed flower borders of the Clos Normand, including the column-shaped 'Amanogawa' from the Sato-zakura group. This grows to 30 feet (9 m) and has white to shell-pink pom-pom flowers. Along the stroll path of the water garden, and along the stream that feeds and skirts the pond, the predominant cherry is *Prunus subhirtella* 'Pendula', the Japanese weeping cherry. Though ornamental cherries will grow to 60 feet (20 m) high, they can be kept more compact by pruning. Hardy zones 5–8.

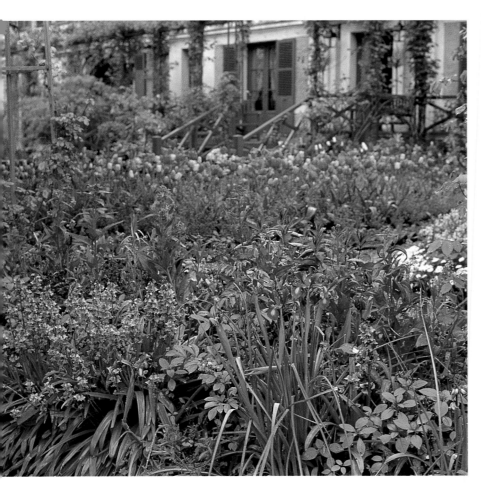

Above: Spanish bluebells in a mixed border.

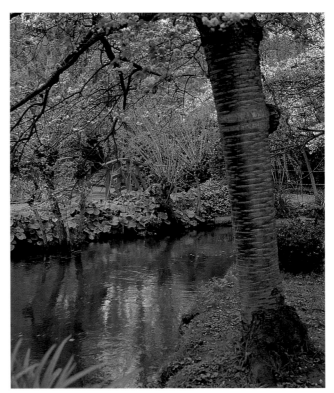

Above: Weeping Japanese cherry in the water garden.

Clematis

(*Clematis* spp. and hybrids) Though clematis is a large plant family containing both herbaceous and woody types, it is the vining kind known as *Clematis montana* that Monet treasured, using three color selections — 'Alba' (white), 'Rubens' (pink) and 'Rosea' (deep pink). Native to the Himalayan mountains, the hardy plants are fast-growing to 25 feet (8 m) high. At Giverny they are trained along overhead metal trellises to drape their blooms from 10 feet (3 m) above the ground. Flowering in early May, at the same time as the mixed beds of tulips, Dutch irises and wallflowers, the clematis are invaluable for creating Monet's lace-curtain effect, and an essential part of the garden's shimmering appearance.

Other later-flowering varieties of clematis, such as purple 'Jackmanii' and the bicolored white and pink 'Nelly Moser', Monet planted with climbing roses so the two entwined their colors. In particular, purple 'Jackmanii' partnered with orange *Rosa* 'Westerland', and 'Nelly Moser' clematis partnered with *Rosa* 'Paul's Scarlet', make strong color contrasts.

Clematis like their heads in the sun and their roots to be shaded. In Monet's garden, where summers can be hot, the gardeners place curved clay tiles over the roots to help keep the soil cool. Hardy zones 4–10, depending on variety.

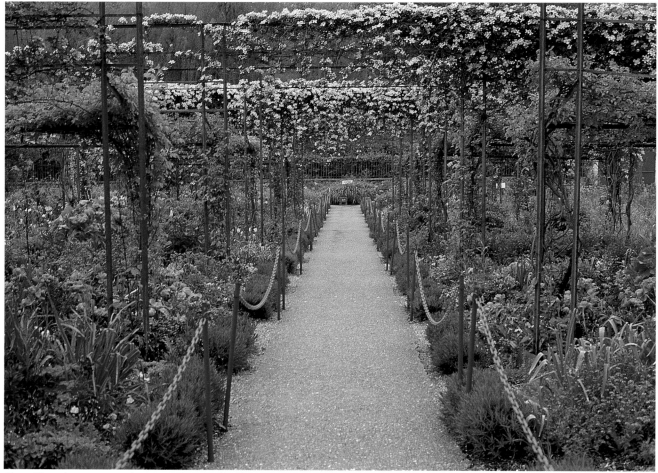

Above: Clematis montana *used to create a lace-curtain effect.*

Coltsfoot, Japanese

(*Petasites japonicus*) Monet planted coltsfoot (also known as butterbur and prized for its huge, heart-shaped, velvety leaves) mostly around his stroll path through the water garden. Even when out of bloom, the leaves contribute an ornamental effect. Japanese coltsfoot has curious lime-green, daisylike flowers that form a cone and bloom before the leaves emerge from dormancy in spring. The leaves measure up to 3 feet (1 m) across but need siting in light shade, as they wilt in full sun. Colonies are planted around the pond margin to contrast with the arching, sword-shaped leaves of daylilies and the spiky foliage of water iris. Hardy zones 5–10.

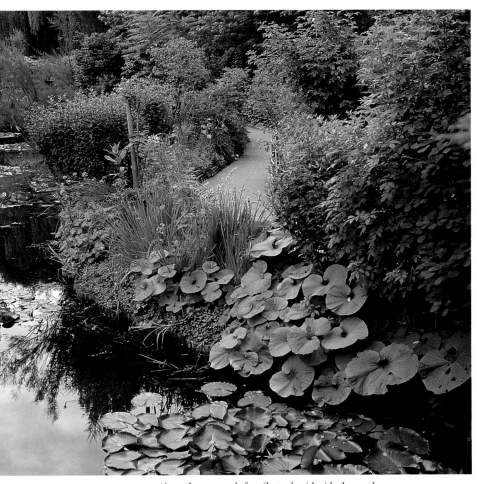

Above: Japanese coltsfoot (butterbur) beside the pond.

Cosmos

(*Cosmos* spp.) Two kinds of cosmos are used extensively in Monet's garden, particularly in the mixed borders during summer and autumn. They are *Cosmos bipinnatus* 'Sensation', a mixture rich in shades of red and pink, plus white, and *C. sulphureus* 'Bright Lights', in mostly shades of yellow and orange. Both are annuals and bloom continuously from midsummer until autumn frost. The former tends to grow tall, up to 5 feet (1.7 m) high, holding its translucent, daisylike flowers to face the sun. When the flowers are viewed from the back, against the sun, the petals appear to shine brilliantly, so the blooms seem to twinkle like a galaxy of stars, adding to the garden's Impressionist shimmer.

The red, pink and white cosmos are interplanted among taller double-flowered hybrid dahlias. These dinner-plate sized dahlias add a strong purity of color (especially pink, red and orange), but since they lack any translucent quality, they provide a perfect background for the glimmering cosmos.

Two other important cosmos varieties in the mixed borders are *C. bipinnatus* 'Seashells', a red, pink and white mixture that has bicolored, fluted petals, and the bicolored 'Candy Stripe'. The latter's white petals are flecked with pink and red as though an artist has taken a paintbrush and streaked them.

The 'Bright Lights' cosmos are lower growing, and many are double flowered. Mostly they are planted among yellow sunflowers, orange black-eyed Susans and golden marigolds to produce a dramatic hot-color harmony in the mixed borders. Grown as annuals, cosmos thrive in all zones.

Crabapples

(*Malus floribunda*) A handsome specimen of this beautiful flowering crabapple from Japan, planted by Monet in front of his house, is now 20 feet (8 m) high, with snaking branches. When it blooms in early spring it produces a profuse display of white blossom, tinted pink.

At the time Monet lived there, the village of Giverny was surrounded by apple orchards. When these

Above: Cosmos 'Candy Stripe'.

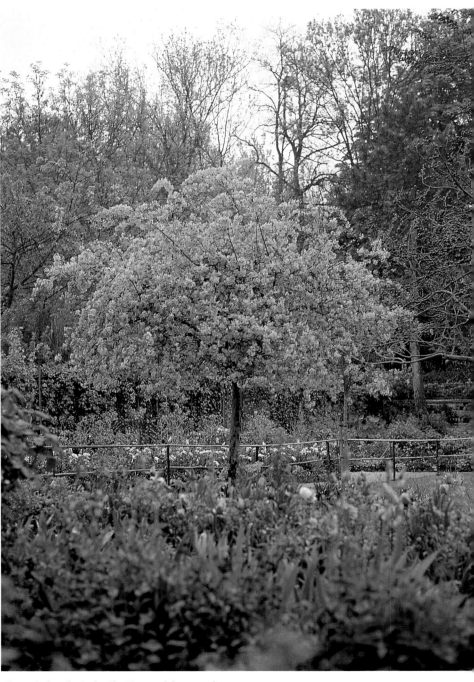

bloomed in April they covered the hillsides with a blizzard of white and pale pink blossoms, which he liked to paint. To intensify the floral extravaganza in his garden, especially to enhance its shimmering effect, he chose pink and white crabapples. They are more floriferous than the domesticated apple and produce mostly small red or yellow apples that are relished by birds.

Other spring-flowering trees that bloom with the crabapples include the Judas tree or redbud (*Cercis* spp.), with rosy-red, pea-shaped flowers, and Japanese ornamental cherries (see page 100).

Growing to 40 feet (12 m) high unless pruned to keep them compact, crabapples are easy to grow trees mostly planted as accents along the mixed borders. Hardy zones 4–8.

Above: Crabapples in the Clos Normand flower garden.

Daffodils

(*Narcissus* hybrids) Though snowdrops and hellebores are the first flowers of spring in Monet's garden, planted around the margin of his pond, each season it is daffodils that provide the first big splash of floral color. He painted a meadow of naturalized daffodils near Giverny and introduced the same informal effect in his garden by planting drifts of daffodils through turf in two sections of lawn on either side of the Grande Allée. These are planted in autumn by peeling back the grass, and placing daffodil bulbs 6 inches (15 cm) deep in a ditch of loose soil. When the turf is rolled back into place over the bulbs they have sufficient strength to push

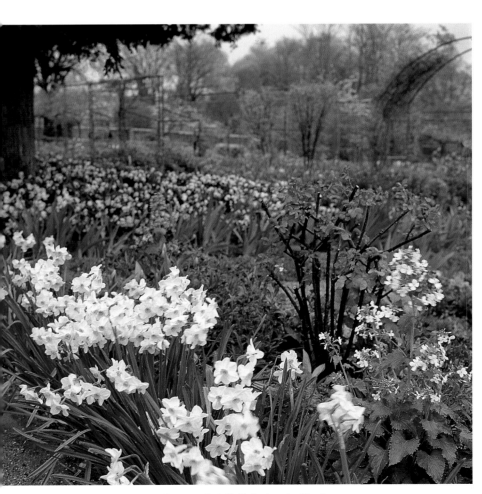

Above: Poet's daffodils in the mixed borders.

their leaves and flower stems through the grass, to flower year after year. After the daffodils fade the gardeners take care to avoid cutting their leaves for a period of 10 weeks to ensure that each bulb is rejuvenated.

Broad brushstrokes of daffodils are planted along the stroll path in the water garden, and as an edging to some of the mixed borders in the Clos Normand.

Garden writer Georges Truffaut, reporting in *Jardinage*, remarked on the profusion of daffodils in spring at Giverny, especially the large yellow trumpet kinds and the more diminutive, fragrant, cluster-flowered "poet's" daffodils. Early, mid-season and late flowering daffodils allow a succession of bloom from mid-April, when the garden opens for the season, until early May. Many are chosen for their heavy fragrance. Among the early bloomers are 'Ice Follies' (white with yellow cup that fades to white), 'Professor Einstein' (a white with flat orange cup) and several kinds of large trumpet daffodils, such as 'Unsurpassable' and 'Bestseller'. Later blooming are 'Geranium', a highly fragrant cluster-flowered white and orange, and 'Actaea', a white with small red cup resembling a bull's-eye. Hardy zones 4–10, depending on variety.

Dahlias

(*Dahlia* hybrids) "The dahlias are stars that tremble and twinkle atop fragile branching stems … the air is filled with so much glimmering, so much quivering," wrote Octave Mirbeau in 1891 following a late-summer visit to Monet's garden. These dahlia crosses between species native to Mexico are the scene stealers in Monet's late-summer and early-autumn display. For brilliancy and purity of color, few flowers can match them. Tall kinds tower high above the mixed borders, mingling their dazzling, flamboyant blooms with those of climbing roses. Both single-flowered kinds, such as 'Bishop of Llandaff', with bronze foliage and crimson flowers, and double dinner-plate kinds, such as 'Red Majorette', with quilled, fire-engine red petals, are prominent. The bronze foliage of 'Bishop of Llandaff', and dark maroon flowers of 'Nuit d'Eté' produce the illusion of shade in full sun. The contrast of sunlight and shadow is usually

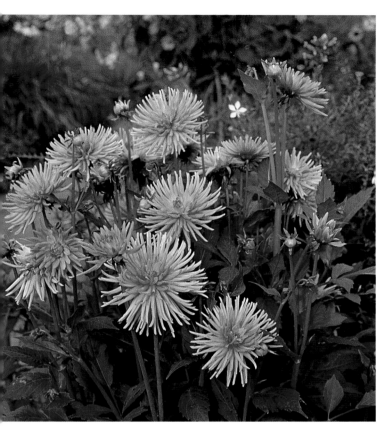

Above: Cactus-flowered dahlias in a mixed border.

Daisies, English

(*Bellis perennis*) These are rich in reds and pinks, in addition to white. Monet used mostly the pink and red daisies as an edging and also as an underplanting to pink tulips in the island beds below his front porch. Though the flowers individually are small, they cluster together to form a colorful cushion. English daisies are biennials best grown from seed started in summer of the season prior to flowering and transplanted to flowering positions in autumn or in a ready-bloom stage in early spring. They are tolerant of frost and bloom until the end of spring at the same time as pansies. Give them full sun or light shade. Hardy zones 4–10.

a feature of Monet's Impressionist paintings, and so the deliberate scattering of bronze foliage or darkly colored flowers was an extension of his painting technique.

Dahlias from the Collarette group are planted throughout the mixed borders, and usually grow to 6 feet (2 m) high by late summer. The bicolored, daisylike blooms have an outer circle of flat petals overlapped by a ring of smaller fluted petals around a yellow crown of anthers. They seem to radiate energy, as though the flowerhead is an explosion of color.

Dahlias are tender to frost and will not tolerate frozen or prolonged cold, wet soil. They are best planted from tuberous roots in spring, and lifted in autumn after frost kills the top growth, for storage in a dark, frost-free area. They grow quickly from a spring planting, and flower nonstop more prolifically when faded flowers are picked. Hardy zones 8–10.

Above: English daisies underplanted among tulips.

Daisies, ox-eye

(*Chrysanthemum leucanthemum*) Daisies are part of the world's largest plant family, known as Compositae. Most have a flower form where slender, oval, symmetrical petals surround a contrasting eye, which can be yellow, black, green or brown. The hardy perennial white ox-eye daisy with golden yellow button center, from meadows and waysides around Giverny, helped to make Monet's garden special by not only adding to the garden's shimmer in late spring, but also brightening the bold colors of his hybrids, particularly his bearded irises and peonies. Also known as *Leucanthemum vulgare*, ox-eye daisies have been hybridized to produce the larger-flowered shasta daisy, but for Monet's purpose the perky ox-eye was more highly valued.

Other daisy plants used in the mixed borders include blue asters, yellow black-eyed Susans, pink cosmos, red dahlias and orange sunflowers. Ox-eye daisies are hardy from zones 3–9.

Dame's rocket

(*Hesperis matronalis*) This hardy biennial resembles pink or white phlox, though it is the white that Monet planted liberally throughout the mixed borders to produce the Impressionist shimmer. It adds generous flecks of white to bolder colors of peonies, Oriental poppies and bearded irises. Dame's rocket also helps bridge the gap between waist-high irises and tall tree-form roses. Planted among blue bearded irises and pink peonies, it helps produce the pink-blue-white color combination Monet liked because it reminded him of colors he encountered along the Mediterranean.

Dame's rocket can be direct-seeded into bare soil the year before flowering, or it can be transplanted into

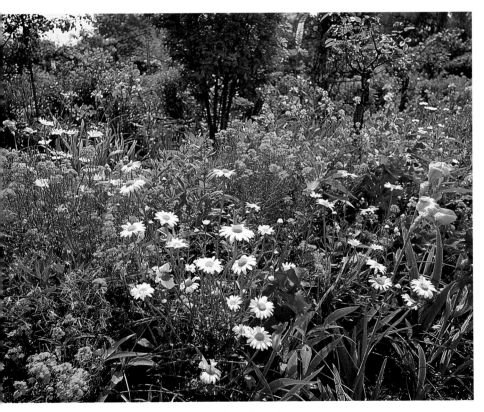

Above: Ox-eye daisies in a mixed border.

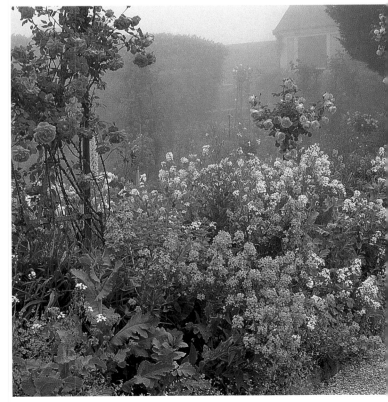

Above: Dame's rocket along the Grande Allée.

final positions in summer for flowering the next spring. Hardy zones 3–10.

Daylily

(*Hemerocallis* hybrids) There are now thousands of daylily hybrids in an extensive color range that includes bicolors and tricolors; however, the breeding frenzy among daylily growers did not begin until after Monet's death, so the artist's garden today is mostly planted with the hardy perennial wayside daylily that produces orange, trumpet-shaped flowers in early summer. Clumps of these are planted in full sun at the bottom of the Clos Normand in the company of pink tree roses, and also along the lightly shaded pond and stream banks in his water garden. Here fountains of slender, sword-shaped leaf blades arch out and touch the water. These look decorative even when the plants are not in bloom, especially when partnered with the broad leaves of Japanese coltsfoot or hostas.

Given the color range available today, one wonders what color magic Monet would have worked with modern daylilies. Undoubtedly he would have collected them like he collected bearded irises, and probably he would have chosen clear colors and bicolors to produce a polychromatic mixture to follow on from his bearded irises. The new mahogany tones in particular are the type of dark color Monet desired for his mixed flower borders to add a shading effect to a garden in full sun.

Propagate daylilies by root division at any time of the year. Plants tolerate poor soil as long it has good drainage. Though the leafy clumps grow little more than 3 feet (1 m) high, the flower stems can extend to 5 feet (1.7 m). Hardy zones 4–10.

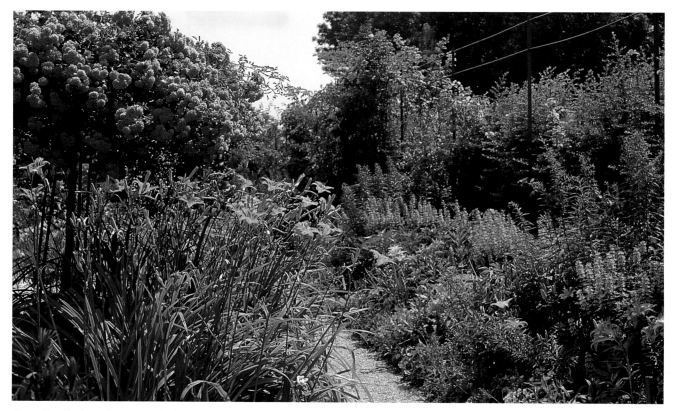

Above: Daylilies beneath a rose standard.

Delphinium

(*Delphinium elatum*) and larkspur (*Consolida* spp.)
There is a wonderful archive photograph of Monet
proudly standing before a mass planting of delphiniums,
the tall stems towering well above his head. He grew
them for cutting, but today the gardeners are more
likely to mix blue and white delphiniums among other
flowering plants in the mixed borders.

Though classified as a hardy perennial,
delphiniums are mostly grown as biennials, the plants
set out in position in late summer for blooming the
following summer, or in early spring for flowering
later that summer. They are greedy feeders, and require
cool nights to form their solid spikes, which are mostly
shades of blue, but also white and pink. The floret of
a delphinium is generally made up of a circle of outer
petals and a circle of smaller petals at the center, known
as a "bee." The bee can be black or white and, judging
from the archive photograph, Monet preferred them
black. Though delphiniums are reportedly hardy from

zones 3–9, plant losses can occur from alternate
thawing and freezing. An application of mulch to keep
the ground frozen will reduce losses.

Similar in appearance to delphinium, but
with more slender flower spikes, is annual larkspur
(*Consolida ajacis* syn. *C. ambigua*). Larkspur is much
easier to grow than delphinium, and best sown
directly where the plants are to bloom. Gardeners at
Giverny scatter seed liberally among the mixed flower
borders in late summer and early spring. From a
late-summer sowing the seed germinates and quickly
forms a crown of leaves, then the plant goes dormant
during winter to flower extra early the following
spring. They are especially beautiful partnered with
red and pink corn poppies (*Papaver rhoeas*). White
larkspur used alone produces a charming shimmering
effect, while the blue and the pink are used in cool-
color harmonies.

Both delphinium and larkspurs make beautiful
arrangements, with their strong, wiry stems fanning
out in a vase to create an instant bouquet.

Above: Delphinium with black bees.

Forget-me-not

(*Myosotis sylvatica*) Blue was Monet's favorite color.
His paintings of blue skies and blue water are among
his most popular images. He even used blue to paint
shadows in woodland and meadows. Blue flowers
feature extensively in shady parts of his water garden,
and also in sunny parts of the Clos Normand. In sun
and shade blue is usually partnered with pink and
white, or with yellow and orange to create the "gold
and sapphire of an artist's dreams."

Other species of forget-me-not are widely
available, but generally they do not have the vigor of
selections of *Myosotis sylvatica,* which is a biennial.
Plants are best grown from seed sown the previous
summer, and transplanted into flowering positions in
autumn or early spring. Plants also readily self-seed
into bare soil to come back year after year.

The blue of forget-me-nots is like no other flower
in nature. Healthy plants produce a network of stems
with tiny blue flowers that bloom above the slender

green leaves like a billowing cloud. From a distance a drift of forget-me-nots resembles mist.

At Giverny the most striking use of forget-me-nots is in early spring in the island beds close to the house, where blue forget-me-nots are massed beneath tall pink tulips to create what appears to be a ground mist and a stunning pink and blue color harmony. Today this mistiness is not only achieved with blue forget-me-nots, but also pink and white color selections. The plants start to flower in early spring when daffodils bloom, and continue until midsummer. Hardy zones 5–10.

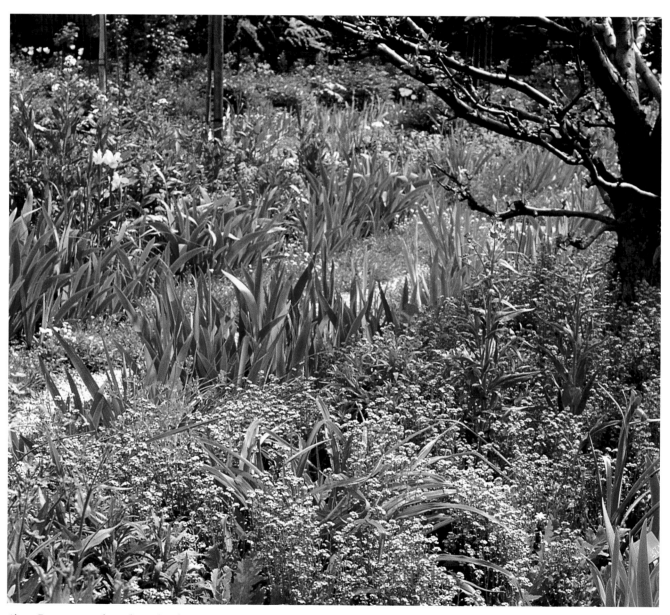

Above: Forget-me-nots beneath a crabapple.

Foxglove

(*Digitalis purpurea*) Throughout Europe, foxgloves are prolific wayside wildflowers, seeding into bare soil. They are biennials, producing a rosette of leaves the first year and flowering in spring. Though foxgloves have been hybridized to create large flower spikes in white, pink, purple and apricot, both the common purple foxglove and the more flamboyant Excelsior Hybrids are seen throughout the Clos Normand and the water garden in sunny and lightly shaded places. Growing to 5 feet (1.7 m) high, the tapering spikes tower above bearded iris in the mixed borders. The wild kinds, especially, bring a touch of the countryside into the garden.

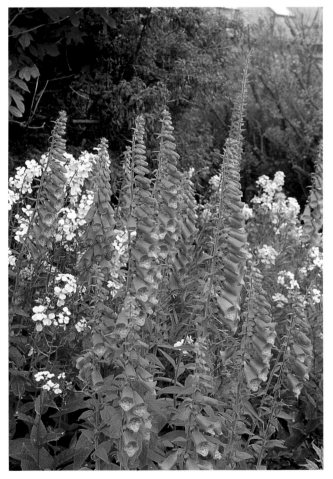

Above: Foxgloves planted in shade.

Foxgloves are also partnered with pink Canterbury bells (*Campanula medium*), red valerian and silvery lamb's ears to make a charming pink, red and silver color harmony. Hardy zones 4–9.

Foxtail lily

(*Eremurus* spp. and hybrids) This tall, tapering plant is a desert flower from Afghanistan. Its pokerlike flower stem is clustered with hundreds of star-shaped florets, rising from a rosette of spiky blue-green leaves. Mostly available in white and yellow, they are also offered in hybrid mixtures that include orange, pink, apricot and lemon in the color range. Though a hardy perennial that is best planted from dormant roots in autumn to flower the following spring, foxtail lilies can be temperamental unless their fleshy roots are given sharp drainage. To ensure this, the gardeners at Giverny today create special gravel pits to accommodate groups of foxtail lilies. Monet particularly cherished the white because the flower spikes mingled with his climbing roses and added to the shimmering effect of his garden, as they do today.

Foxtail lilies are valued for floral arrangements, especially the mixture known as Spring Valley hybrids, propagated in Idaho by Ken Romwell, a cut-flower grower. His selection is generally more vigorous and the color selection more varied than older mixtures, such as Shelford Hybrids.

Geraniums and pelargoniums

(*Pelargonium* x *hortorum*, *Geranium* spp.) Monet grew what were then known as "zonal geraniums," which are hybrids of species native to South Africa, so called because their ivy-shaped, ruffled green leaves have a brown, horseshoe-shaped zone around the leaf margin. He massed the red and the pink in three island beds along the length of his house facing the garden. Many visitors today wonder why Monet would bother with such a common bedding plant, used extensively in French parks. Several qualities endeared these plants to him. First, the uniformity of height ensured a carpet effect. Also, the velvet-textured leaves provide a luxurious green contrast to the red and the pink. A

Above: Spires of foxtail lilies along the Grande Allée.

bonus is their long-lasting bloom period, from early summer to autumn frost. In order to make these mass plantings more interesting, Monet spaced pink tree-form rose standards in a line down the middle of the beds, and edged the beds with a perennial dianthus with silvery leaves. This produces a striking color harmony involving red and pink contrasting with green and silver, the pink of the geraniums heightened by the pink house façade.

Since bedding geraniums, now correctly called pelargoniums, are mostly grown as annuals, they are suitable for all zones.

Hardy perennial geraniums (*Geranium* spp.), commonly called cranesbill, are also planted extensively throughout Monet's mixed borders, notably *G. psilostemon*, a magenta with black eye. Hardy zones 6–9.

Above: Pelargoniums (bedding geraniums) in island beds.

Gladiolus

(*Gladiolus* hybrids) These tender perennials grow from bulbs that are generally planted in spring to flower in midsummer. They have tall flower stems studded with ruffled flowers and they form a spike. The satinlike brilliance of the flared petals caused Monet to grow dozens of varieties in his mixed borders to carry color above waist height, and also he massed them as a mixture in order to produce cut flowers for the house. He liked the way a mass of stems can be clumped in a vase, to splay out naturally and form a fan.

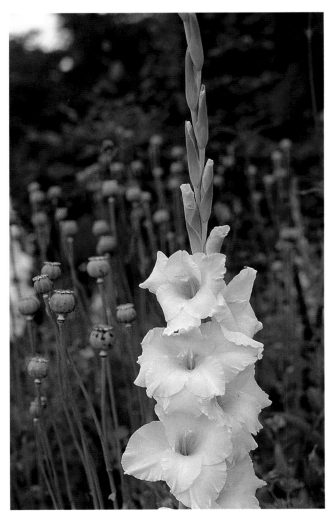

Above: Gladiolus among poppy seed heads.

Gladiolus are rich in solid colors, including all shades of red, pink, yellow, orange, blue, purple and green, plus white. Many are bicolored and even tricolored, adding greatly to the twinkling and shimmering effect of Monet's mixed borders.

To survive winters where the ground freezes, gladiolus need to be lifted after autumn frost and stored in a dark, frost-free place, for replanting in spring. Hardy zones 9–11; all zones as an annual.

Hogweed, giant

(*Heracleum mantegazzianum*) When Monet began to plant around the edges of his pond he preferred to tone down the color and strive for a more tranquil effect than existed in his sunny, shimmering Clos Normand. He therefore sought foliage contrasts — not just different degrees of green, but also leaves that are bronze, and particularly leaves with interesting shapes or textures.

Though giant hogweed is considered an invasive plant in many temperate areas of the world, especially in boggy soil, Monet liked to plant this species for its huge indented leaves and the massive, umbrellalike white flower it bears atop an 8 foot (2.5 m) high stalk. Be warned, however, that the sap of giant hogweed can cause a nasty rash. As soon as the flowerhead is formed and it starts to set seed, it is best to cut it down and destroy because it may self-seed aggressively. Only a few plants are ever needed to produce a dramatic accent in the garden. Hardy zones 3–9.

Hollyhock

(*Alcea rosea*) As you walk through Monet's garden today you will see color carried high above eye level, mostly from flowering vines trained to grow up trellis and spread horizontally, and also from tall, spirelike plants to connect low-growing flowers with the overhead floral curtain. Hollyhocks, with their strong, erect stems studded with cup-shaped flowers, are a favorite tall plant to achieve this transition. Flowering in midsummer in mostly red, pink, yellow, apricot, purple, maroon, plus white, hollyhocks can be single-

Above: Giant hogweed beside the pond.

Above: Hollyhocks in one of the mixed borders.

flowered, or double-flowered like a pom-pom. Of the two kinds, Monet preferred the old-fashioned singles because their satinlike petals are transparent when backlit, and this added to his garden's shimmering effect.

In fertile soil hollyhocks can grow to 10 feet (3 m) tall, and though they are considered hardy perennials, they are best treated as biennials, started from seed in summer. Husky transplants can be placed into flowering positions in late summer or early autumn to overwinter and flower the following season. Hardy zones 3–10.

Hydrangea

(*Hydrangea macrophylla*) The mophead hydrangea from northeast Africa is grown throughout France, especially along the Normandy and Britanny coasts where it forms a billowing shrub crowded with large round flower heads in all shades of blue, red, purple and pink, plus white. Usually the flower color can be controlled by soil acidity — a heavily acid soil produces blue flowers and an alkaline soil produces pink. Monet grew hydrangeas along the margin of his water garden, in the shade of weeping willows, and also in containers close to his porch, where they can be seen today, making a bold

summer display. They are long-lasting in bloom. After the petal color fades the flowerhead turns papery and will dry, remaining ornamental even into winter months. Give them good drainage and a fertile soil. Hardy zones 5–11.

Impatiens

(*Impatiens* spp.) Commonly called patience plant, several kinds of annual impatiens are used throughout Monet's garden in shady areas of the Clos Normand and the water garden, including the common bedding impatiens or busy Lizzy (*Impatiens walleriana*) and balsam (*I. balsamina*), in mostly pink and red. However, it is the less familiar species, *I. balfourii*, that is planted more abundantly because it contributes to the Impressionist shimmer. Growing to 3 to 4 feet (1 to 1.5 m) high, it has a cloudlike habit, with numerous pink and white nodding flowers that seem to twinkle. The plants bloom continuously all summer until autumn frost.

Impatiens are grown as tender annuals best started from seed 10 weeks before they are transplanted to their outdoor flowering positions. Hardy in all zones as an annual.

Above: Mophead hydrangeas beneath a weeping willow in the water garden.

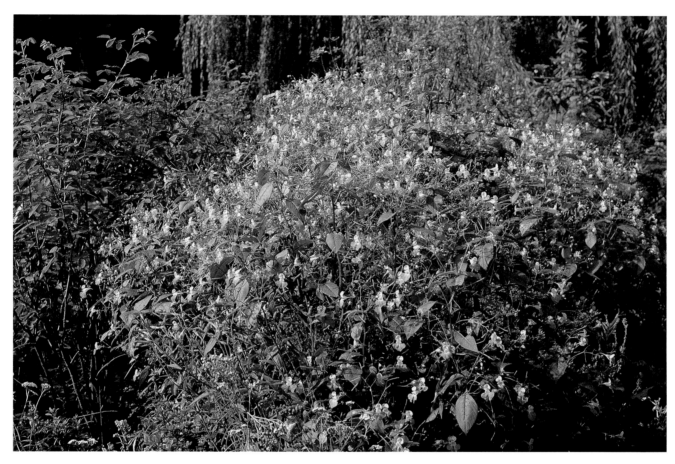

Above: Impatiens balfourii *has flowers that seem to twinkle.*

Iris, bearded

(*Iris* x *germanica*) The most prolific iris in Monet's garden is the bearded iris (also known as German iris), since Monet collected them. He visited specialist iris breeders in France, Holland and England, and acquired the latest hybrids, especially blues, and also any irises that displayed two colors in their flower form. Monet once wrote to Caillebotte: "Don't forget to come on Monday, as arranged; all my irises will be in flower, later they will be faded."

Bearded iris are composed of upward-facing petals called "standards" and downward-facing, broader petals called "falls." In bicolors the falls can be two colors, such as a white center and a blue petal edge that matches the standards; or the standards can be a different color from the falls. For example, in the award-winning iris 'Edith Wolford', the standards are yellow and the falls are blue — one of Monet's favorite color combinations. An added decorative element is the "beard," a cluster of stamens that can be yellow or orange, depending on variety.

In addition to grouping blue and purple iris together for a monochromatic border, he planted white iris in his mixed borders to produce the Impressionist shimmer. Also, he made rainbow borders, or polychromatic color harmonies, using every imaginable iris color — not only all shades of blue and yellow, but also red, orange, ginger, black and even green.

Since bearded irises like full sun, these are mostly confined to the Clos Normand. Unlike many other kinds

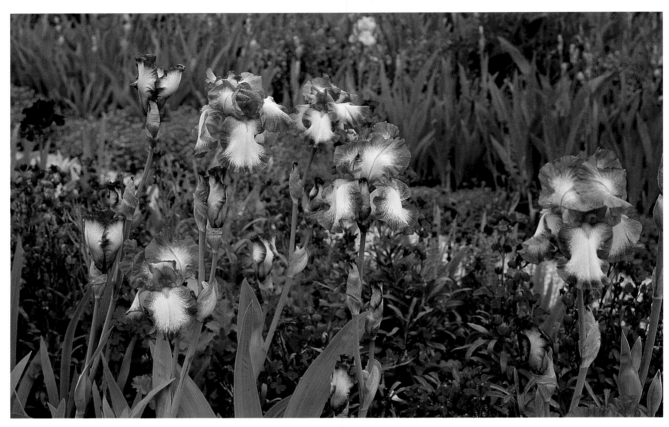

Above: Bearded iris, showing bicoloration, that Monet admired.

of iris, they also like good drainage, and are best planted
from rhizomes dug after flowering and planted into
flowering positions in late summer or early autumn.
Usually a minimum of four groups of leaves per
rhizome (called fans) are preferred in order to flower
the following spring season. Monet's irises are divided in
September and replanted 12 inches (30 cm) apart. Some
are left undisturbed for seven years. Hardy zones 5–9.

Iris, Dutch
(*Iris* x *hollandica*) Blooming in early spring, at the
same time as tulips, colonies of Dutch iris serve
several purposes in the Clos Normand. Mostly
available in blue, yellow, bronze and white, they are
massed to create pools of blue close to yellow Siberian
wallflowers. The whites are planted throughout the
mixed borders to produce the Impressionist shimmer,

while the yellow and bronze are partnered with red
and orange tulips for a dramatic hot-color harmony.
Like bearded irises, Dutch irises prefer a sunny
location and good drainage. They are planted from
bulbs in autumn to flower the following spring.
Hardy zones 5–9.

Iris, Japanese
(*Iris ensata*) French author Georges Truffaut, in an
article entitled "The Garden of a Great Painter," for the
French garden magazine *Jardinage*, wrote this about
Monet's liking for irises: "There are abundant irises of
all varieties along the edges of the pond. In the spring
there are *Iris siberica* and *Iris virginica* with their long,
velvet petals; later Japanese iris (*Iris ensata*) abound and
impart an original touch, which is further enhanced
by such plants as Japanese tree peonies. Numerous

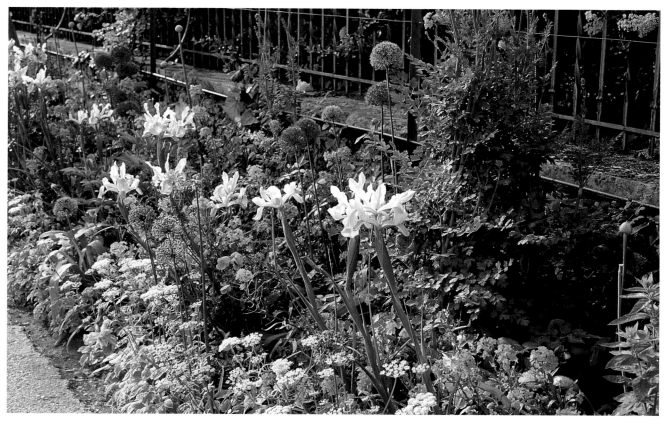

Above: Dutch irises rise above a mixed border at the bottom of the flower garden.

specimens of these were sent to Claude Monet twenty years ago and have adjusted to the Normandy climate."

Japanese iris, in mostly shades of blue, are the most prolific iris surrounding Monet's pond. They tolerate moist soil, and will even thrive with their roots permanently covered with shallow water. They flower in early summer, closely following the yellow flag iris (*I. pseudacorus*), which is native to Europe. Both kinds tolerate light shade, and so the water garden is a perfect environment for them. Also planted around the pond is the blue Siberian iris (*I. sibirica*), which tolerates moist soil and light shade. Planted close to yellow flag iris, the two types flower together and create one of Monet's favorite color harmonies — blue and yellow. All these can be divided after flowering. Japanese iris are hardy in zones 5–8; the Siberians 4–9 and the yellow flag zones 6–10.

Above: Japanese iris in the water garden.

Laburnum

(*Laburnum* x *watereri* 'Vossii') A wild form of laburnum, *Laburnum alpinum,* grows in the hills around Giverny; its yellow, pendant flower clusters bloom in early June. Commonly called golden chain tree, the hybrid selection 'Vossii' has the longest flower clusters. It is used mostly in the water garden, along the stroll path, one specimen planted close to the wisteria-covered bridge so that the yellow of the laburnum flowers and the blue of the wisteria create Monet's favorite blue and yellow color harmony. Another arches its branches over the stroll path so the flowers create a tunnel effect. Hardy zones 5–9.

Lavender, English

(*Lavandula angustifolia*) Monet used this hardy English lavender much like he used forget-me-nots — to create a misty appearance. The variety 'Munstead' has powder-blue flowers, while those of 'Hidcote' are deep

Above: Laburnum arches its flowers over the stroll path.

violet-blue. Both are used in Monet's garden to edge paths. Since lavender does not grow well in shade, it is confined to the Clos Normand. Blooming in early summer, lavender tolerates high heat and sparse rainfall. It forms a cushion of gray-green leaves up to 2 feet (60 cm) high and all parts are aromatic. A sprig placed beside a pillow will evoke the fragrance of a wildflower meadow. Steeped in boiling water, it makes a refreshing tea, and soaked in a bathtub of hot water it imparts a pleasant fragrance to the steam.

Lavender grows wild in the mountains of Provence, fully exposed to the sun, and in harsh soil. It demands good drainage, and though there are varieties that bloom the first year from seed, the best displays are produced from cuttings of perennial varieties planted in the spring of the previous bloom season. Hardy zones 6–10.

Lilacs

(*Syringa vulgaris*) Monet was famous for painting the same scene repeatedly in different light and at different seasons to capture nuances of atmospheric effect. His first experiment was with a mature common lilac, with purple blooms, in full flower. Painted on a sunny day and again on a cloudy day, with one of his stepdaughters sitting beneath it in shade, the effect so pleased him that he went on to paint an expanded series of poplar trees, waterlilies and also haystacks. Of the haystack paintings, art historian William H. Fuller wrote in 1899:

> I suppose he has painted 'The Haystacks', one of his most famous subjects, at least twenty times. They stood in a field close to Monet's House … He portrayed them in summer, in the autumn, and in the winter; in the morning, at noon, and at twilight; sometimes sparkling with dew, sometimes enveloped in fog, sometimes covered in frost, sometimes laden with snow; and though each picture was different from all the rest, one scarcely knew which to choose, they were all so true and beautiful.

Above: English lavender behind a Monet bench in the stable yard.

Above: Lilacs, trained to form trees, flowering in spring.

Using *Syringa vulgaris* as a parent, many beautiful hybrids have been produced, notably a strain known as French hybrids, developed mostly by the Lemoine Nursery. Many have French names, such as 'Mme Lemoine' (white), 'Président Grevy' (double blue), 'Decaisne' (single blue), 'Belle de Nancy' (single pink) and 'Charles Joly' (single magenta). They are generally larger flowered than the original species, which hails from southeastern Europe and Asia. Hybrid lilacs are used along the mixed flower borders as punctuation marks. Monet bunched cut lilacs in vases to fill the rooms of his house with fragrance, and today there is a fine collection in the parking lot, including the unusual 'Primrose', a pale lemon-yellow.

Plants will grow to 10 feet (3 m) high and equally wide. Hardy zones 4–9.

Lilies

(*Lilium* hybrids) Monet declared that his favorite flower was the heavily fragrant white Japanese lily, *Lilium auratum*, which he grew in pots close to his porch and also edging the path of his water garden. Writing in 1920, J.C.N. Forestier described the pond as having tall poplars that sheltered a colony of acid-loving plants, including azalea, rhododendrons and heathers, "… with tall blooms of the auratum lily rising through them." This is the same lily featured in John Singer Sargent's beautiful Impressionist painting entitled *Carnation, Lily, Lily Rose*, showing a child among auratum lilies backlit by a setting sun. Monet loved his friend's highly atmospheric painting.

Plants grow up to 5 feet (1.7 m) tall, with lance-shaped leaves and enormous nodding white flowers with recurved petals up to 12 inches (30 cm) across. The petals are further accented with gold bands and usually crimson speckles.

Today in Monet's garden, lily varieties are planted that the artist never knew, for the major improvements in lily breeding did not occur until after he died. It was the late Jan de Graaff, a Dutchman working in Gresham, Oregon, in the 1950s and 1960s, who

Above: Auratum lilies were Monet's favorite flower.

produced some of the world's most beautiful lilies, including Asiatic hybrids and Oriental hybrids. It is the Asiatics, with upward-facing flowers, which are prominent today in the Clos Normand, planted in bold clumps of mostly yellow, red and orange to create dramatic hot-color harmonies in early summer.

Lilies grow best in full sun, but tolerate light shade. Their most important requirement is good drainage. By planting dormant bulbs in autumn or in early spring, they will bloom by midsummer. Hardy zones 5–9.

Lupine

(*Lupinus* hybrids) Monet liked to step into his garden and see spirelike flowers rise above his borders as though they were minarets. Lupines do this admirably, growing bushy plants up to 5 feet (1.7 m) high, with sometimes as many as 50 tall, tapering flowers all open at one time. In Monet's day lupines were mostly blue and yellow, but today, as a result of the crossing of hardy North American species, lupines in red, pink, white and bicolors are planted in the sunny mixed borders of the Clos Normand and also at intervals along the stroll path in light shade around the pond.

Lupines are biennials, easily raised from seed started in midsummer and transferred to flowering positions by early autumn to survive winter. They bloom in late spring. Plants will readily self-seed into moist soil. Hardy zones 3–9.

Maple, Japanese

(*Acer palmatum dissectum*) Commonly called thread-leaf maples, these bear a fleecy spread of feathery leaves in mostly vivid green and purple and were much admired by Monet. Partnered with deciduous orange and yellow-flowering azaleas along the stroll path in the water garden, they create a spectacular hot-color harmony, and since the grouping is close to the pond's edge, the colors of leaves and flowers are reflected boldly in the water.

Thread-leaf maples are slow growing and easily pruned to maintain a low, compact habit, though they will mature into small trees up to 10 feet (3 m) high. They thrive in full sun or light shade, providing the soil has good drainage. In autumn the leaves turn orange. Hardy zones 6–9.

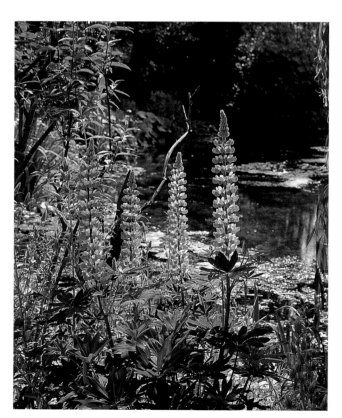

Above: Lupine beside Monet's pond.

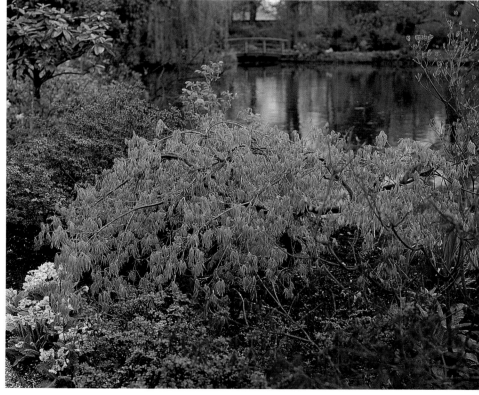

Above: Japanese maple beside Monet's pond.

Marigold, African

(*Tagetes erecta*) Although Monet is said to have disliked the small-flowered French marigold (*Tagetes patula*), he grew the tall, larger flowered African for the way its petals are tightly packed to create a sphere. Blooms of this variety have been described disrespectfully as "round sponges." Monet also grew annual scarlet sage (*Salvia splendens*), which many gardeners now find garish and commonplace, synonymous with parklike carpet bedding. However, the artist did not care how commonplace a flower might be; if it contributed a unique color sensation he would use it, and few flowers can create a red-and-green color harmony as quickly and effectively as scarlet sage.

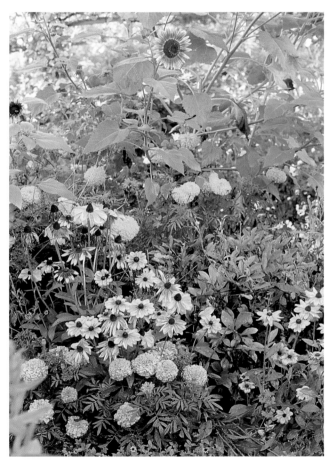

Above: African marigolds among black-eyed Susans.

With African marigolds it is the brilliance of their yellow and orange petals that appealed to Monet. He did not plant them alone, as you will find ad nauseum in public parks, but partnered them with black-eyed Susans, yellow and orange cosmos, and yellow and orange gladiolus. Since African marigolds are annuals and flower within six weeks of sowing seed, they are suitable for all zones.

Coincidentally, Vincent van Gogh admired the African marigold for its bright yellow and orange petals, and even wrote to his youngest sister, a keen gardener, suggesting she plant yellow African marigolds with blue cornflowers and white feverfew for a striking color harmony.

Meadow rue

(*Thalictrum aquilegifolium*) Monet liked flowers that produce a special textural quality, like frothiness or airiness, because he wanted plants that produced a mistiness in the landscape. A favorite frothy plant was meadow rue, especially the dusky pink flowering species with cloverlike leaves. It tolerates light shade, and so he planted it generously around the pond. A hardy perennial, it blooms in late spring, and is easily propagated by seed or root division. Hardy zones 5–8.

Nasturtium

(*Tropaeolum majus*) Monet first experimented with nasturtiums in his garden at Vétheuil, prior to moving to Giverny. There he had a garden beside the Seine with a steep flight of steps leading to a flat area where he grew sunflowers and gladiolus. He planted vining nasturtiums at opposite ends of the stairway so the stems could creep across and meet in the middle. A painting entitled *The Artist's Garden at Vétheuil* (1881) shows this clearly: the yellow, red, mahogany and white flowers of the nasturtiums complementing yellow sunflowers towering above them. Some of the nasturtiums even creep up the stalks of the sunflowers to mingle their flowers.

When Monet moved to the Giverny property and started to garden, the land sloped gently and so

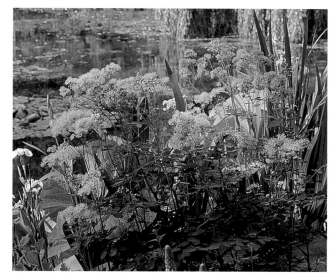

Above: Meadow rue beside the pond.

he did not need steps, but he transferred the idea of parallel creeping stems to a flatter plain by planting the same type of nasturtiums at opposite sides of his Grande Allée, arched over with roses. By September the nasturtiums meet in the middle and bloom riotously. Nasturtiums are annuals and the pea-size seeds are direct-seeded in spring after being soaked in tepid water overnight to speed germination.

Another kind of vining nasturtium Monet grew is called 'Empress of India'. It has bronze leaves and dark red flowers. He grew these up towers strategically spaced among his island beds of red bedding geraniums.

Nasturtium vines will grow to 12 feet (4 m) in a single season, flowering best when nights are cool. Avoid high nitrogen fertilizer as this may encourage more leaves than flowers.

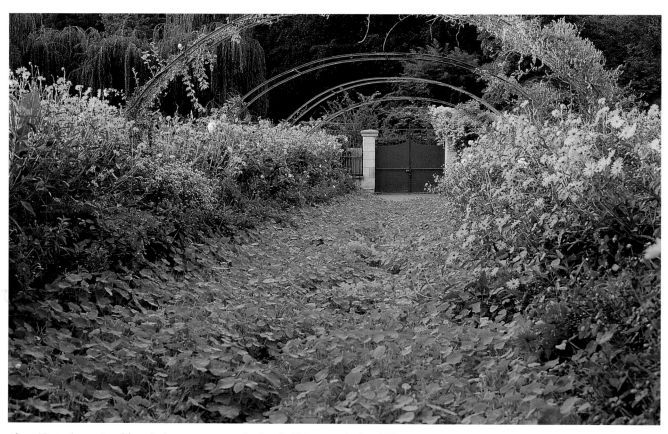

Above: Nasturtiums, viewed from the house, creep across the Grande Allée to meet in the middle.

Pansies

(*Viola* x *wittrockiana*) Monet grew lots of pansies and their smaller-flowered cousin, the viola, especially the kind known as Johnny-jump-ups (*Viola tricolor*). True pansies have a rich color range that includes all shades of red, blue, yellow and orange, plus white. They bloom early, allowing them to be partnered with tulips, wallflowers and even daffodils.

Monet especially liked pansies with black blotches on their petals, as this adds a contrast similar to sunlight and shadow — a stippling effect that tempers the boldness of solid colors. In other words, the opposite effect of shimmer, produced from the proximity of white. A black-and-white color contrast in the garden today is achieved through the use of white pansies with black markings, in partnership with dark maroon 'Queen of the Night' tulips.

Blue pansies are partnered with orange Siberian wallflower for a striking blue and orange color harmony, while orange and red pansies embolden hot-color harmonies involving orange and yellow Siberian irises and bicolored yellow-and-red tulips.

Violas are primarily used for edging the mixed borders. Individually, the flowers are small, but the sheer quantity of bloom lasts into early summer. In the variety 'Helen Mount', three colors are evident — yellow, purple and black — so that the stippling effect below plantings of tulips and bearded irises is enchanting.

Both pansies and violas are best treated as biennials, seed being sown in summer of the previous flowering season so husky transplants can be set into flowering positions in early spring. Hardy zones 4–10, depending on variety.

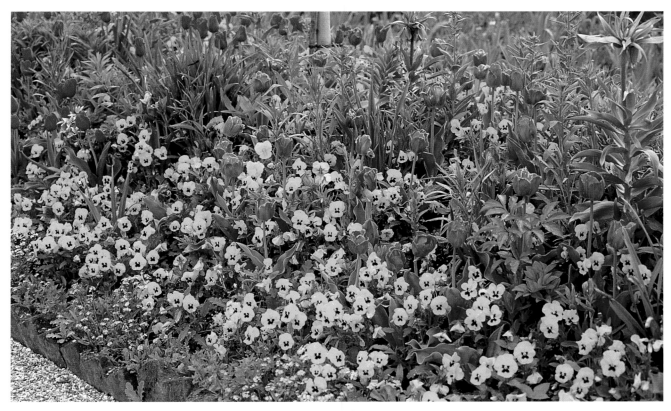

Above: White pansies with black faces partner pink tulips for pink and yellow color harmony.

Patrinia

(*Patrinia scabiosifolia*) This wayside weed of Provence is a hardy perennial that produces a tall flower stem topped with airy panicles of small yellow flowers. It likes a sunny position and is used in spring all through the mixed borders to veil stronger flower colors, especially areas of the garden with tulips. This contributes the Impressionist shimmer and also creates a misty effect. Patrinia is best grown from seed started in summer of the season prior to flowering. Hardy zones 5–8.

Peony, Chinese

(*Paeonia lactiflora*) Monet liked Chinese peonies (also called herbaceous peonies) so much he not only planted them in the mixed borders of his Clos Normand, but also cultivated hundreds more as hedges to surround vegetable plots in his Blue House vegetable garden located at the other end of the village. Leaving the ones in his flower garden for display, those in his vegetable garden were picked by the armload so every room in the house could be filled with them. Mostly hybrids with globular blooms up to 6 inches (15 cm) across, from

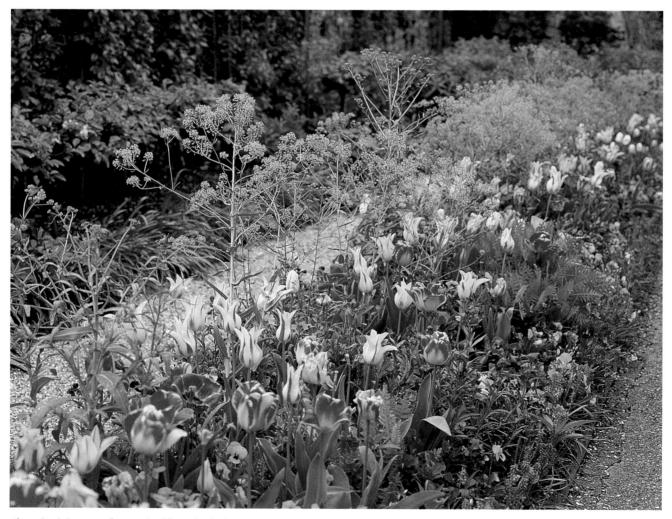

Above: Patrinia towers above a mixed flower border in spring.

Above: Chinese peony in a mixed flower border.

the following season. They prefer full sun, but tolerate light shade and need good drainage. Monet partnered pink and red herbaceous peonies with blue bearded irises and scarlet Oriental poppies, all flowering together the last week of May. Plants grow 3 to 4 feet (0.9 to 1.2 m) tall, and equally wide. Hardy zones 6–9.

Peony, tree

(*Paeonia suffruticosa*) "The tree peonies, in colors ranging from white with yellow flecks to a vivid violet toned red, beneath groups of laburnum, give one the impression of being transported to the suburbs of Yokohama," wrote Georges Truffaut of the water garden.

Early in his development of the water garden Monet was introduced to Japanese tree peonies by a Japanese horticulturist. They were not well known in France, and Monet so much liked the exotic touch they added to his water garden, he acquired the largest

the French nurseryman Emile Lemoine, they are highly fragrant in shades of red and pink plus white. 'Edulis Superba', a rosy-pink double, introduced in 1824, and 'Sarah Bernhardt', a double pink introduced in 1906, are still considered among the best. Other heritage peonies, by French nurseryman Felix Crousse, are widely available, including 'Félix Crousse', a double red introduced in 1881, and 'Monsieur Jules Elie', a double deep pink (1888).

Herbaceous peonies are mostly planted from root divisions taken in late summer and planted in autumn. These will survive winter from dormant roots to flower

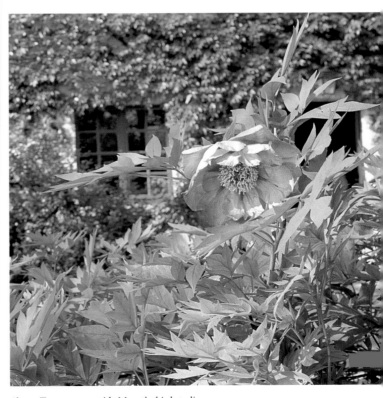

Above: Tree peony outside Monet's third studio.

collection in Europe, at great cost. These were mostly planted in a sunny clearing beside the stroll path close to the Japanese bridge so the planting could be admired early along the walk. Some of the blooms measure 12 inches (30 cm) across, in mostly white, pink, red, apricot and yellow — many with handsome black markings at the base of the petals.

Tree peonies are mostly propagated by root cuttings grafted onto herbaceous peony roots because dividing a tree peony is difficult. Even so, the success rate of grafts is usually 50 percent or less, which is why *Paeonia suffruticosa* plants are more expensive to buy than herbaceous peonies.

Poppies

(*Papaver* spp.) In his liking for poppies Monet went from one extreme to the other. On the one hand, he admired the wild annual corn poppy (*Papaver rhoeas*) that seeds itself into fallow ground throughout France, creating sheets of blood-red color in early summer, and on the other hand he cherished the large-flowered, flamboyant, hardy perennial Oriental poppy (*P. orientale*). He also grew a non-narcotic form of pink annual bread seed poppy (*P. somniferum*), allowing it and the corn poppies to self-seed themselves wherever they wished in his mixed flower borders. Though their flowering period is brief, both varieties of annual poppy are appealing for the way they temper the overbred look of the hybrids. If Monet's garden featured only hybrids it might look too contrived, so he referred to his wildlings as "the soul of the garden," bringing in from the waysides white ox-eye daisies, blue cornflowers and pink corn cockle for the same purpose.

Oriental poppies are available in pink, purple, orange and white, but it is the scarlet-red and crimson that are dominant in Monet's mixed borders. Planted generously between clumps of blue bearded iris and herbaceous pink peonies, they produce a strong discordant splash of color that Impressionist artists liked to use to provoke drama in a painting. Indeed, red was known as a passionate color and the post-Impressionist Vincent van Gogh referred to it in a letter as "angry."

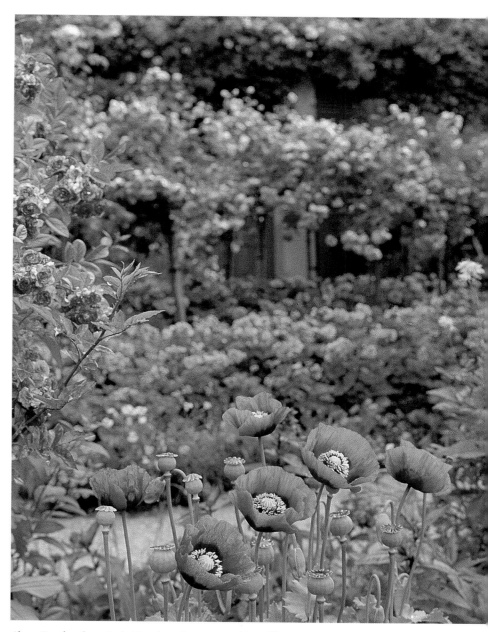

Above: Bread seed poppies in Monet's garden contrast with rambler roses.

Of particular note is the Oriental poppy variety 'Turken Louise', which has scarlet fringed petal tips. Poppies have a satinlike sheen, even down to the diminutive California poppies, and collectively they add greatly to a garden's brilliance. Oriental poppies are hardy zones 3–10.

Primrose

(*Primula* x *polyantha*) The common yellow primrose, known as the English primrose, grows wild throughout the waysides of France, especially in lightly shaded places, and Monet planted it along the stroll path in his water garden. However, hybridized primroses, or polyanthus, are also used in the Clos Normand and in the water garden to create a hot-color harmony of mostly red, yellow and orange shades. Some of these are the Barnhaven strain developed since Monet's death by a housewife, Florence Bellis, living in Gresham, Oregon. She bred these from a hybrid strain known as "bunch primroses" that originated in the garden of the Edwardian horticulturist Gertrude Jekyll, whose garden writing Monet admired. Following the death of Mrs. Bellis, rights to the Barnhavens were acquired by Mrs. Angela Bradford, an Englishwoman living in Britanny. It is these that are used today in Monet's garden, since they are hardier than other *Pruhonicensis* hybrids, such as the Pacific Giants strain. Barnhaven are hardy in zones 5–9, depending on variety. Many are also drought-resistant.

Above: Primroses in shade beside Monet's pond create a hot color harmony.

Rhododendron

(*Rhododendron* hybrids) The botanical name *Rhododendron* describes two kinds of flowering shrubs — the bushy, large-flowered, broad-leafed evergreen of the same name, and the smaller-flowered, slender-leaf kind commonly called an azalea, which can be evergreen or deciduous. Monet grew both rhododendrons and azaleas in lightly shaded areas of the Clos Normand and the water garden. The rhododendrons are mostly pink and strategically located at intervals along the stroll path of the water garden, while the azaleas are mostly the deciduous kind, such as the Exbury hybrids, which are fragrant and rich in hot colors — notably scarlet-red, yellow and orange. These are massed close to the water's edge so their reflections show in the water, partnered with bronze-leafed Japanese maples.

Generally speaking, azaleas are easier to grow than rhododendrons, which are shallow-rooted and become stressed during dry periods. Deciduous azaleas generally have a pleasant fragrance, making them desirable for cutting to create indoor arrangements. Hardiness depends on variety, deciduous hybrid azaleas usually being suitable for zones 5–9.

Above: Rhododendron beside the stroll path in the water garden.

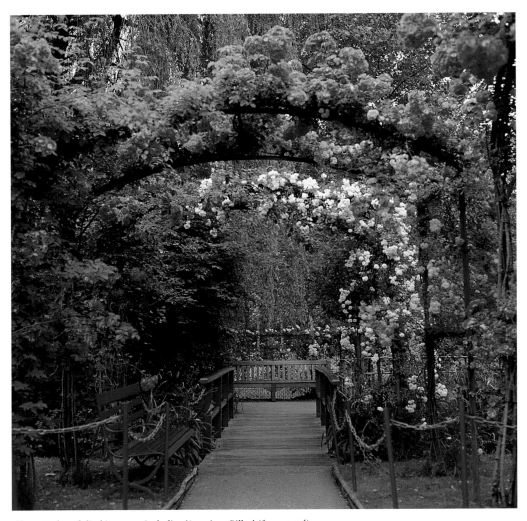

Above: Arches of climbing roses, including 'American Pillar' (foreground).

Roses

(*Rosa* hybrids) Monet loved roses so much he visited the Bagatelle Rose Test Gardens each year in early summer to evaluate new varieties submitted for trial by the world's leading rosarians. It is believed he was one of the first in France to recognize the value as a climber of 'American Pillar'. Submitted for evaluation at Bagatelle by Conard & Jones, Pennsylvania rose growers, 'American Pillar' was hybridized by an American, Dr. Walter Van Fleet, involving crosses between *R. wichureana* and *R. setigera* onto a red hybrid perpetual, and released in 1908. Monet admired its extraordinary vigor and ability to produce a pillar of carmine-pink, cup-shaped flowers in dense clusters against glossy, leathery foliage. A touch of white at the center of each flower and golden yellow stamens enhances its vibrancy. Capable of growing to 20 feet (6 m) high, 'American Pillar' not only covers the high rose arches above Monet's boat dock in his water garden, but is strategically planted on trellis in the Clos Normand, and also trained as a standard.

Before 'American Pillar' won his heart and became his favorite climber, Monet used the older rose, 'Belle Vichysoise', to carry color high above the garden.

A small-flowered pink that bears its double blooms in large clusters, it can grow to 50 feet (16 m) high. Discovered in Vichy by the French rosarian P. Leveque, it was introduced in 1897.

Another of Monet's favorite climbing roses is 'Mermaid', introduced in 1918 by British rosarians Paul, William & Son. A cross involving *R. bracteata* and a double yellow tea rose, 'Mermaid' has fragrant single flowers measuring up to 4 inches (10 cm) across. The creamy-yellow flowers have golden anthers, and contrast boldly against dark green, glossy foliage. 'Mermaid' climbs to around 10 feet (3 m), and Monet planted this rose to grow along trellises.

For heavy fragrance, Monet grew a number of old shrub roses, notably 'Reine des Violettes', introduced into cultivation prior to 1860 by a French nurseryman who discovered it among seedlings of 'Pius IX'. The fully double purple flowers are up to 4 inches (10 cm) across, its petals arranged in a swirling pattern. One flower can fill a room with its fruity fragrance.

Three other important roses in Monet's garden today are 'Veilchenblau', a free-flowering, German-bred shrub rose that bears clusters of small, violet-blue flowers; 'Nevada', a repeat-flowering Spanish-bred rose that arches its saucer-size white flowers out over the surface of Monet's pond; and 'Westerland', a vigorous, repeat-flowering apricot-colored climber from Germany. 'Westerland' has a longer flowering display and heavier bloom than the old garden rose 'Gloire de Dijon', which Monet liked for its large, double orange flowers.

Rose hardiness varies, but generally modern hybrids are suitable for zones 5–10 and old garden shrubs and climbing roses zones 6–9.

Smokebush

(*Cotinus coggygria*) This bushy small tree has two qualities Monet admired. First, in the regular species the pale pink or white flower clusters produce a smokelike appearance, resembling mist; second, the deep bronze foliage varieties such as 'Royal Purple' produce faux shadows in sunlight, and smoky-pink

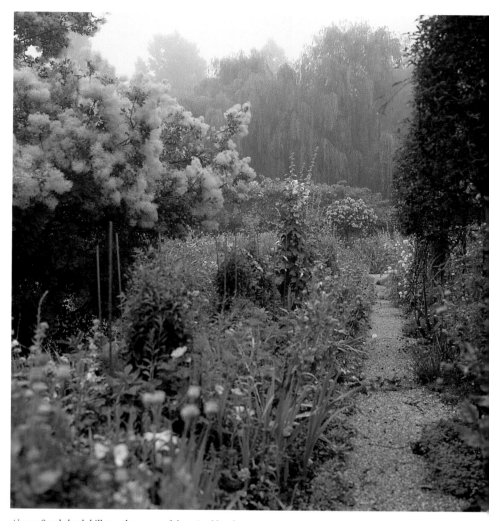

Above: Smokebush billows above one of the mixed borders.

flower clusters that resemble pink mist. The species is planted in the Clos Normand, while two beautiful specimens of the deep bronze form are planted at opposite ends of the Japanese bridge in the water garden. Here they add a handsome dark element to the predominantly leafy-green tapestry around the bridge.

Plants grow to 15 feet (4.5 m) high, with an equal spread, display oval leaves and flower in midsummer. The branches are brittle and usually some pruning is needed at the start of each season to maintain their billowing outline. Hardy zones 4–9.

Spider flower

(*Cleome hassleriana*) This summer-flowering annual sparkles in every kind of light because of its spidery flowers. These help to accentuate the shimmer in Monet's garden. Its most common form — and the one Monet favored — is a pink and white bicolor, the florets arranged in a perfect sphere atop a tall stalk. Sets of whiskers or filaments radiate out from each floret to produce the spidery appearance. There are solid white and solid pink versions, but the bicolored pink and white is planted liberally throughout the mixed borders, where it mingles with late-blooming asters, black-eyed Susans and sunflowers.

Plants are easily raised from seed, either started indoors six weeks before outdoor planting, or direct-seeded where plants are to bloom. Grown as an annual, it is suitable for all zones.

Above: Spider flower adds to the garden's shimmer.

Sunflower

(*Helianthus* spp.) Vincent van Gogh, the post-Impressionist painter whose art-dealer brother represented Monet, wrote that he was inspired to paint sunflowers after seeing a still-life arrangement of large-flowered annual sunflowers by Monet in a Paris exhibition. What endeared the sunflower to Monet was not only its huge flowerhead, but also its height, which allowed the blooms to contrast harmoniously with a blue sky. Though the annual sunflower (*Helianthus annuus*) is fast-growing from seed sown directly into the garden, both annual and perennial kinds are an

Above: Bouquet of Sunflowers *(1880)*

Metropolitan Art Museum, New York

Monet grew two kinds of sunflowers — the large-flowered annual kind (seen here) and smaller-flowered perennials. This painting impressed Vincent van Gogh when he saw it exhibited in Paris, and it inspired his famous sunflower series.

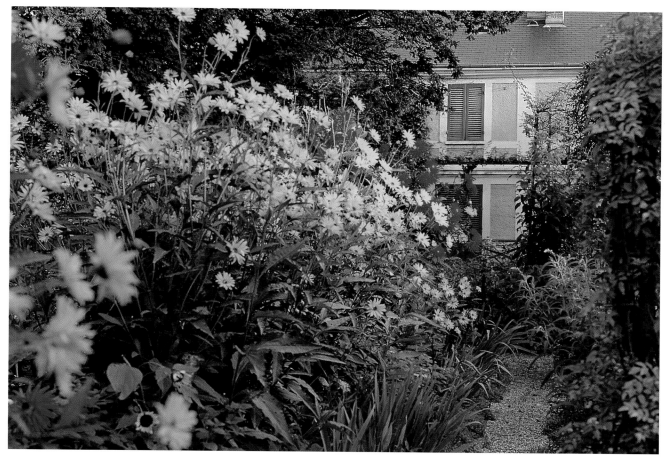

Above: Perennial sunflowers bloom in late summer.

important part of the late-summer and autumn scene in Monet's garden.

The annual variety known as 'Russian Mammoth' grows a single flowerhead on a stem that can be 10 feet (3 m) high, and once the flower fades, the display is finished. However, there are smaller-flowered varieties with multiple stems that will bloom continuously from midsummer to autumn frost. Monet painted his mammoth sunflowers in his garden at Vétheuil, with orange and red climbing nasturtiums creeping across the ground. In another painting of the same sunflowers, Monet painted them from the opposite direction, with a blue sweep of the River Seine in the background.

'Autumn Beauty' is a variety with mostly yellow, orange and red petals surrounding a black seed disk. Other varieties can be bicolored, usually with a dark red or mahogany zone around the center. Pale sunflowers such as cream-colored 'Valentine' and 'Moonwalker' add a twinkling effect to the mixed borders today.

There are also several perennial kinds of sunflower planted in solid rows to contrast with blue New England asters, especially along the Grande Allée in late summer and early autumn. These are mostly *Helianthus maximilianii*, a free-flowering species native to Texas. Planted in long, broad brushstrokes, the 8 foot (2.5 m) tall plants produce a top-knot of multiple golden-yellow blooms with dark brown centers. Hardy to zones 3–9.

Sweet peas

(*Lathyrus odoratus*) "Sow 60 pots of sweet peas …" wrote Monet to his head gardener while he was away on a trip. Climbing sweet peas with heavy fragrance were grown up tall bamboo tripods called *tuteurs*, strategically spaced along the mixed flower borders throughout his garden. These not only took color above eye level, but also provided armloads of cut flowers for indoor arrangements. To get extra-early blooms, Monet started the sweet peas in pots for transplanting in early spring, and also grew them out of season in his greenhouse, to cut and fill his home with fragrance. Suitable for all zones.

Tamarisk

(*Tamarix ramosissima*) The main appeal of this bushy small tree is its spring display of fluffy pink flowers that produce a misty, cloudlike effect similar to the smokebush. Strategically placed at intervals in the sunny mixed borders, blooming at the same time as tulips, tamarisk flowers change color according to the light — a dusky pink on cloudy days and a vibrant bright pink in sunlight. Plants are tolerant of dry conditions, and need rigorous pruning at the end of each season to keep their beautiful billowing shape. Propagate by stem cuttings after flowering. Hardy zones 2–10.

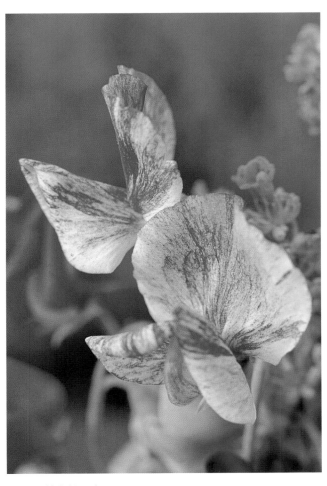

Above: Old-fashioned sweet pea.

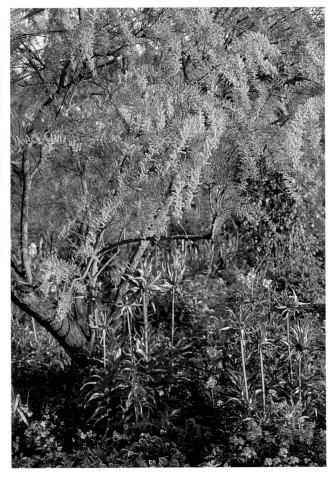

Above: Tamarisk partnered with crown imperials.

Tulips

(*Tulipa* spp. and hybrids) Monet developed a special liking for tulips during visits to Holland at "tulip time" — a four-week period from mid-April to mid-May when they flaunt their brazen colors and diverse flower forms in display gardens and vast production fields. On his first trip to Holland in 1886 he was a guest of a Dutch diplomat who admired Monet's art and wanted his country's tulip fields immortalized in the Impressionist style.

However, when Monet arrived at the main tulip-growing area near Leiden, west of Amsterdam, he was thwarted by a period of incessant cold and rain, and it was not until the end of his stay that he had a few bright days in which to paint outdoors. He still felt frustrated by the way the tulip fields were planted in regimented rows of solid color blocks. After considerable experimentation he discovered that by choosing a field with many ribbons of color, and by positioning himself at an oblique angle, he could paint the blocks as though they were more informally planted, the checkerboard pattern of individual colors merging into each other, rather than regimented. The result was five paintings that greatly satisfied him and his sponsor.

Dutch breeding ingenuity has produced many classifications of tulips, from the familiar cottage tulips,

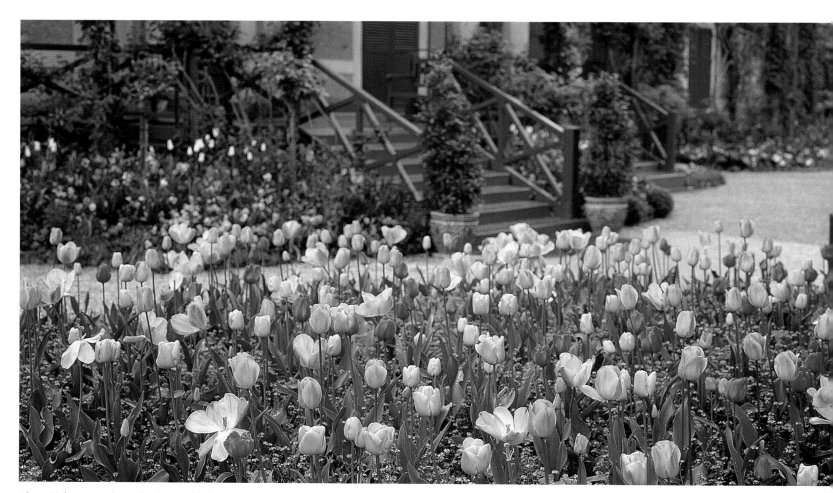

Above: Pink cottage tulips underplanted with forget-me-nots.

or triumph tulips, with their urn-shaped flowers, to the bizarre "parrots" with immense flower heads composed of feathered petals like a parrot's tail feathers.

Monet particularly admired lily-flowered tulips, with their pointed petals, and a favorite in the garden today is yellow 'West Point'. Also widely used are varieties of cottage tulips and artists' tulips from the Viridiflora group. These have mostly pale pink petals with green flames, as though an artist has streaked them with a paintbrush.

The color range of tulips is among the most diverse in the plant kingdom, lacking only sky blue. Moreover, the colors are exceedingly bright, in all shades of red, yellow, purple and orange, plus white and even black (actually a deep, dark maroon).

All classes of tulip can be bicolored and even tricolored, and so in early spring they steal the show, adding greatly to the brilliance of Monet's garden.

At Giverny, after flowering in spring, all the tulips are pulled up, bulb and all, and composted, since tulips do not return reliably each year, unlike daffodils that are left in place. Once the tulips have been cleared, the space is then filled with ready-to-bloom plants from cold frames, such as summer-flowering African marigolds and Asiatic lilies. Hardy zones 5–9.

Valerian

(*Centranthus ruber*) This hardy perennial has two strong visual qualities — a see-through, veiling effect when the dusky pink or red frothy flower clusters extend well above the foliage, and in the pink variety especially, a misty quality when planted in mixed borders. Easily propagated from seed or division, plants are drought-resistant, prefer full sun and good drainage. Hardy zones 5–8.

Verbascum

(*Verbascum* spp.) Monet planted several varieties of verbascum for their spiky flower clusters. He liked the ramrod-straight flower stems of mullein (*Verbascum thapsus*), with its large silver leaves and tightly packed yellow flowers rising above his mixed borders. Also

Above: Pink valerian has a see-through quality.

evident in summer are clumps of spiky, nettle-leafed moth mullein and yellow-flowering *V. chaixii* in the mixed borders. From rosettes of thick, spear-shaped velvety leaves the plants produce a dozen or more flower stems that pierce the air like rockets.

Above: Verbascum (or moth mullein) has velvetlike leaves and rocketlike flower spikes.

Virginia creeper

(*Parthenocissus quinquefolia*) Expanses of wall at the end gables of Monet's house, also the walls of his second and third studios, and sections of the boundary wall of the property, are covered in Virginia creeper. A fast-growing vine with ivylike leaves, Virginia creeper is one of the most extraordinary sights in Monet's autumn garden, for that is when the emerald-green leaves change to molten red. The vines climb by means of aerial roots that can cling to any rough surface. Monet erected wooden trellis specially to aid its coverage of his boundary walls and allowed the entire front façade of his house to be cloaked in Virginia creeper. However, today the front of the house is left uncovered so visitors can better appreciate the pink walls. To prevent it invading the roof of the buildings, the Virginia creeper is cut back in late October.

A hardy woody plant, Virginia creeper is easy to grow in full sun. The tiny green flowers and small black fruits are hidden by the leaves and have little ornamental value. Propagate by stem cuttings — every leaf node pushed into moist soil will root. Hardy zones 3–10.

Above: Virginia creeper decorates a wall of Monet's second studio.

Wallflower

The English wallflower (*Erysimum cheiri*) has a more extensive color range than the Siberian wallflower (*Erysimum* x *allionii*), which blooms in mostly yellow and orange. Both appealed to Monet for their bold colors and early spring flowers. The two kinds are barely distinguishable in flower form, and because their blooming coincides with pansies and tulips, he used all three in combination to create hot-color harmonies.

English wallflowers are rich in reds, yellow, orange, purple and maroon, plus white. When massed together as a mixture the effect is electric. Both the English and Siberian wallflowers are hardy biennials. They are best started from seed sown the previous summer, so that husky transplants can be placed into their flowering positions in autumn where winters are mild, or in early spring to flower then and in the early summer.

Because the Siberians can be clear yellow or golden orange, Monet partnered them with blue flowers, especially blue Dutch irises, blue Spanish bluebells, blue forget-me-nots, and blue pansies. Today, they are planted in the mixed borders of the Clos Normand, and also in the lightly shaded woodland encircling Monet's water garden.

Hardy zones 7–9 (English wallflower); 3–7 (Siberian wallflower).

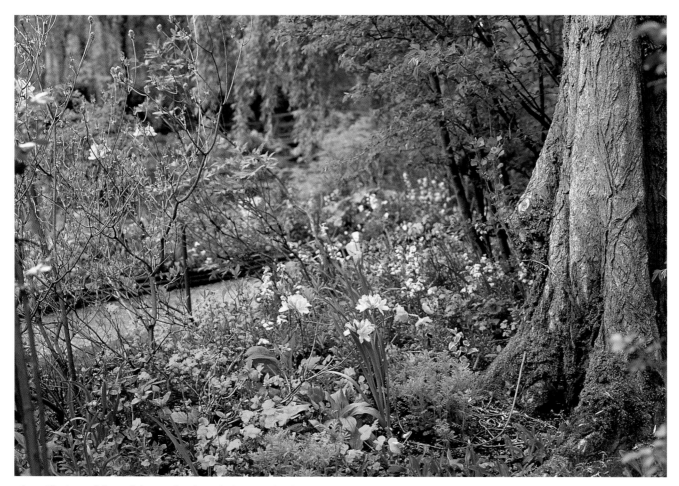

Above: Siberian wallflowers help to make a hot-color harmony beside Monet's pond.

Waterlilies

(*Nymphaea* hybrids) In a rare explanation of his planting philosophy, Monet once said of his waterlilies: "I have painted these waterlilies many times, modifying my viewpoint each time ... since the water flowers are far from being the whole scene; rather they are just the accompaniment ... The essence of every motif is the mirror of water whose appearance alters at every moment, thanks to the patches of sky which are reflected in it, and which gives it its light and movement."

Monet started his water garden at a time when hardy waterlilies were undergoing a miraculous transformation, thanks to the work of nurseryman Joseph Bory Latour-Marliac (1830–1911), who had begun to hybridize them at his nursery at Temple-sur-Lot, near Bordeaux, in the south of France. Latour-Marliac had a background in genetics, and before

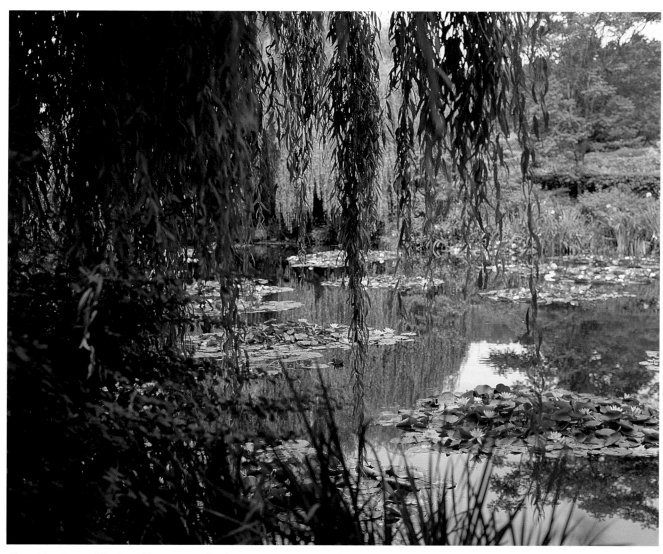

Above: Monet's waterlilies framed by weeping willow branches.

breeding waterlilies he worked at breeding new plum varieties. He turned to hybridizing waterlilies in 1875, attempting to cross tropicals with hardies to introduce blue into the color range of hardies, but without success. It was only when he concentrated on using pollen from hardy species that he achieved his objective.

When he began his project, European nurserymen offered mostly a white waterlily, but Latour-Marliac discovered a red mutation in a Swedish lake, a pink mutation on Cape Cod, Massachusetts, and a yellow in Mexico. From this gene pool Latour-Marliac developed a richer assortment of colors. These were all sterile, and since they did not set seed they were more free-flowering than the original species, and larger flowered. Latour-Marliac varieties that Monet grew include 'Chromatella' (yellow), 'Attraction' (rosy-red), 'Comanche' (orange), 'Caroliniana' (a soft pink) and 'Marliac White'. Bright red 'James Brydon' and dark red 'William Falconer' are also listed on an early invoice.

Monet tried to grow tropical waterlilies but his pond water was too cold. Tropicals can be day-blooming or night-blooming. Their flowers can be more than twice the size of hardy waterlilies, and Monet did manage to grow them in tubs in his greenhouse.

Monet's success with Latour-Marliac's hardy waterlilies helped to popularize varieties from this hybridizer, to such an extent that he was invited by the prestigious Royal Horticultural Society to deliver a lecture about his breeding work. During the lecture, Latour-Marliac claimed his extensive color range was the result of crossing tropical kinds with hardies. However, it is now known that this is genetically impossible since the two kinds are incompatible as parents, and Latour-Marliac may have deliberately misled his audience to discourage British nurserymen from setting up in competition.

Latour-Marliac's waterlilies can be extremely aggressive. A single root division will take hold in the mud of a pond and produce so many offsets with plate-size leaves that they can cover the entire surface of the pond in a single season. "It took me a long time to understand my waterlilies," Monet wrote about them. Rather than growing them in the mud of the pond, he confined them to submerged concrete containers, planting at least three roots of a selected color to each container. So they would not exceed their bounds, excess foliage is pruned away to form floating islands. "I had planted them for the pure pleasure of it, and I grew them without thinking of painting them … and then all of a sudden I had a revelation of the enchantment of my pond. I took up my palette. Since then I've had no other motif."

When he discovered what a good subject waterlilies were to paint, Monet realized that expanses of reflective water must separate the plantings. "I have painted many of these waterlilies, modifying my point of view each time, renewing the subject depending on the season and as a result, following the differences of the luminous effect which bring about changes," he told a visitor, François Thièbault-Sisson. "The effect for that matter varies continuously. What is essential in the subject is the mirror of water whose aspect, at any moment, changes thanks to patches of sky reflected in it and which give life and movement. The cloud which passes over, the breeze which freshens, the heavy shower which threatens and falls, the wind which blows and beats down suddenly, the light which fades and reappears, so many causes, imperceptible to the layman, which transform the color and change the ponds."

Though the waterlilies in Monet's pond are rarely fertilized, to maintain lustrous green leaves and generous bloom, fertilizer tablets can be pushed into the soil around waterlily roots every two weeks during the growing season. The roots are best positioned 12 to 18 inches (30 to 46 cm) below the pond surface, beneath the ice line. Though hardy waterlilies tolerate winter cold, they do not like their roots to be frozen. Best planted in full sun, waterlilies will flower in light shade. Hardy zones 3–10.

Weeping willow

(*Salix babylonica*) After the islands of waterlilies, nothing evokes the impression of Japan in Monet's water garden more than weeping willows. Even bamboo is dwarfed by these magnificent trees. Their cloudlike outline and curtains of slender leaves are a feature of numerous paintings by Monet of his water garden. He even painted the branches framing other elements — usually his waterlilies and Japanese bridge.

Willows are fast-growing. A small branch will root itself in water or moist soil. They like to be close to bodies of water, sending out aggressive roots in search of moisture. They are one of the most recognizable trees in the landscape, their gently swaying branches adding a softness and soothing aura to a scene. The green leaves shimmer silver and gold in the slightest breeze, and when they drop in winter they leave a network of conspicuous yellow branches.

Monet planted willows for another quite different visual effect — along a stream bank, to be pollarded. Locally, farmers grew willows to produce withies — long, pliable branches they can weave to make sheep hurdles and baskets. Hundreds were once planted in regimented rows across damp meadows around Giverny.

Pollarding requires the willow to be topped at about 5 to 6 feet (1.5 to 2 m) in spring, all the previous season's branches being removed from the trunk so it sends out an explosion of new branches as straight as bamboo canes, but more pliable. Today, throughout Monet's water garden these withies are used as a low edging, known as a "wattle" fence. The wattle is even used to hold in the soil along the stream banks.

Several pollarded willows today line the stream in Monet's water garden: they are pruned back to the trunk in winter. Hardy zones 5–10.

Above: Weeping willow pollarded to produce an explosion of slender, pliable branches.

Wisteria

(*Wisteria floribunda*) This shrubby vine is synonymous with Japanese gardens where it is trained under the eaves of houses, along bridge rails, up into the canopy of evergreen pine trees and over arbors. In Monet's garden, the sensation of walking under the wisteria canopy, according to writer Marc Elder, was "like walking through a tunnel of vanilla."

Wisteria grows quickly and can strangle a tree with its coils. In spring its branches are covered with clusters of blue flowers that hang in long racemes. Instead of one color, Monet used two — a blue and a white — so they mingled their flowers and produced one of his favorite visual floral effects: a lace curtain.

In another area of his water garden Monet planted a blue wisteria vine along a section of trellis, between his stroll path and the water's edge, so that the flowers are reflected in the water. Also, in early May when this wisteria fades, it drops its petals on the footpath to briefly color it blue.

To bloom profusely, wisteria needs a fertile soil. In some seasons the bloom is heavier than others, depending on the severity of late frost, which can nip the buds so they do not open. Hardy zones 5–9.

Above: Wisteria flowers backlit to create a shimmering effect.

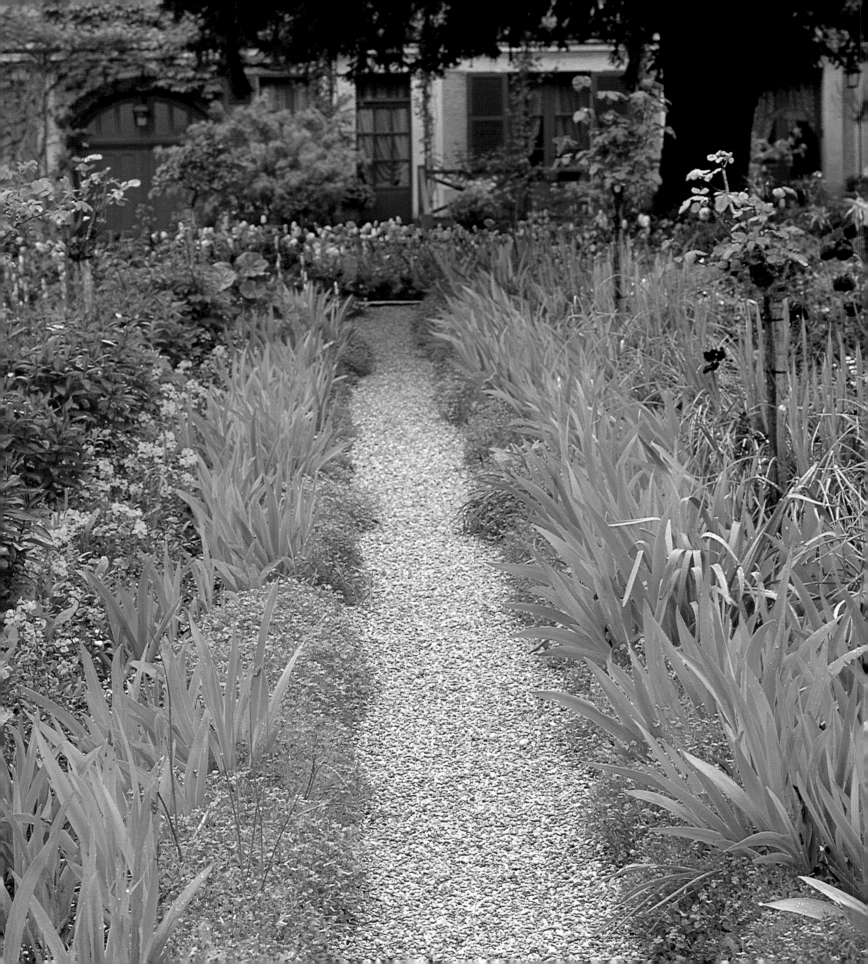

Conclusion:

Continuing the Magic

"He has dared to create effects so true to life as to appear unreal, but which charm us irresistibly, as does all nature revealed. Who inspired all this? His flowers. Who was his teacher? His garden."

Arsene Alexandre, *Le Figaro*, 1901

Monet was innovative with his painting technique, and equally innovative with his garden plantings, to such an extent that even the smallest space within the sunny Clos Normand or the lightly shaded water garden is instantly recognizable as Monet's work. Primarily, this is notable for the sheer exuberance of flowering plants, crowded together so that, when viewed through half-closed eyes, the flowers themselves appear to be brushstrokes on an Impressionist canvas.

Flowers with brilliant colors he planted en masse to create bold color splashes — tulips, bearded irises, dahlias, gladiolus, roses, waterlilies and peonies, all hybrids. Mixed randomly among these major players were the wildflowers — field poppies and daisies — representing smaller dabs of paint. He surrounded these with a shimmering effect, using white flowers like a white stipple, and he carried color to a great height in the landscape, using spirelike plants and tall growers such as hollyhock and sunflowers, plus flowering vines such as clematis.

Misconceptions about the gardens and its creator

Since the property at Giverny opened to the public in 1980, many writers and photographers have analyzed the garden. There has been much speculation presented as fact, and as a result the opinions of one expert often contradict another. I don't agree with one writer who thought Monet's plant bands came from his observation of Dutch bulb fields, or that his nasturtium path came from the name of a boulevard in Paris. His friendship with Gustave Caillebotte, the

Previous page: Aubrieta lines a path leading from the bottom of the flower garden to Monet's house.
Right: White cosmos twinkle like stars against a mass of perennial sunflowers.

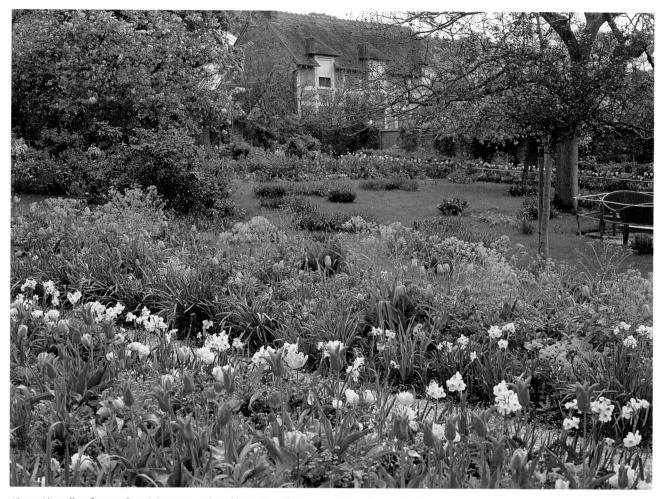

Above: Airy yellow flowers of patrinia create a misty, shimmering effect in mixed flower borders that feature daffodils and tulips.

Impressionist master of perspective, predates his trips to Holland. Moreover, a study of his paintings of the Clos Normand shows clearly the main purpose of the plant bands is to create long lines of perspective similar to those in Caillebotte's garden, while a study of his painting *The Artist's Garden at Vétheuil* shows he first planted nasturtiums on either side of a steep flight of steps and then adapted it to a gently sloping wide path. The claim that he disliked double flowers for their hybridized appearance is false because he planted many double dahlias and double peonies for sheer brilliance. The suggestion that he disliked hybrids is untrue when he deliberately sought out hybridizers and the majority of his plantings are still hybrids.

The visual sensation of the Impressionist shimmer in Monet's garden is now more clearly understood, and the realization that Monet's water garden is an example of a traditional Oriental cup garden, pioneered in China and then refined by the Japanese, is also a recent revelation.

The dynamics of the garden as an artistic masterpiece

It is miraculous that Monet's garden survived more than half a century of neglect before its remarkable restoration, and that such clear insights into the dynamics of the

garden as an artistic masterpiece are now evident. Because of their ephemeral quality, we often overlook the fact that gardens can be magnificent works of art. Leave a picture in the attic and it can increase in value with no effort on the part of the owner, but neglect a garden for only a few weeks and it starts to revert to wilderness.

Adapting Monet's ideas in smaller gardens

Few people have the space, or the financial means, to plant a garden like Monet's, and so we must think of how to adapt his ideas to a smaller compass. His favorite color harmonies are easily adapted to a space as small as a container planting, even a window-box planter. Indeed,

when such unconventional plant color partnerships as black and white and black and orange are concentrated in a small area, the effect is often enhanced.

At Cedaridge Farm, my home in Pennsylvania, I have a smaller version of Monet's pond, a stroll path that leads through a series of leaf tunnels, a white garden with black highlights and peonies surrounding my vegetable garden plots. I have made wide use of airy white plants such as dame's rocket to produce the "Impressionist shimmer."

In my garden I have used in abundance the same flowers that Monet planted to provide season-long color — daffodils and tulips in early spring; irises, peonies

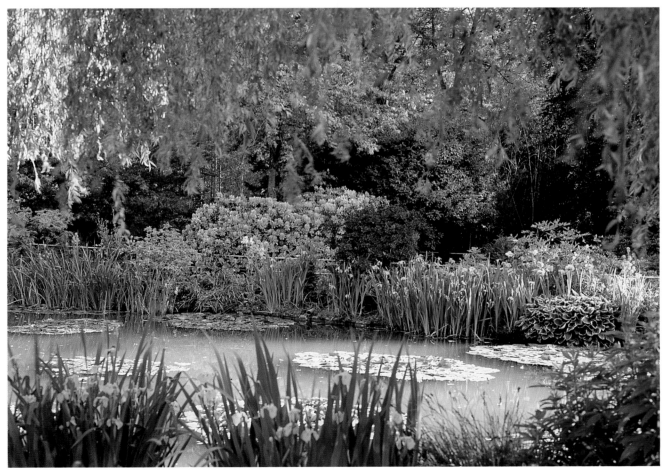

Above: Masses of yellow flag iris edge the pond in spring.

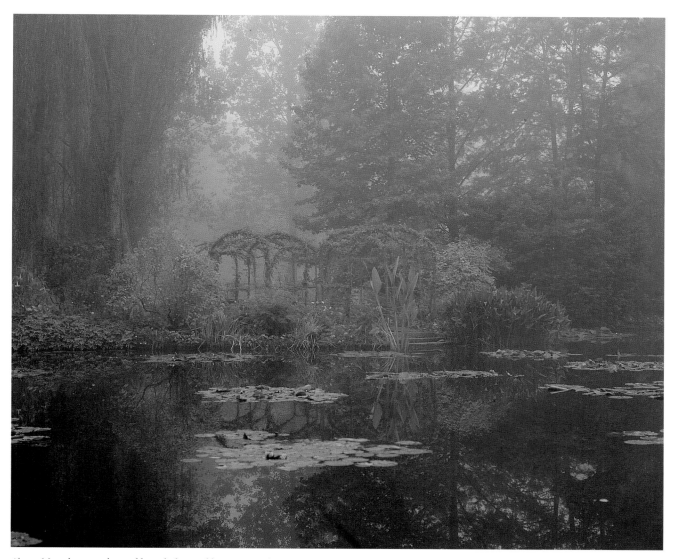

Above: Monet's rose arches and boat dock muted by autumn mist.

and Oriental poppies for late spring; roses, gladiolus and waterlilies for summer; sunflowers, asters, nasturtiums and dahlias for autumn. Lots of arches carry color high into the sky. I have my own version of Monet's arched footbridge, also a border of cool colors and another of hot colors, plus container plantings featuring lots of Monet's favorite color harmonies — especially yellow and purple, orange and blue, and red, pink and silver.

All these ideas are possible in small spaces, and the simple addition of a Monet-style bench or a Monet-style arch with clematis and roses entwined is often all that is needed to evoke a feeling of Monet's fabulous garden.

Continuing the magic
I hope a study of my photographs and chapters devoted to important aspects of this enchanting garden's design and plantings will encourage you to try to capture some of Monet's magic in your own surroundings.

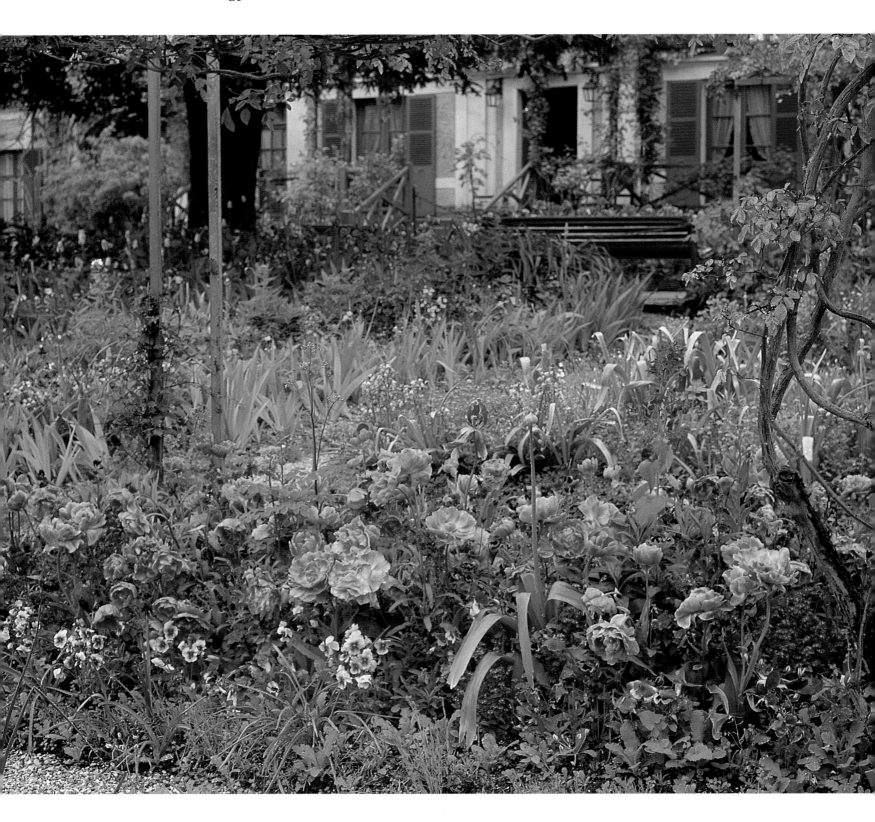

Chronology

1840: Claude Monet born in Paris, November 14.

1845: Monet's father moves his family to Le Havre, Normandy, to join his brother in a wholesale food supply business. At school young Monet draws cartoons, and, after meeting the landscape artist Johann Jongkind, takes up oil painting.

1859: Monet studies painting in Paris, encouraged by an aunt, Marie-Jeanne Lecadre, who believes he has talent.

1861: Monet sees military service in North Africa, where his interest in landscape painting intensifies.

1865: Monet and a young model, Camille Denceaux, begin living together.

1867: Monet and Camille have their first son, Jean.

1870: Monet and Camille marry.

1876: Monet meets Ernest Hoschedé, owner of a Paris department store and an art patron, and his wife Alice. On their long-delayed honeymoon on the Normandy coast Monet and his wife flee to London, fearing that the artist will be conscripted into the Franco-Prussian War.

1877: Monet's second son, Michel, is born. Monet's main client, Ernest Hoschedé, declares bankruptcy and deserts his wife. Alice and her six children move in with Monet and Camille and their two sons.

1879: Camille dies from complications of childbirth. Monet and Alice continue to live together.

1883: After living in a series of rental properties and enduring financial difficulties, Monet rents a farmhouse, Le Pressoir, in the village of Giverny, northwest of Paris. There he begins planting his Clos Normand flower garden.

1886: Monet visits Holland for the third time to paint tulips.

1890: Monet travels with Renoir to explore the Mediterranean in search of motifs and visits Cézanne at Aix-en-Provence.

1890: As a result of exhibitions in Paris, Belgium, London and New York, Monet's sales improve, enabling him to purchase the farmhouse he has been renting at Giverny.

1891: Ernest Hoschedé dies and is buried in Giverny.

1892: Monet and Alice marry. It is a second marriage for them both. He continues to expand his garden, hiring a head gardener, Félix Breuil, and five assistant gardeners.

1893: Works by Monet and other Impressionists exhibited at the Chicago World's Fair. Monet purchases additional land for his water garden.

1894: Cézanne visits and paints with Monet in Giverny, staying at the Hotel Baudy.

1901: The water garden is enlarged.

1908: Monet's eyesight begins to fail as a result of cataracts.

1909: Monet's garden is severely damaged by flooding along the River Seine.

1911: Monet adds a wisteria-covered canopy to his Japanese bridge in the water garden. Alice dies May 19.

1914: Monet's eldest son, Jean, dies of a mental illness. Jean had married his stepsister, Blanche, and after his death she moved in with Monet to help care for him. Construction begins on a new studio, his third, with sufficient space for him to embark on an ambitious painting project, a series of 19 waterlily panels.

1923: Monet suffers such serious loss of sight he has an operation to remove cataracts, a new procedure. His sight is restored.

1926: Monet dies on December 5, at age 86.

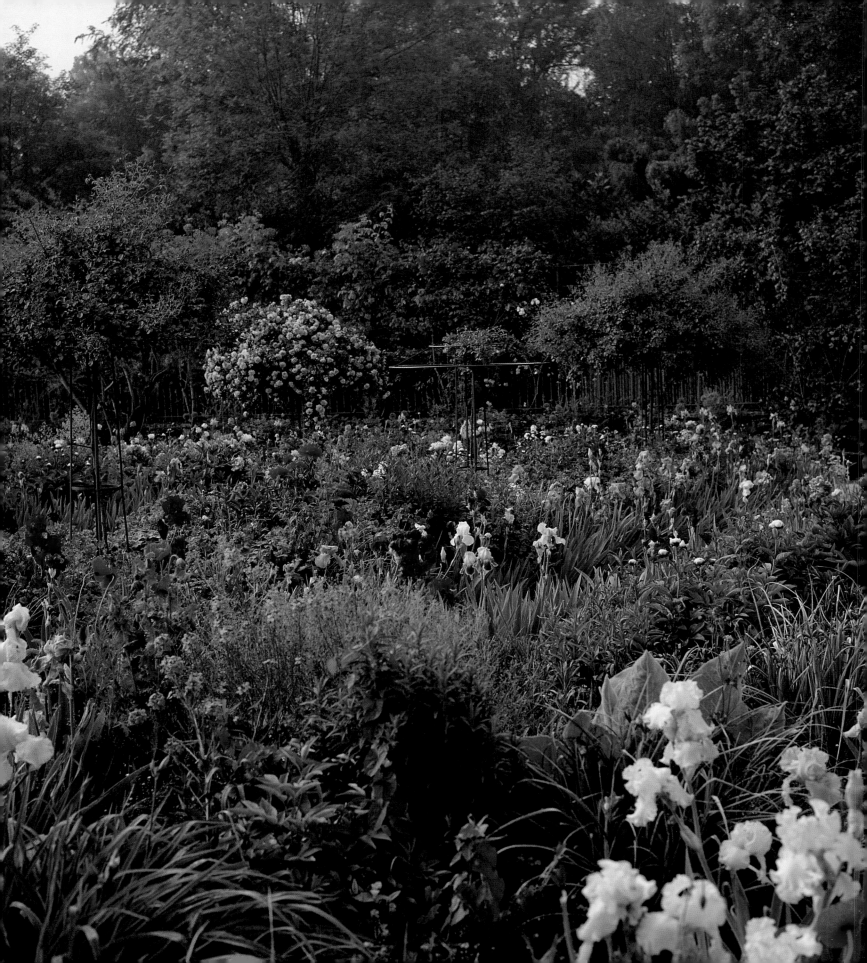

Opening Times and Other Places to Visit

GIVERNY IS 32 MILES (50 km) from Paris off the A13 motorway, north toward Rouen. The closest railway station is Vernon, a one-hour train ride from the Gare Saint Lazare, Paris. There are also tour buses than run day-trips from Paris to Monet's garden. The garden is open from April 1 through October 31, 10 a.m. to 6 p.m. daily, except Mondays, when it is open only to painters with appointments and VIPs. For those wishing to paint, contact the administration office (33) 32 51 28 21 and ask for a permit.

A good place to stay in the area is the Hotel d'Evreux, in the center of Vernon. Monet himself stayed in the hotel and dined there with Renoir. Also recommended is the Chateau de Brecourt, northeast of town.

Opposite: View from the main house to the bottom of Monet's flower garden in early June.

While visiting Monet's garden, consider a visit to the Musée Américain, which is a short walk through the village. Founded by American art patrons Judith and Daniel Terra, it features work by the American Impressionist artists who descended on Giverny after Monet moved there.

There are many beautiful gardens to see in Normandy, such as Clos Coudray, featuring an English-style cottage garden, north of Rouen; also Parc Floral des Moutiers, at Varengeville. This features a residence designed by the famous British architect Sir Edwin Lutyens, and a garden with plantings inspired by Gertrude Jekyll. A few miles south of Varengeville is Le Vasterival, a superb woodland property owned by Princess Greta Sturdza, whose garden features many of the design principles espoused by Gertrude Jekyll in her book *Wall, Water and Woodland Gardens*. Nearby are cliff walks to scenic vistas painted by Monet.

Dedication

To the memory of Gerald van der Kemp (1912–2001)

A director of Christie's auction house, in Paris, and formerly curator of Versailles Palace, Gerald was appointed curator of Monet's house and garden in 1976, and took on an enormous challenge. Together with his American wife, Florence, he not only raised sufficient funds to bring back to life what appeared to be irretrievable, but also attended horticultural classes at L'École d' Horticulture at Versailles, consulted with people still living who remembered Monet's garden, and amassed an enormous amount of published material, letters and photographs to create a restoration as close as possible to the original. What he achieved is remarkable, and only a person of keen foresight, boundless enthusiasm and astute art appreciation could have accomplished it.

Acknowledgments

My research into Monet's garden philosophy has covered a period of 16 years, requiring more than 10 visits to the garden in all seasons. During that time I received help from many people involved in the garden, particularly among the administration staff at the Monet Foundation. These include the head gardener Mns. Gilbert Vahé, Mme. Florence Van der Kemp, Mme. Claudette Lindsay, Mme. Nelly Wallays and Mns. Laurent Echaubard.

At the Maison de la France, the French Government Tourist Office, I wish to acknowledge the help of Ms. Louise O'Brien and Ms. Marion Fourestier for their help as interpreters. My office manager, Joan Haas, helped with photography research, while my wife, Carolyn, a color specialist for the fashion industry, provided expertise in identifying Monet's favorite color harmonies.

My friend Hiroshi Makita, Japanese landscape designer, provided valuable information about traditional Japanese landscape design and parallels with Monet's water garden.

I also value the advice of my agent, Albert Zuckerman, of The Writers House, New York.

Picture Credits

The publishers would like to thank the following sources for their kind permission to reproduce the pictures in the book.

(t = top, b = bottom, c = centre, r = right and l = left)

Cover (all photographs): Derek Fell; **10:** The Bridgeman Art Library/Claude Monet (1841–1926) in his garden at Giverny, c.1925/French photographer/Musée Marmottan, Paris; **12 (tl):** The Bridgeman Art Library/Claude Monet (1841–1926) at Giverny, c.1913/Sacha Guitry/Musée Marmottan, Paris; **13:** Errol McLeary; **14:** Frances Lincoln Ltd/Liz Pepperell; **23 (br):** The Bridgeman Art Library/Wild Poppies, near Argenteuil, 1873/Claude Monet/Musée d'Orsay, Paris; **25 and 27:** Errol McLeary; **31 (t):** The Bridgeman Art Library/A Pathway in Monet's Garden, Giverny, 1902/Claude Monet/Kunsthistorisches Museum, Vienna; **34 (tr):** Errol McLeary; **41 (br), 42 (cl), 46 (cr), 47, 48 (cr), 49 (b) and 50 (tl and br):** Errol McLeary; **50 (bl):** The Bridgeman Art Library/ Poppy Field in a Hollow near Giverny, 1885/Claude Monet/Museum of Fine Arts, Boston, Massachusetts/ Julia Cheney Edwards Collection; **51 (t) and 54:** Errol McLeary; **55 (t):** The Bridgeman Art Library/The Magpie, 1869/Claude Monet/Musée d'Orsay, Paris; **55 (bl), 56 (cr) and 61 (br):** Errol McLeary; **79:** The Bridgeman Art Library/ Branch of the Seine near Giverny, 1897/Claude Monet/Musée Marmottan, Paris; **87:** The Bridgeman Art Library/The Waterlilies – The Clouds (central section), 1915–26/Claude Monet/Musée de l'Orangerie, Paris; **88 (bl):** The Bridgeman Art Library/Waterlilies, 1907/Claude Monet/Private Collection; **132 (cr):** The Bridgeman Art Library/Still Life with Sunflowers, 1880/Claude Monet/Metropolitan Museum of Art, New York; all other photographs: Derek Fell.

Every effort has been made to acknowledge correctly and contact the source and/or copyright holder of each picture, and David Bateman Limited apologises for any unintentional errors of omissions, which will be corrected in future editions of this book.

Picture Captions
3: Monet's water garden on a rainy day in autumn.
5: Front entrance to Monet's house framed by rambler rose.
7: Skyline trees and pond reflection, spring.
150: The first week of May is peak flowering time for the mixed flower borders.

Index